THE
PROFITABLE
ARTIST

THE PROFITABLE ARTIST

A HANDBOOK FOR ALL ARTISTS IN THE PERFORMING, LITERARY, AND VISUAL ARTS

BY
ARTSPIRE

EDITED BY
PETER COBB, SUSAN BALL,
AND
FELICITY HOGAN

ALLWORTH PRESS
NEW YORK

COPUBLISHED BY THE NEW YORK FOUNDATION FOR THE ARTS

Allworth Press books may be purchased in bulk at special discounts for sales promotion, corporate gifts, fund-raising, or educational purposes. Special editions can also be created to specifications. For details, contact the Special Sales Department, Allworth Press, 307 West 36th Street, 11th Floor, New York, NY 10018 or info@skyhorsepublishing.com.

15 14 13 12 11 5 4 3 2 1

Published by Allworth Press,
an imprint of Skyhorse Publishing, Inc.
307 West 36th Street, 11th Floor, New York, NY 10018.

Allworth Press® is a registered trademark of Skyhorse Publishing, Inc.®, a Delaware corporation.

www.allworth.com

Cover design by Adam Bozarth

ISBN: 978-1-58115-872-4

Library of Congress Cataloging-in-Publication Data

The profitable artisit / by Artspire
 p. cm.
 Summary: "How to use your artistic skills to make money"—Provided by publisher.
 "Copublished by the New York Foundation for the Arts."
 Includes bibliographical references and index.
 ISBN 978-1-58115-872-4 (pbk.)
1. Art—Economic aspects. 2. Art—Marketing. I. Artspire (Online community) II. New York Foundation for the Arts.
 N8600.P745 2011
 706.8—dc23
 2011032421

Printed in the United States of America

Table of Contents

SECTION FOUR:
SELLING AND PROMOTING YOUR WORK

SECTION FIVE:
ARTIST FUNDRAISING

Foreword

THE PROFITABLE ARTIST

The New York Foundation for the Arts (NYFA) believes that an artist, no matter the discipline, needs three components to build a career in his or her field: access to funds, entrepreneurial skills, and an opportunity to showcase work. At NYFA, we create programs to provide all three as our mission is to empower artists at critical stages in their creative lives.

Since our founding in 1971, we have awarded more than $30 million to individual artists and small and mid-size organizations through several key grant programs. Our Fiscal Sponsorship Program is one of the oldest, largest and most respected in the country and, since 1973, has helped artists and emerging arts organizations raise and manage more than $50 million to achieve their dreams. We provide the resources needed to ensure that artists continue to produce and exhibit their work, and that artists have the time, space and materials to facilitate the creative process.

We also advocate for artists to undergo professional development training to cultivate successful careers. Master of Fine Arts (MFA) and Doctor of Fine Arts (DFA) programs frequently overlook the importance of business and professional skills. MFA and DFA students hone their craft in their course of study, but recipients typically graduate with little to no applied knowledge of professional artists' business practices. Artists may wonder, "How will I pay for my studio space?" "Where can I find money to produce my play?" or "How should I market my book?" These are the same questions emerging artists without advanced degrees also find themselves asking. Therefore, our new publication, *The Profitable Artist*, compiles a wealth of information gathered by the arts professionals at NYFA and presents a complete "how-to" guide to being a professional and profitable working artist.

The Profitable Artist is unlike similar artist's guidebooks in that it pertains to artists in all disciplines. It is our hope that painters, digital artists, poets, and choreographers will all benefit from an interdisciplinary general guide to building a career in the arts. The approach presented in this book can be applied to all aspects of one's career and all stages.

Addressing the core aspects of artistic entrepreneurship and business skills, *The Profitable Artist* serves to make artists self-sufficient, to build strong careers in the arts, and to answer questions like: How do I brand myself? Can I start a business? How do I improve and monetize? How do I keep my records?

The Profitable Artist also clarifies more specific concepts, like explaining the most common types of alternative funding—*grants, awards,* and *donations*—and the differences between them. *Strategic Planning, Finance, Legal Issues, Marketing, Networking,* and *Fundraising* are among the easy-to-follow sections included in the publication.

Helping artists succeed in their creative endeavors benefits not only the artists but also the communities in which they live and work, by supplying new perspectives and innovative ideas, lifting the spirits of citizens, and encouraging them to think differently. No boundaries exist in ways to express oneself creatively; therein lies the innate power of art, the ability to suspend one's disbelief and create that which would otherwise be impossible.

As long as artists create work and evolve their creative practices, NYFA will continue to provide resources like *The Profitable Artist* to empower them in their creative lives. For more information on *The Profitable Artist* or any other NYFA programming, visit *www.nyfa.org*.

Putting this book together took, as they say, a village, and it could not have been done without the leadership of NYFA's Chairman J. Whitney Stevens and its Board of Directors, the expertise and professionalism of the NYFA staff, and the support and encouragement of our many funders. To all of them I owe a great deal of gratitude and thanks for continuing to bring forth new ideas, funding innovative programming, and leading by example. A special thank you to Peter Cobb, Esq, whose generous spirit and guidance made everything come together. This book is dedicated to all the artists who read it and to all the people who foster the creative activities at NYFA.

Michael L. Royce
Executive Director
New York Foundation for the Arts

Introduction

THE PROFITABLE ARTIST AND THE ARTIST'S ROADMAP

What do we mean by "The Profitable Artist"? What is a "profitable" artist? you might ask. Does it mean that you have to turn a profit? That it's all about money? That you should conform your art to fit consumer expectations? Of course not.

Rather, the purpose of this book is to demystify the business of being an artist and to provide a structured framework of information that will help you move toward profitability, stability, and/or sustainability. We recognize that most artists, despite the fact that they are running their own businesses (and often without realizing that is exactly what they are doing), have not had formal business training and are unfamiliar with many of the terms and concepts in the business world. Not only are these terms and concepts unfamiliar they are often confusing and overwhelming.

NYFA believes that artists are not only capable of interweaving art and business, but that they are uniquely qualified to do so. Our premise—based on forty years of observation—is that artists are innately prepared with the skills needed to be "profitable artists." We know from our observation that artists of all disciplines possess special skills and qualities that they use in their art and can apply to their careers. For example, artists are keen critical thinkers and problem solvers. They combine creativity with ingenuity on a regular basis. They possess a strong work ethic that helps them complete their work, and the emotional fortitude to stick with a project when it becomes difficult. Finally, they are fiercely independent. Any one of these qualities would be highly prized in an entrepreneur; the combination is formidable.

If this sounds daunting, just remember, developing yourself and your practice professionally is infinitely easier than developing your art. It boils down to having an awareness—

and working knowledge—of practical business information in five main topic areas: strategic planning, financial management, legal rights and obligations, marketing, and fundraising. These are learnable skills, quite different from the innate and inimitable talent that you possess as an artist. If you have trained or focused on your art, you probably haven't had training in law or finance. Why would you? After all, investment bankers rarely sing arias or weld sculptures.

This book aims to bridge the gap between what you know now—your fundamental skill-set—and the day-to-day practicalities of running a business in the arts. To help you bridge, or rather eliminate, that gap and get the most out of this book, we have created the "Artist's Road Map." NYFA recognizes that it is impossible to create a "one size fits all" document that will take you through every step of your career. How could we? We don't know you individually and we won't pretend that there is a tidy template that answers all of your questions. That said, however, with the Artist's Road Map we give you a series of targeted and often difficult questions that, if answered thoroughly and realistically, will put you in a position to achieve your professional goals as an artist.

The Artist's Road Map tracks the five broad topic areas of strategic planning, financial management, legal rights and obligations, marketing, and fundraising. Each of these sections is in turn broken down into a series of specific questions. By probing each of these topics and exploring their relationship to your art, you will understand what you need to know to make informed decisions on the direction of your career and the viability of a particular project or strategy. The Artist's Road Map is intended both to be a standalone document and a companion to this book. Where a question is addressed by a section of the book, we have provided a reference to the relevant chapter or section. You do not necessarily need to read the book cover to cover. You may be stronger in one area than another: follow the road map, assess your skills, and use the guidance we provide to build strength where you decide it is needed.

One final note: Many books that deal with professional development for artists focus on a single discipline or even a single medium. *The Profitable Artist* focuses instead on all artists and art forms because we believe that artists share more similarities than differences when it comes to their professional development needs. This is not simply a matter of artists being more likely than non-artists to run into copyright concerns, or having to deal with grant applications more than the average person. Instead, it is a recognition that the fundamental skills that make for artistic success also can lead to professional success, regardless of the discipline. While we cannot possibly cover all of the major topic areas in a few chapters, we can help you to become more aware of the environment in which your business operates. We cover the basics and give you direction in exploring individual topics in greater depth. Reading the book attentively will give you guidance as you hone your skill-set and put it to its best possible use, both professionally and artistically.

Good luck!

The Artist's Roadmap

Instructions: Answer these questions on a separate piece of paper or create a digital document. These answers will ultimately be for you, but write them with the intention that others will see them. You will be collecting this information so that it will be at your fingertips and ready to use or adapt for any opportunity in your professional life. Err on the side of including too much information, as you can always pare down or refine an answer later.

The chapter and page numbers correspond to NYFA's book *The Profitable Artist*. Where referenced, you will find a definition, discussion, or resources about that particular topic. All of the information you write down will be taken from your own life, and you will provide your own data.

PART I. MISSION

- What is your mission? See pages 5–8.
- Do you have a mission statement? See page 8.
- What is your vision? See pages 5–8.
- Do you have a vision statement? Does it reflect your core personal and artistic values? See page 8.
- Have you identified any important goals or objectives that you believe will help you to achieve your mission? See pages 13–16.

PART II. FINANCES

- What are the costs of your project or practice? See pages 41–45.
- What assets do you have? See pages 24–26.
- What liabilities do you have? See page 26.

- Can you separate your fixed costs from your variable costs? See pages 27–29.
- Do you know which tax forms you will need to fill out for next year? See pages 33–36.
- Do you have income as an employee or independent contractor? See pages 33–34.
- Do you employ others? See pages 33–34.
- Do you have a savings plan? See pages 65–67.
- Do you have a budget? See pages 51–52.
- Do you track your expenses? If so, for how long have you been tracking expenses? See pages 54–58.
- What units of time do you use to track expenses (weeks/months/years)? See page 54.
- What spending patterns do you notice in your art practice, or with prior projects? See pages 58–62.
- Are there certain expenses that repeat again and again? See pages 58–62.

PART III. LEGAL ISSUES

- Identify any contractual relationships that you have. In other words, what professional relationships do you have for which a contract exists? See pages 73–75.
- Are your contractual relationships written or verbal? See pages 74–77.
- Do you understand the terms of each contract to which you are a party? See pages 77–79.
- What intellectual property do you own? See pages 81–82.
- If you own copyrights or trademarks, have you registered them? See pages 89 and 93–94.
- Have you licensed your intellectual property to anyone? See pages 89–91.
- Are you using the intellectual property of another? See pages 89–91.
- Do you have a license for the use of others' intellectual property? If not, is it in the public domain or do you believe that it is "fair use"? See pages 89–92.
- Do you have a legal business entity other than a sole proprietorship? If so, what kind? See pages 99–105.

PART IV. MARKETING AND NETWORKING

- How would you define your art to the outside world? See pages 117–118.
- Is this definition consistent with your mission and vision? See pages 5–8 and 124–125.
- Are you part of a specific genre or are there any particular categories that fit your work? See pages 117–120.
- What other artists do similar work to you? See pages 118–119.
- What sources will you use for your market research? See pages 119–121.
- Can you identify your target market and some key demographics within that market? See pages 119–120 and 145–147.

- Do you have a brand? If so, what is it? See pages 123–124.
- Is there a slogan, icon, or simply a descriptive phrase of your brand? See pages 124–126.
- What kinds of promotional tools will you use or develop? See pages 129–145.
- Will you create press releases? A website? A media kit? See pages 129–138 and 139.
- Will you use advertising? If so, will it be paid or unpaid? See pages 138–139.
- How does your advertising relate to your market research? See pages 119–120, 138–139, and 145–147.
- What kinds of social media will you use, if any? See pages 143–147.
- Email? See pages 139–143.
- Blogs? See pages 144–147.
- Do you have a pricing structure for your work or services? See pages 150–156.
- Do you have a system for customers or clients to pay you? See pages 149–150.
- Do you use specific networking sites? List those sites and resources. See pages 143–147.
- Do your promotional materials and social media presence align with your brand if you have one? See pages 123–126 and 129–145.
- Can you list those people whom you believe to be part of your network? See pages 157–159.
- What do you consider to be your greatest strength in networking? See pages 159–163.
- What do you consider to be your greatest weakness in networking? See pages 159–163.

PART V. FUNDRAISING

- Have you identified those costs associated with your project or practice for which you are looking to fundraise? See pages 41–45, 169–170, and 183–185.
- Which of these costs require cash as opposed to in-kind donations or other forms of funding? See pages 185–187.
- Are there areas of your project or practice that you believe are a good fit for collaborations or partnerships? See page 176.
- What companies, organizations, or individuals might be interested in sponsoring your project or practice? See pages 176–177.
- Have you identified a list of grants, awards, scholarships, or residencies for which you want to apply? See pages 171–175, 177–179, and 188–193.
- Do you have the deadlines and requirements written down for these grants? If so, how are you tracking them? See pages 188–193 and 196.
- Have you developed a set of materials that you can use as a template for applications? See pages 198–206.
- What funding have you received in the past? Be as inclusive as possible, making sure to include alternative sources of fundraising. See pages 200–201.

Strategic Planning for Artists

Introduction to
Strategic Planning

Any artist seeking to improve or professionalize his or her practice—or a specific project—inevitably faces one daunting question: Where do I begin? And the only thing worse than not knowing the right answer to this is recognizing that there may not *be* a right answer. The sheer number of possibilities can overwhelm any one of us.

The need to plan a course of action, to move toward a specific goal rather than just move, has dominated the thinking of business strategists for years and has spawned a sizable body of literature on the subject. Your directional difficulties as an artist are not only shared by many of your peers, but keep CEOs of Fortune 500 companies up nights, too.

The planning process does not need to be paralyzing or mysterious. There is no right way to make a decision, and no one formula to make a plan. In this section of *The Profitable Artist*, we will examine one form of decision-making known as strategic planning. Because formal strategic planning is mostly used by large organizations rather than individuals, we will give an overview of the theory and then turn to how artists can make use of different elements of the planning process to shape their careers in a logical manner. Briefly, these elements are (1) defining your mission (or vision) and goals; (2) assessing the environment in which you work—your strengths and weaknesses as well as the opportunities and challenges you face in realizing your goals; and (3) setting specific objectives to achieve the goals and mapping the course to reach them.

The first element—defining your mission and vision—is a fundamental issue facing any artist. The answers to several basic questions (and more) comprise your vision. Who are you as an artist? What do you want out of your artistic life? How does that coexist with your personal life? What are your ultimate dreams and do you know what you can accept and what you must avoid? For some, developing a vision will be simple and for others almost unfathomably complex, but this initial process will guide all your subsequent choices.

The second element—assessing your strengths and weaknesses, opportunities and challenges—the environment in which you practice—is daunting for most of us. In short, where are you now vis-à-vis where you want to be when you achieve your goals. The difficulty lies not so much with making a dispassionate, objective analysis of your project or practice, but rather with the amount of information with which you must make that analysis. Just as few of us can dance, sculpt, sing, and write poetry equally well, we are rarely equipped to analyze financial, legal, marketing, and fundraising issues comprehensively either. As we discussed earlier, that is one of the functions of this book and of the Artist's Road Map, which corresponds to the different sections of the book and provides guidance (prompts and hints) that will help you ask hard questions about your project or practice.

Finally, we will examine the third element of setting objectives that will help you to reach your goals and thereby fulfill your mission. How are you going to get where you want to be? What is the course or map that you will follow?

A QUICK NOTE ON TERMINOLOGY

We use the term "project or practice" repeatedly throughout this book because the phrase includes almost every type of artist reading this book. An artist's practice might include her entire professional or artistic life. For example, a printmaker looking to quit her day-job in an unrelated field and find more studio time might be looking to improve her practice (i.e., the interaction of her artistic life with her personal and other professional lives). An actor searching for ways to land more (and higher-paying) roles might also be addressing his practice. Conversely, an opera singer who wants to open a school for aspiring vocalists has a specific project in mind, as does a dancer who wants to create his own company to perform his choreography.

From a planning perspective, there is no significant difference among any of these artists. The disciplines may vary, and the end results most certainly will, but the process that each undertakes to achieve his or her goals will adhere to the same basic principles. Likewise, the substantive issues that each will face along the way—legal, financial, promotional, strategic—can be tackled by the same strategies and will draw from similar pools of information.

Organizational Strategic Planning and Artists

Strategic Planning on an organizational level is an art, not a science. There are a variety of models in existence, all of which may be appropriate depending on the size, history, resources, field, or character of the company or organization in question. Despite the absence of one dominant model, strategic plans tend to have certain basic common characteristics. Most embody a top-down structure, beginning with defining the mission and values of the organization, along with a long-term goal or vision. These are known as a mission statement and a vision statement. Strategic plans then enter an informational stage, where the organization surveys the environment in which it operates and begins to classify some of that information. This is often accomplished through what are known as an "environmental scan" and a SWOT (Strengths, Weaknesses, Opportunities, and Threats) analysis. Finally, the organization uses that information to plan specific goals and objectives that are defined in the context of its vision and the internal and external data gathering (environmental scan) and assessments (SWOT analysis). Let's look at these steps in more detail and see how they can be applied to your art career.

A MISSION STATEMENT AND VISION STATEMENT

While mission statements and vision statements are sometimes combined, they have distinct roles. A mission statement is typically a short pithy phrase that answers the following questions: What does the company/organization do? What is its reason for being, its fundamental purpose or direction? To be able to accomplish this in less than two dozen words is ideal, but very challenging. For example, NYFA's mission is "to empower artists at critical stages in their creative lives."

A mission statement can also spell out the large, long-range goal of the organization. The statement's primary audience is internal—it serves to give direction and purpose to those working at every level of the organization, as well as other stakeholders (board of directors, volunteers, members, etc.).

A vision statement can take different forms. One, it may be aligned with the current strategic plan, stating that, for example, by 20xx (the terminus of the plan) the organization *will be, and do,* whatever goals are stated in the plan. More commonly the vision statement lays out the organization's core values and answers the questions: What is the organization committed to, and what will it refuse to sacrifice under any circumstances (the "nonnegotiable")? Sometimes the vision statement is referred to as a values statement insofar as it is the lens through which all other decisions are filtered. In other words, if a product, service, or activity does not align with the organization's vision, it should not be undertaken. For example, a funder offers a handsome sum to start a new project that is only tangentially related to the core mission of the organization. In this case, the mission and vision provide a litmus test for assessing the efficacy of accepting the gift.

A strategic plan will ultimately spell out how to achieve the company's mission statement, in accordance with the core values set forth in the vision statement. For example, an organization whose mission is dedicated to supporting artists working in photography and engaging audiences through creation, discovery, and education, will use that mission as a filter when setting programmatic goals to be accomplished during the three- to five-year span of a strategic plan, which means that they are highly unlikely to (or should not) plan to develop a ceramics or jewelry program.

For an artist, establishing a plan for your project or practice begins with your mission and vision statement. Before you can set goals and benchmarks, or make plans to reach these, you need to have a clear understanding of who you are and what you want. Depending on where you are in your life or career, you could begin with identifying either your mission or your vision. If you have a project in mind or a clear long-term goal, it makes sense to start with your mission. If you are at the beginning of your career, or more focused on your overall practice, clarifying your vision may help you to discover your mission. If you are having trouble differentiating the two, think of your vision statement as those core values and principles upon which you will base your project or practice.

ADDING SUBSTANCE TO YOUR VISION

Recognizing your mission and vision is a great start. However, you still need to generate both a written mission and vision statement. These must be clear enough both to guide you and to communicate your mission and vision to the outside world. Think of this as your response to a stranger or a family member asking what you do and why. This is sometimes referred to as the "elevator speech."

That is where the practice of writing a statement (or multiple statements) becomes essential. As we will discuss throughout this book, having the ability to summarize your mission, vision, artistic approach, methodology, and anything else related to your project or practice both verbally and in writing, is vitally important. Different kinds of statements are required (or are at least useful) in different contexts. Most visual artists have encountered the term "Artist Statement" at some point, and any artist who has worked with a business or not-for-profit organization has likely come across a "Mission Statement." As we will discuss in later chapters of this book, a statement is a necessary tool for taking advantage of opportunities like grants, jobs in the field, marketing and branding efforts, and even certain legal requirements. Whether it is for art, business, marketing, or fundraising, writing a statement that coherently communicates your message is vitally important!

In terms of the actual nuts and bolts of statement-writing, we would recommend keeping it simple, clear, and removing any unnecessary words. You do not want the reader (including yourself) to be confused—try to avoid "art speak." Most muddy statements

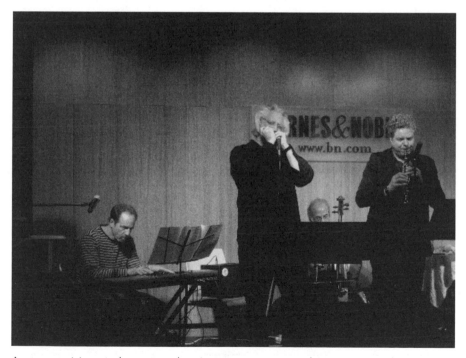

A strong vision and proper planning can turn even the most complex projects into reality. Dave Schroeder (Director, Jazz and Contemporary Studies, New York University), The NYU Steinhardt Jazz Interview Series at Barnes & Noble, 2010.

PHOTO BY Ellen Colcord

reflect muddy thinking, so if you have carefully thought through your mission and vision you will have an easier starting point. One technique is to start with making sure your verbal statement is clear: sit down with several friends or acquaintances and describe both your mission and vision. Give them a few minutes, then ask them to repeat both back to you. When you start to hear consistent results that reflect your thinking, you have gotten it right. You may even want to note some of the language that your friends use—if a phrase or term sticks with several people who are not intimately familiar with your project or practice, there's a good chance that phrase is powerful.

Exercise #1: Writing a Mission Statement and Vision Statement

Using the space below, draft (1) the mission statement for your project or practice, and (2) the vision statement for your project or practice. Use additional sheets if necessary, and be prepared to revise.

Mission Statement:

Vision Statement:

AN ENVIRONMENTAL SCAN AND SWOT ANALYSIS

The next step in the organizational strategic planning process is to do an environmental scan and a SWOT analysis. This allows the organization to gather and filter the information it needs to make good decisions about achieving its long-term goals. Without having done these analyses, it is very difficult to set both the shorter-term objectives and the most efficient ways to reach them, which are at the heart of the planning process. Artists will benefit from undertaking the same process. Let's examine the definitions of each:

ENVIRONMENTAL SCANNING

An environmental scan is a fancy way of saying, "Take a look around you." Defined in the business world as gathering and analyzing information about the environment in which an organization operates, environmental scanning emphasizes a thorough and dispassionate analysis. In a comprehensive scan, an organization would examine the political climate and the makeup of the government, all regulations that affect the organization's industry (as well as those that might be under consideration), consumer trends, technological developments, the labor market, aspects of the larger economy like interest rates, and virtually anything else that could affect the organization.

The scan should consider internal issues as well, such as the finances, staff, and even infrastructure. If the organization has done strategic plans in the past, these should be considered as well, if for no other reason than to see how well the organization sticks to a plan.

For an artist, just how comprehensive an environmental scan you are able to do is a question of resources. Most individual artists won't have the time to account for every relevant factor in their environment. However, an environmental scan can take place on a limited basis and still be effective for an artist, provided she analyzes those factors which have the greatest impact on her project or practice.

This might seem like something of a catch-22—it is impractical for most artists to undertake a complete environmental scan, but they would have to do a complete environmental scan in order to know which factors they can effectively ignore. While there may be some truth to this, most artists face similar kinds of challenges regardless of their discipline or project. NYFA has observed that certain universal issues arise time and time again for artists and their businesses, and an artist can organize a basic scan around these issues.

The difficulty, as we noted in the introduction, lies with the lack of familiarity that many artists have with certain financial, legal, and other business-related topics. Not only is it difficult to understand every issue deeply, but it is often impossible to be aware of issues that may impact you if you don't have a framework to recognize them. And that is one of the main functions of this book, to give you the information you need to understand how your

project or practice intersects with the practical realities of an arts business. We cannot cover every detail—and those will vary depending on your situation—but we can give you an overview, help you ask more targeted questions, and point you toward resources that will get you the answers you need. This is one of the main functions of the Artist's Road Map.

SWOT ANALYSIS

SWOT is an acronym that stands for Strengths, Weaknesses, Opportunities, and Threats (or, to use a more positive word, challenges). A SWOT analysis follows the business's environmental scan and serves to put to use all of the information that you gathered during the environmental scan in a well-informed analysis.

A SWOT analysis involves examining each of the four categories as they relate to the business, with the first two categories relating to the internal analysis and the second two categories representing an external analysis.

As artists, you will examine each category as it relates to your project or practice. If you are analyzing your entire practice as opposed to a discrete project, you may want to focus on the present and up to no more than three to five years in the future. The farther in advance you plan, the more speculative it becomes. Furthermore, your strengths and weaknesses will evolve over time. Anecdotal evidence works just fine to give a general sense of the scene.

Below are analyses of the categories as they relate to both organizations and artists.

Strengths

An organization will begin with those things that it does best, as well as any other resources at its disposal. The organization's ability to adapt quickly (the time between conception and implementation), or its ability to complete projects under budget are both examples of strengths.

Strengths can also include significant resources. This might include a recognizable brand, a well-developed infrastructure to carry out a new task, or even good staff morale.

While many artists will instinctively list those skills related to their art, it's very possible that you have talents and abilities outside of your discipline or the arts in general. Perhaps you are a singer who happens to write well, or a visual artist with excellent public-speaking skills. Both can ultimately be put to use in service of your project or practice. Management/organizational skills are always an asset. Some people are just better than others at certain things, hence the value of collaboration.

Another point to consider is whether you have a background, training, or a degree in another field. For example, someone with an MBA in marketing may also be a fiction writer. Due to economic and sometimes social pressures, many artists spend considerable time

away from their art practices and working in another field. But if that artist has gained a new skill set in the process, those skills will go down as strengths. The point of this process is not necessarily to connect strengths to a larger plan, but just to see what is there.

Finally, you will want to look at what resources you have that can be put to good use. These might include savings, grant awards, a well-documented library of intellectual property, or goodwill.

As a first step to analyzing your strengths, you may want to create several lists. The first will be a list of capabilities that you have. Remember to list everything, no matter how unrelated it may seem. Then make a similar list of your resources. The most effective SWOT analyses are those that do not leave out any potential elements from a category, as that may ultimately lead to an unrealistic strategic assessment.

Weaknesses

Weaknesses are usually the absence of a resource or skill, rather than a fundamental flaw. If an organization is seeking to expand its services into a new market that is dominated by a different language, then the absence of language skills could be a weakness. Similarly, a lack of expertise with an important form of technology in that industry might be seen as a weakness as well.

For many artists, a major weakness has to do with finances: usually a lack of capital to fund their art, an absence of the financial know-how to manage effectively those resources they do have, or even a lack of funds to learn new skills that would correct something identified as a weakness. Another weakness may be time management or not having a sufficiently flexible schedule to achieve their artistic goals. For others, weaknesses may be more specific, such as a lack of computer skills for a project that involves heavy use of the Internet, or no experience with grant writing for a project that requires soliciting external funds. As you did with your strengths analysis, you may want to make lists of both the capabilities and resources that you feel that you lack or that represent a weakness.

Opportunities

The opportunities analysis typically focuses on external factors, some of which may have led to the need for a plan in the first place. A significant opportunity could be a change in regulations affecting the organization's industry that allows for new activities, or a treaty that allows for trade with a new country or region. An opportunity could also be a development in technology that reduces the organization's costs in a particular area.

For an artist, this could be as large as the emergence of some new form of technology that lowers the costs of your medium, or a new interest in your medium from the general public (perhaps another artist who does work similar to yours has just been in the news for

some reason). It could also be that a new grant or other source of funding becomes available for artists in your situation. Sometimes it is a specific opportunity that led to the new project which initially prompted the SWOT analysis. As with strengths and weaknesses, make a list of opportunities that you have identified.

Threats (Challenges)

The second part of the external SWOT analysis focuses on threats or challenges that the organization faces. Many threats are economic, and if an organization is dependent on using a particular resource, any event that raises the cost of that resource would be a threat. Changes in the job market could be a threat as well—if the organization depends on staff with certain training, and changes in another industry draw from the same pool of eligible workers, that would be a threat to the organization.

Very generally, this includes anything in the environment that could jeopardize the success of your project or practice. For artists focusing on work with mass market appeal, this could include shifts in taste, or for others it could mean that some event has occurred to raise the costs associated with an important raw material used by the artist. NYFA does not consider competition from other artists to be a threat—it is our belief that every artist's work is sufficiently unique to sustain its own market. As we will discuss in the chapter on Networking, we feel that you should look to your fellow artists as resources, sources of inspiration, collaborators, and potential models. The competition among you for exhibitions, performances, grants, and awards is a reality of the world you are in, not a threat.

Exercise #2: Perform Your Own SWOT Analysis

Reexamine your environmental scan in light of the discussion on the SWOT analysis. Try to classify those elements you identified in the scan as either a strength, weakness, opportunity, or threat/challenge.

Strengths:

Weaknesses:

Opportunities:

Threats/challenges:

SETTING GOALS: S.M.A.R.T.

Setting goals or objectives is the nitty-gritty of strategic planning and involves testing against the mission, vision, and the well-informed internal and external analyses. If a company has a well-defined mission, a good sense of its vision and values, and a comprehensive grasp on how internal and external environmental factors affect the organization's current and future options, then setting goals should be a logical process. Developing the goals within this context ensures that they are both unique to the organization and aspirational, but also realistic and grounded in fact. When an organization considers a goal or objective, it will need to confirm that the objective furthers its mission. Having surveyed and categorized the

organization's strengths, the objective will draw on the strengths, avoid the weaknesses, respond to the opportunities, and factor in the threats. Finally, in order to be a viable choice, any specific objectives will have to align with the organization's vision and values.

There is a widely used mnemonic device for setting goals known as SMART. This stands for *Specific*, *Measurable*, *Achievable*, *Realistic*, and *Timely*. A substantive and useful goal will have each of these qualities. If an organization's goal meets these criteria and filters through the lens of the organization's mission—against the backdrop of the environmental scan and SWOT analysis—the goal is appropriate for the organization to pursue and is set on a course to succeed.

For artists, the same conditions apply. The goals (or objectives) you select will ultimately plot the course of your practice or guide your project. Remember that goals can be benchmarks, tasks, measuring points, and sometimes an end in and of themselves.

Good goal setting and strategic planning is identifying which of those types of goals most closely align with your vision, and then choosing the most efficient route to get there.

SMART GOAL SETTING

Following are components of an effective goal—one that describes performance standards that will "tell us what good behavior looks like." The SMART acronym can help us remember these components.

Specific	The goal should identify a *specific* action or event that will take place.
Measurable	The goal and its benefits should be *quantifiable.*
Achievable	The goal should be *attainable* given available resources.
Realistic	The goal should require you to stretch some, but allow the *likelihood of success.* Your ultimate goal is to succeed at whatever you set out to do!
Timely	The goal should state the *time period* in which it will be accomplished.

Here are some tips that can help you set effective goals:

- Develop several goals. A list of maximum five to seven items gives you several things to work on over a period of time. Too many portends failure.
- Attach a date to each goal. State what you intend to accomplish and by when. A good list should include some short-term and some long-term objectives. You may want a few objectives for the year, and some for two- or three-month intervals.

- Be specific. "To find a job" is too general; "to find and research five job openings before the end of the month" is better. Sometimes a more general goal can become the new long-term mission, and you can identify some more specific objectives to take you there.
- Write down your objectives and put them where you will see them. The more often you read your list, the more results you get.
- Review and revise your list. Experiment with different ways of stating your goals. Goal-setting improves with practice, so play around with it.

Exercise #3:

Let's now apply the SMART objective-setting concept to your goals. The following exercise is one that NYFA uses in many of its Professional Development seminars for artists. Try using this to set some of your own objectives in accordance with your mission and vision statements.

Identify Your Goal (one sentence):

Outline all potential obstacles or concerns:

Steps:

1)

2)

3)

TAKE CONTROL OF YOUR FUTURE: PLAN

The strategic planning process has been demystified and you are enlightened about the benefits and empowerment that come with taking charge of your future. We caution you, however, that this empowerment comes with hard work, following as closely as possible the steps we outline: (1) figuring out who you are (mission/vision) and what you want SMART (goals), (2) where you are now (SWOT analysis/environmental scan) vis-à-vis where you want to be (goals), and last but not least, (3) how you are going to get there (objectives/ mapping the course). We have suggested a strategic planning framework of a maximum of three to five years. It is essential, in order to keep the plan alive and working, that you reevaluate and update your plan at least every year or two, taking into consideration both internal and external factors that may impact the route you have plotted on your Artist's Road Map. For example, you are accepted into a prestigious artist residency giving you the opportunity not only to focus on developing a body of work, but also to network with other artists, critics, and dealers, thereby possibly accelerating your career. Conversely, in another example, you feel compelled for financial reasons to take a full-time job that may have a negative impact on the timeline you set for attaining your goals.

You now have the basic tools to chart your own course, to become the cartographer for your future using the Artist's Road Map. The tools and guidance in this section both complement and supplement those in other sections, all designed to help you become a profitable artist.

Finance:
"It Costs Money"

Financial Issues for Artists: Why Does Finance Matter?

Why do you need to know about the financial details of your art career? In some ways, this may seem like a silly question. Money—or lack thereof—is an important issue for all of us, regardless of whether you are a painter or a doctor. Furthermore, most of us believe that we understand *something* about our own financial picture. After all, we deal with it every day.

However, anything beyond a cursory glance at financial issues reveals a longstanding tension between the arts and finance. How many of us have heard well-intentioned friends and relatives discourage a budding art career because it was perceived as a poor financial choice? *"You can't support yourself as an artist!"* How many potential projects have been scrapped before they were undertaken (or worse still, in the middle of the project) because they were not economically viable? No artist is a stranger to the stereotype that artists are financially impractical or simply "bad with money." And on the other side of the issue, many artists view financial matters as the enemy of creativity, a dry and unforgiving topic that is at odds with artistic goals, perhaps even encouraged by the stereotype to think this way. In other words, somehow dealing with financial issues (and realities) means "commodifying" your art, as if dealing with financial practicalities was a bad thing.

Like many stereotypes, there is some truth here. Many people (not just artists) find financial matters intimidating, hence the constant demand for financial service professionals like accountants and tax preparers. Even more importantly, having a clear understanding of your financial realities can be downright sobering. It is no wonder that people would rather ignore the numbers, or buy into the argument that dealing with numbers brings one down from the lofty heights of creating art.

But artists shouldn't ignore the numbers any more than anyone else who is supporting him- or herself. No matter how nontraditional an artist's work or practice may be, she is not relieved of the need to fulfill obligations like paying taxes. A sale of a fifty-foot sculpture

that took ten years to create is still a sale, just the way a pack of gum sold at a convenience store is a sale. You might want to ignore financial rules and regulations, but rest assured that they will not ignore you!

Still, we recognize that many aspects of a business's finance are unpleasant for artists, as they are for most people. Who wants to interrupt a good session in the studio to file away receipts or keep a balance sheet updated? Or after coming home from dancing in a full-length ballet, probably the last thing that a person wants to do is fill out a W-9 for his employers. Many creative minds balk at the notion of having to micromanage details. Furthermore, numbers can be intimidating to lots of very intelligent people (not just artists). And financial terminology that sounds completely foreign to one's daily vocabulary only makes things worse. The end result is that a lot of artists simply "tune out" and do their best to avoid business situations that require them to venture into unfamiliar territory. We caution you against using being an artist as an excuse to avoid dealing with your financial picture(s)—large and miniscule.

This unfortunate though understandable reaction can lead to serious financial problems, including debt, bankruptcy, and audits. More commonly, however, the result is missed opportunities: the chance to grow as a business, generate more income from your project or practice, and a greater sense of financial security, which can actually lead to more time for creative work. We all know the old adage that money can't buy happiness, but not worrying about an unidentified impending financial crisis can certainly leave you free to tackle other problems.

In this section of *The Profitable Artist* we will help to get you started on better understanding your finances. We start by offering basic familiarity with some key financial terms and how they function in the larger financial landscape. These terms are not presented in any special order—instead they represent concepts, which NYFA believes artists can use to navigate the financial landscape more easily to help make their projects more financially viable. If you want to study any of these concepts in greater depth we encourage you to do so, and have provided some suggested resources that address the topics comprehensively. Or you may just choose to use this knowledge to clean up your books a bit (or start them), and allow a professional accountant or financial advisor to help you more efficiently. Given that many professionals charge by the hour, the more orderly and complete the information is that you take to the accountant and/or financial advisor, the less it will ultimately cost you.

As we will emphasize throughout this book, a little planning combined with a little extra knowledge can go a long way toward easing both your fears and your financial burdens. We won't presume to tell you how to do your taxes, pick your stocks, or choose an accounting or budgeting system, because there is no "one size fits all" answer here. These are individual choices that you will need to make after carefully considering your options and

consulting with experts. What we will do is give you a starting point and show examples of how other artists have approached similar decisions. In the end, you will start to see that art and business finances share more similarities than differences. Furthermore, you will feel more comfortable taking charge of your financial life.

As promised, we start with some general financial terms commonly used in financial accounting, and some others that are simply associated with important aspects of a business's or individual's financial activities.

We will then go on to provide you with strategies to help you start thinking like a business person. By the end of this chapter you should not only be able to recognize and classify your expenses but also to analyze and hone your business activities. We want to emphasize that finances are already a big part of your artistic practice. Profitable artists study, grapple with, and shape their businesses *in addition* to their art practices.

Defining and Demystifying Financial Terms

These definitions are for your general reference; when you learn them you will become familiar with the terms and ideas that are commonly used by small businesses. As we define these terms, we will demonstrate how they might apply to artists specifically. However, the majority of these terms and concepts are fairly universal, and our goal is for you to familiarize yourself with financial terms on a general level. We have grouped them according to three common financial concepts: the balance sheet, the income statement, and tax issues.

BALANCE SHEET

A balance sheet is one of the most important documents in financial accounting and is something that even the most basic businesses, yours included, should use and understand. A balance sheet should be thought of as a financial snapshot, as it summarizes the financial status of a company or an individual at a specific point in time. Depending on the size of a business and how detailed it needs its records to be, it will make a balance sheet on a monthly, quarterly, or annual basis. The actual mechanics behind a balance sheet are relatively simple (at least in theory): you add up both the business's assets and its liabilities and then record the difference. This difference between the assets and liability is referred to as equity.

 A balance sheet is one quick way to see the financial health of your business (or yourself for that matter). If a theater company has assets worth $20,000 and liabilities of $50,000, they have a deficit, or negative net "worth" of $30,000; obviously, this could indicate a problem, although it is always necessary to examine things more closely before jumping to conclusions. Remember, this is a snapshot of the balance sheet at a point in time. The theater company could have been anticipating a large gift from a donor, but prudently left this uncertain gift off the balance sheet, not "counting its eggs before they were hatched." At the

same time, they would have been in trouble if the gift had not come through, so this is living a little too close to the edge for many people's comfort level.

From the perspective of artists who are seeking to get a better grasp on their finances, the balance sheet represents a good opportunity to apply some basic concepts of valuation and classification (determining what their assets and liabilities are and putting this on paper).

ASSETS

An asset is anything that has economic value. The key feature of an asset is that, while it may be tangible or intangible, it is owned by an individual (or a business entity) and it can be converted into cash if necessary. Tangible assets can be further subdivided into current assets and fixed assets.

Many people find the concept of "current assets" versus "fixed assets" to be confusing, so let's look at some examples. Current assets are defined as the balance of all assets that can readily be converted into cash. This would include cash itself—quite literally the money you or your business has in the bank. It can also include any inventory that you are intending to sell. A graphic artist may have a checking account with $1,000 in it, and six prints in her studio that are realistically worth $500 apiece (although she may hope to sell them for more). She therefore has $4,000 in current assets. Conversely, fixed assets are those assets that are not expected to be converted into cash in less than a year's time (or within the fiscal—or financial—year). A common example of a fixed asset is physical property. If the same graphic artist owns a two-year CD or the building that houses her studio, this would be a fixed asset, as she intends to continue producing work in the studio throughout the fiscal year. Keep in mind that the distinction between current and fixed assets is conceptual as much as it is practical—it might be that this artist's studio is in a particularly desirable location and that she could sell the property on very short notice (certainly before the end of her fiscal year). For accounting purposes, she will still consider this as a fixed asset because she intends to use it throughout the fiscal year to produce work. She could cash the CD too, but for a penalty if the two years have not elapsed, reducing its short-term cash value.

Intangible assets are simply any non-physical resources that can be used to the business or individual's economic advantage. These include most intellectual property such as copyrights, trademarks, and patents, or "goodwill," and brand recognition. It can be more difficult to place a value on these assets (less so with intellectual property), but they can be incredibly valuable. A musician who has a business playing background music at events and who has been doing so for years with repeat clients has likely accumulated a lot of goodwill for the business. In other words, if another musician had the same repertoire and even used the same instrumentalists, she might not be as successful, at least not at first. Brand recognition (which we will discuss in greater detail in Chapter 15) is similarly valuable. A

John 123 Art Company
Sample Balance Sheet
December 31, 20XX

ASSETS
Current Assets
Cash $ 31,500
Accounts Receivable $ 7,500
Inventory and Supplies $ 15,000
Pre-paid Insurance $ 4,000
 Total Current Assets $ 58,000
Fixed Assets
Studio $175,000
Studio Improvements $ 27,500
Equipment $ 60,000
Less: Accumulated Depreciation ($ 52,500)
 Total Fixed Assets – net $210,000

Intangible Assets
Goodwill $ 50,000
Brand Name/Recognition $200,000
 Total Intangible Assets $250,000

Total Assets $518,000

LIABILITIES
Current Liabilities
Accounts Payable $ 4,500
Wages Payable $ 7,000
Taxes Payable $ 1,200
Unearned Revenue $ 10,000
 Total Current Liabilities $ 22,700

Long-term Liabilities
Mortgage Payable $125,000
Equipment Loan/Financing $ 42,000
 Total Long-term Liabilities $167,000

Total Liabilities $189,700

Owner's Equity $328,300

Total Liabilities & Owner's Equity $518,000

Fig 4.1 - Sample Balance Sheet

film producer might want a famous actor to play a small role, or even a cameo, simply because that actor's name will attract a wider audience.

RECEIVABLES

A receivable is an amount of money owed to an individual or a business for goods or services provided. An artist who works as an assistant on a photo-shoot submits a bill for her services. Until paid, it is listed as a receivable. Recognizing that the same "transaction" might be defined differently depending on where you stand is important and will help to demystify much of the terminology used in financial accounting. Just as learning to recognize costs is a skill you can develop, so is learning how to see that accounting terminology exists to help people classify our everyday activities. Once you learn a few of the terms, you will quickly see that you are very familiar with the underlying actions they describe!

To continue with the general theme of classifying business activities according to when they occur, businesses will often list receivables as current assets if they expect to receive payment within the course of the fiscal year, or long-term assets if the outstanding balance will not be paid for a more significant length of time. And, as in the case of the hoped-for gift, uncertain anticipation is not justification for inclusion as a receivable; on the other hand, grants that are typically awarded year after year with regularity may be.

LIABILITIES

The term "liability" refers to an amount of money or a service that you owe to another individual (or business). This can include loans, mortgages, taxes, or wages due. In the example above with the photographer and her assistant, the same bill for services that was a receivable for the assistant would be considered a liability for the photographer. Once it is paid, it is no longer a liability.

As with fixed and current assets, liabilities can be further divided by how they need to be dealt with during the fiscal year. "Current liabilities" refers to debts to be paid within the course of one year, and "long-term liabilities" refers to debts paid over a long-term period. The term is often used in conjunction with assets because they figure so prominently in another area of accounting, the balance sheet. It is also worth noting that liability in the financial context has a somewhat different meaning than liability in the legal context (which we will address in Chapter 9).

EQUITY

Equity is the owner's right to an asset or property. On a balance sheet, equity equals the sum of owner's contributions to the company, plus or minus profits from the business that have

not been distributed to its owners yet, or losses. Equity can also describe the net worth of a company or an individual with the formula: *Equity = Assets−Liabilities*

In real estate, equity refers to the value of a property minus outstanding debt (e.g., mortgage payments).

CAPITAL

Capital is money invested in a business for the purpose of generating future revenues. Capital can also refer to the collective value (including money and property) of a business or an individual.

INCOME STATEMENT

The income statement calculates revenue vs. expense to record a company's or an individual's net income or loss over a specific period of time, as opposed to the balance sheet, or the snapshot at a specific point in time.

The income statement is a very important way that artists can understand the profitability of their business in a given time period, usually over a year (although it could be applied to a specific project, such as a tour, exhibition, or print run). It clearly spells out both gains and losses. For example, suppose a rock band spent $25,000 last year paying roadies, maintaining instruments, renting rehearsal and performance space, and printing flyers for publicity. The band also earned $15,000 from ticket sales and other merchandise like CDs and T-shirts. By subtracting what was spent from what was earned, the band's income will be reflected on its income statement—in this example, the band lost $10,000.

While many artists may find in the beginning that they inevitably lose more than they make, it is important to maintain regular income statements in order to keep abreast of gains and losses no matter how discouraging. This way, artists can detect trends in their business or artistic activities and make adjustments if necessary, including how much they charge for their products and services.

FIXED COSTS

Fixed costs are defined as business expenses that are "static." In other words, they do not vary according to production level or sales volume. Fixed costs can include rent, salaries, loan payments, and insurance. Perhaps one way of envisioning fixed costs is to think about what tools (or infrastructure) you need to produce your work, as opposed to what raw materials you need. Another way to think about fixed costs is those that are known (e.g., rent) or easily knowable over a period of time (e.g., materials). This is obviously a very rough generalization, so let's look at some specific examples. Imagine a potter who runs a commercial studio—in order to produce pottery, she needs space (the studio itself), a kiln, and clay-

working tools like a banding wheel and trim blades. The rent or the mortgage that she pays for the studio, the price of purchasing the kiln, and the price she paid for the banding wheel and trim blades are all fixed costs. Even if she does not produce a single piece of pottery that she likes during the year (recycling her clay over and over again) she has incurred these fixed costs. Nor would these costs rise even if she produces hundreds of pieces in a single year. In other words fixed costs do not fluctuate; our ceramicist continues to pay the same studio and tools expenses no matter what she is making.

Fixed costs are one of the two most confusing classifications in accounting (the counterpart of fixed costs is variable costs), so if you can understand this, you will be able to master any accounting concept that comes your way.

VARIABLE COSTS

Variable costs are defined as those expenses that change according to the production and activity of a business. Some typical expense categories here include raw materials, direct labor (the time of an employee paid by the hour, or the need to hire additional employees), and in certain cases overhead (for example, higher electrical bills due to higher production).

The key point here is the connection between the increase in an artist's production or activity and the increase in her variable costs. Returning to the potter example, if she produces no works then she will probably not purchase any additional clay. If she produces more works, then she will have to purchase more clay as clay is a raw material necessary for her production. Similarly, if she never uses her kiln then it is unlikely to consume any electrical power, but if she is producing more pieces she will be running her kiln much more frequently, which in turn will bring a higher electrical bill. These additional electrical charges are variable expenses, dependent on production. Finally, if she needs to fill a very large order she may have to hire other skilled potters to assist her with the work. These new or temporary hires would be considered variable expenses (conversely, if she had a salaried employee on staff with a set number of hours, that salary would be a fixed expense).

Artists (and many other people) can easily overlook variable expenses because they are tied to production, which is usually a good thing. If you are receiving numerous commissions or are acting in a lot of new roles, that probably means that your practice is enjoying success and you are earning money doing what you love. Nevertheless, the variable costs are still there and, to continue with the theme of awareness of your activities' costs, these may be affecting your ultimate profitability. Simply isolating your variable expenses may help you think of ways in which you can cut back on these expenses (perhaps buying in bulk, or using a different material). Especially where you are producing a large amount of a work, a small adjustment in your variable expenses can have a huge impact on your profit. While we

will not cover accounting calculations in detail, fixed and variable costs are vital to most standard calculations of profitability.

Variable costs can impact your profit margin and although an increase in production may be appealing, one should keep in mind that the additional revenue may not always be worth taking on the additional expense. For example, if the potter took on ten additional orders, increasing her variable expenses by $1,000, but only increasing her revenue by $1,100, the net profit would only be $100 and may not be worth taking on the additional orders.

COST OF GOODS SOLD

The "Cost of Goods Sold" (usually referred to as COGS) is a term used to help calculate the profitability of a given product. The cost of goods sold is the sum of the costs of acquiring or producing the product (the goods) that the business will sell. Speaking *very* generally, the cost of goods sold is usually made up of variable rather than fixed costs, but this is not always the case. Expenses in this calculation often include material costs and labor costs directly associated with producing the product.

Calculating the cost of goods sold is usually most important to businesses that have a high volume of sales, and most of the formulas that address COGS reflect high volume and are concerned with measuring this based on the business's inventory and expenses over time. While some artists have a high volume of sales (for example, those who run galleries, or whose work is designed for large-scale commercial distribution, or who have their own record labels), the vast majority do not produce or sell on a large scale. However, calculating the cost of goods sold is still useful for understanding the true costs of your project or practice, and another tool for evaluating your own profitability.

INVOICE

We discuss invoices not because they are complicated instruments or concepts—most are pretty simple—but because you usually need them to get paid for your work. All too often, artists delay collecting money that is due for their work or services. Sometimes this results from shyness or a lack of confidence in their work. More frequently, however, it is due to being unfamiliar with standard business practices and is only reinforced by the casual business environment in which artists operate. Payment occurs through a barter system, or on the understanding that the other party will pay when he/she has the funds to do so. And some artists prefer to be paid in cash and without records in an effort to avoid paying taxes (*we need to remind you that this is illegal*).

However, good business practices demand that you generate and send invoices to your clients or patrons. An invoice is simply a bill for goods or for services. Its main function is for record-keeping and notification—it allows your client to have a record of what you are

charging, breaking the charges up into specific categories (quantity of items sold, price per item, number of hours worked, rate per hour, etc.). If you are dealing with an established business or institution, most of them will require you to submit an invoice before they will issue a check. Sometimes invoices are issued before anything is performed or delivered, giving the purchaser a chance to review what you will deliver. Not only does this prevent misunderstandings, but it creates a "paper trail" that can be used should a dispute arise.

Most artists are providing or selling something similar on a regular basis, so you can design a basic invoice and adapt it as necessary (a painter will usually be billing for a painting, a dancer for hours worked, etc.). You will want to include certain basic information on any invoice:

- Names—your name (or that of your business), and the client/purchaser.
- Dates—the date the invoice is issued, and the date payment is due.
- Addresses—your business address, and the client's address.
- Descriptions—describe the activities or services performed, the goods provided, the units of (hours, quantity, etc.), and the dates on which these were completed.
- Price—itemize the costs of all goods or service and, most importantly, include the final price.

Additionally, some clients may require you to provide your social security number or Employer Identification Number (EIN), and any other relevant coding (a vendor ID number, for example). Ultimately, how you present an invoice may be at the discretion of your client—they may have internal coding or other requirements and if they need information presented a certain way, give it to them.

There are literally hundreds of templates on the Internet, and we have included a sample invoice here.

CASH FLOW

Cash Flow is the stream of cash revenues or expenses in a business over a period of time. If the closing balance is higher than the beginning balance, the cash flow is "positive." If not, the cash flow is "negative." A positive cash flow is crucial to the survival of a business. Even if a business generates profits, a negative or small cash flow can lead to insolvency, which is a technical way of saying that you no longer have enough money available to pay your bills.

For example, a visual artist might have a substantial amount of money tied up in long-term assets, such as unsold work and a studio space that he owns, but he might face serious financial problems in the present if his cash flow is negative. On the other hand, a musician

Invoice #	**1001**
Date	9/1/2011
Job	5 piece JD
Customer	John Doe
	55 New York Ave
	NY, NY 10001
	212-355-6880

Lightning Up Studios
66 Jay street
Brooklyn, NY 11201

212-366-6900

quantity	Description	price per item	price
2	item a	$6.00	$12.00
2	item b	$6.00	$12.00
1	service c	$50.00	$50.00
1	item g	$32.00	$32.00

INVOICE TOTAL: $106.00

Project Notes: Ready for pick up on 9/30/2011

Fig 4.2 - Sample Invoice

with a smaller net worth but with steady gigs that pay him directly after he performs (and has therefore a positive cash flow) will face fewer financial problems in the present.

INCOME/REVENUE

Income refers to financial gain over a particular period of time. For an individual, this refers to employment and investments, and for a company, this refers to total revenue minus the cost of operations and taxes. Revenue refers to the total amount of financial gain from the sale of goods or services, and sometimes from interest, dividends, and royalties. For non-profit organizations, revenue is often generated through donations, sponsorship, earned income (membership dues or ticket sales, for example), and fund-raising activities.

For a musician, revenue might be generated by ticket and album sales. From the perspective of an arts business for which you are the sole proprietor, however, income would refer to revenue from ticket and album sales minus the cost of the venue, the cost of the equipment, and the expenses incurred recording the album.

EXPENSES

Business expenses are the tax-deductible costs of running the business. For a visual artist, these might include the monthly rent on a studio or the cost of consumable supplies like wood, paper, paint, or darkroom chemicals. Business expenses can also be the cost of shipping artwork from one location to another for a sale or for a show. For an opera singer, business expenses would more likely be the cost of voice lessons, transportation to and from auditions, and rehearsal space rentals. One important thing to remember about business expenses is to keep track of them—with receipts. Whether you are reporting these expenses on your taxes or just keeping records of how much you spend, it is important to maintain accurate records of your business expenses. These accurate records are the only way you really know how much you spend, and therefore how much you need, in order to keep your artistic practice going.

PROFIT OR SURPLUS

Profit refers to the difference between the sale price of an item or service and the expenses incurred in its production, and can be calculated through a simple formula:

Profit = Total Revenue—Total Expenses

This basic formula is important to keep in mind when pricing work. Sculptures, paintings, albums, tickets—all of these things should be priced while considering the base cost for the item. Please refer to Chapter 17 for more tips on pricing your work.

Surplus vs. Loss or Deficit

A surplus is when revenue exceeds expenditure, and a loss or deficit is when expenditure exceeds revenue. Whether you maintain a surplus or a deficit in your arts practice, the most important thing to remember is to stay aware of the amount of your income or your deficit. Once aware of these numbers, you can make financial decisions based on real information rather than speculation and conjecture.

TAXES

The following list of terms relates to taxes that most small businesses encounter, forms you will need to file, specific terms you will see on those forms, and common vehicles for tax deferral.

INDEPENDENT CONTRACTOR

For the purposes of financial accounting and taxation, an independent contractor is someone who is self-employed, but who is then paid by another business or individual to provide services or goods. From a tax standpoint, the hiring party does not withhold income or social security taxes on the independent contractor's behalf. Independent contractors are therefore responsible for filling out a Schedule C as part of the Form 1040 tax return and reporting all business income and expenses.

On its website, the IRS notes that "[T]he general rule is that an individual is an independent contractor if the payer has the right to control or direct only the result of the work and not what will be done and how it will be done."

While almost anyone can be an independent contractor, a typical independent contractor is someone with a specialized skill who is retained for a fairly limited function (either in terms of the scope of the work he/she will do, or for the duration of the project). The assistant, a photographer herself, hired for the photo shoot mentioned above, for example. This is a common arrangement for artists who work both as and with independent contractors. For example, a writer may write reviews for several websites and be paid by the submission—she is working as an independent contractor. Conversely, she may hire a graphic artist to design the cover of her next book—she has now hired an independent contractor. Independent contractors can be appealing to the hiring party because there is much less responsibility and administrative work than with an employee. And many artists find the lifestyle of an independent contractor suits them because they have more flexibility with work hours and no permanent supervisor.

It is worth noting that, especially for artists, a person's status as an independent contractor as opposed to an employee has significant legal implications. We will address this in greater detail in Chapter 8, but for now keep in mind that the ownership of intellectual

property can often hinge on whether the creator is an employee or an independent contractor, also known as "work for hire." There are also differences in (legal) liability.

W-2

A tax form prepared by the employer that declares an employee's wages and taxes withheld (including social security tax information) over the course of a calendar year. In turn, employees are responsible for reporting information from the W-2 form when they file a Form 1040 tax return.

W-9

An IRS form that employers distribute to any freelance or independent contractors to request taxpayer identification number and certification. These individuals (or businesses) are required to furnish information on the W-9 to their employers, who will use the form to later file a 1099 with the IRS. As many artists are self-employed and work as consultants or independent contractors, this is a form that they will fill out frequently depending on the number of different people or companies to whom they provide services. Fortunately it is one of the simplest tax forms the IRS issues.

1099

There are actually a number of tax forms that fall under the 1099 "series," but when people refer to a 1099 they usually mean the IRS form that employers must fill out for independent contractors who earned more than $600 and whose earnings, referred to as *non-employee compensation,* are not reported on a standard W-2. The 1099 also covers interest, dividends, payouts, broker transactions and barter exchanges, among other types of income. The form varies depending on the type of income that it reports, but most artists will receive them for services they provided to a company or individual. 1099 forms are one way that the IRS helps to track freelancer income, so all 1099 forms need to be reported and filed with taxes, although not all types of income will be taxable.

DEDUCTIONS

A deduction is an amount subtracted from total income to reduce the amount of income subject to tax. Deductions include expenses incurred by a business or an individual in order to generate income. Receipts should be kept and filed for every deduction declared to the IRS.

Artists who deduct business expenses on their taxes need to keep tight records of those expenses and maintain a file for their receipts. While artists should deduct real business expenses on their taxes, they need to keep in mind that they have to prove to the IRS that they are, in fact, a business, and therefore generate some income from their art-making. Because determining which expenses you can write off and whether or not you even qualify

Form **W-9** (Rev. November 2005) Department of the Treasury Internal Revenue Service	**Request for Taxpayer Identification Number and Certification**	Give form to the requester. Do not send to the IRS.

Print or type — See Specific Instructions on page 2.

Name (as shown on your income tax return)

Business name, if different from above

Check appropriate box: ☑ Individual/ Sole proprietor ☐ Corporation ☐ Partnership ☐ Other ▶ ☐ Exempt from backup withholding

Address (number, street, and apt. or suite no.)

Requester's name and address (optional)

City, state, and ZIP code

List account number(s) here (optional)

Part I Taxpayer Identification Number (TIN)

Enter your TIN in the appropriate box. The TIN provided must match the name given on Line 1 to avoid backup withholding. For individuals, this is your social security number (SSN). However, for a resident alien, sole proprietor, or disregarded entity, see the Part I instructions on page 3. For other entities, it is your employer identification number (EIN). If you do not have a number, see *How to get a TIN* on page 3.

Note. If the account is in more than one name, see the chart on page 4 for guidelines on whose number to enter.

Social security number

or

Employer identification number

Part II Certification

Under penalties of perjury, I certify that:

1. The number shown on this form is my correct taxpayer identification number (or I am waiting for a number to be issued to me), and

2. I am not subject to backup withholding because: (a) I am exempt from backup withholding, or (b) I have not been notified by the Internal Revenue Service (IRS) that I am subject to backup withholding as a result of a failure to report all interest or dividends, or (c) the IRS has notified me that I am no longer subject to backup withholding, and

3. I am a U.S. person (including a U.S. resident alien).

Certification instructions. You must cross out item 2 above if you have been notified by the IRS that you are currently subject to backup withholding because you have failed to report all interest and dividends on your tax return. For real estate transactions, item 2 does not apply. For mortgage interest paid, acquisition or abandonment of secured property, cancellation of debt, contributions to an individual retirement arrangement (IRA), and generally, payments other than interest and dividends, you are not required to sign the Certification, but you must provide your correct TIN. (See the instructions on page 4.)

Sign Here Signature of U.S. person ▶ Date ▶

Purpose of Form

A person who is required to file an information return with the IRS, must obtain your correct taxpayer identification number (TIN) to report, for example, income paid to you, real estate transactions, mortgage interest you paid, acquisition or abandonment of secured property, cancellation of debt, or contributions you made to an IRA.

U.S. person. Use Form W-9 only if you are a U.S. person (including a resident alien), to provide your correct TIN to the person requesting it (the requester) and, when applicable, to:

1. Certify that the TIN you are giving is correct (or you are waiting for a number to be issued),

2. Certify that you are not subject to backup withholding, or

3. Claim exemption from backup withholding if you are a U.S. exempt payee.

In 3 above, if applicable, you are also certifying that as a U.S. person, your allocable share of any partnership income from a U.S. trade or business is not subject to the withholding tax on foreign partners' share of effectively connected income.

Note. If a requester gives you a form other than Form W-9 to request your TIN, you must use the requester's form if it is substantially similar to this Form W-9.

For federal tax purposes, you are considered a person if you are:

● An individual who is a citizen or resident of the United States,

● A partnership, corporation, company, or association created or organized in the United States or under the laws of the United States, or

● Any estate (other than a foreign estate) or trust. See Regulations sections 301.7701-6(a) and 7(a) for additional information.

Special rules for partnerships. Partnerships that conduct a trade or business in the United States are generally required to pay a withholding tax on any foreign partners' share of income from such business. Further, in certain cases where a Form W-9 has not been received, a partnership is required to presume that a partner is a foreign person, and pay the withholding tax. Therefore, if you are a U.S. person that is a partner in a partnership conducting a trade or business in the United States, provide Form W-9 to the partnership to establish your U.S. status and avoid withholding on your share of partnership income.

The person who gives Form W-9 to the partnership for purposes of establishing its U.S. status and avoiding withholding on its allocable share of net income from the partnership conducting a trade or business in the United States is in the following cases:

● The U.S. owner of a disregarded entity and not the entity,

Cat. No. 10231X Form **W-9** (Rev. 11-2005)

Fig 4.3 - Form W-9

as a business are difficult questions, you might want to consult an accountant or a tax expert, ideally one with experience dealing with artists and not-for-profits.

SCHEDULE C FORM

A Schedule C is the IRS form that you must submit, along with the Form 1040, which details the profit and loss generated by your business each tax year. The Schedule C is usually the document in which people seek deductions for "business expenses." Accountants typically recommend that you retain any receipts related to expenses claimed on your Schedule C for seven years.

IRA

This stands for Individual Retirement Account. Contributions to a Traditional IRA are tax-deferred, as are all the gains in value they earn. "Tax-deferred" means that no current income tax has to be paid on any contribution to, or for any gains in the amount invested in, the account until it is removed from the account and paid (or "distributed") to the account-holder. It allows individuals to set aside money they have earned in their job or their business over the year. It is important to note that you cannot contribute to *any* type of IRA unless you have a profit from your business or wages from an employer. Earnings within the IRA are tax-deferred until you begin to withdraw money, which is best postponed until you reach age 59½ to avoid IRS penalties for early withdrawal.

ROTH IRA

This is a newer version of an IRA. Unlike the Traditional IRA, it allows individuals to contribute money that has already been taxed so that earnings and withdrawals from the account are ultimately tax-free. It's important to realize that you will not be able to deduct contributions to a Roth IRA, as you can with a traditional IRA, but the "payoff" is that you are *not* taxed when you withdraw the money you contributed, or any earnings on that money.

401(K)

A plan offered by a company to its employees which allows them to set aside income for retirement. The income and all the investment gains it accumulates is never taxed until withdrawal. Employers may choose to match a certain percentage of 401(k) contributions. Some non-profits offer employees a similar plan called a 403(b), another tax-advantaged retirement savings plan for the public sector, including not-for-profits in the 501(c)(3) category.

Learning to Recognize and Evaluate Your Costs

Perhaps the most important step that any artist can take toward exercising greater financial control of her life is to understand the costs associated with her practice. Sound intimidating? You're in luck: this important step requires no formal training or specialized knowledge, at least not beyond what you already do every day. With a little practice, you will not only learn to identify the key costs in every aspect of your professional life, but you will also become adept at estimating these same costs for future projects. But before we get to the specifics of how to do this, let's briefly examine where and why this is so important.

SPECIFIC PROJECTS

This is one of the most straightforward instances of cost analysis. Most projects share some common characteristics. They have a discrete beginning and end: a new piece of installation art, the performance of a dance company's choreographed work, a folk music concert, designing and delivering a set of custom engraved wedding invitations. In more commercial circumstances there is often a client-imposed deadline. Other examples of projects may be less connected to the art itself: planning a semester-long class on abstract painting techniques as an adjunct professor, building a functional website from which to sell your band's catalog of recorded music, or even scheduling a book tour to promote a novel.

While some of these activities may ultimately be folded into a larger part of an existing practice—or viewed as a completely unrelated activity—from a cost recognition and analysis standpoint, these are all considered "projects." Throughout this book we'll refer to projects and, especially in the finance context, we intend the term to have the broad meaning we have given it here.

When we first look at projects, we tend to notice only the largest and most obvious costs. For a concert, perhaps we'll factor in the cost of a theater rental, artist fees for the musicians, and equipment rental. For an exhibition, we might focus on the costs of the materials used in creating the work and the costs of hiring an art mover to transport the work from the studio to the gallery.

This is a good start, but we will need to go deeper if we are to gain an accurate picture of what our art projects truly cost. For the concert, how will you get to the venue? Do you have to pay for parking? Will you take out advertising or did you engage the services of an agent to secure the venue? Do you need to rent rehearsal space to prepare for the show? In the case of the gallery exhibition, will you be printing flyers? Is the gallery covering insurance or are you? Are you expected to provide refreshments?

The more in-depth your analysis, the more likely you are to uncover hidden costs that are associated with your project and which affect its ultimate profitability. These hidden costs can also be "opportunity cost," or the revenue that your resources (whatever these may be) could have generated in their next-best use. We will address opportunity cost in greater detail later in Chapter 7 as it applies to many financial decisions. For now, it simply represents what else you could have been doing. In the day-to-day lives of most artists, this will refer to lost days of income (when you take time off from work or do not take a freelance job because you need to attend to something art-related). Remember, that opportunity cost (or foregone revenue) is revenue that will not appear on your balance sheet or income statement. Conversely, examining the financial details may also uncover potential revenue streams or valuable opportunities. For these reasons, analyzing your costs is inextricably linked to the planning process.

YOUR OVERALL PRACTICE

Arts practices exist in all sorts of shapes and sizes. For some full-time artists with no other outside jobs, analyzing the costs of their practice is relatively straightforward. A number of commercial practices fall into this category. The costs of these practices may be analyzed in a manner similar to a traditional business, especially where the "product" or "service" provided by the artist does not vary all that much. For example, a puppeteer who performs at children's events, a salaried violinist with a symphony orchestra, and a potter who produces pottery for home-use will tend to have costs which—once identified—will continually be associated with their practices. The puppeteer will always need a set of puppets and accompanying props—he may buy new puppets to replace damaged ones, or to supplement and expand the act. But he is unlikely to need fire insurance for his kiln. Similarly, the violinist may have medical expenses for physical therapy for tendonitis, but does not necessarily deal

with children and therefore won't need to become certified in first aid. The potter may have significant utility bills but never need to purchase rosin for a violin bow. The costs for these types of practices are more consistent and predictable.

For other arts practices, the types of costs can be quite wide-ranging and unpredictable. A studio artist may be equally proficient as a painter, sculptor, and photographer, and may support herself through all three disciplines simultaneously. In a typical week, she may teach a community center class on painting, act as a "second shooter" at a large wedding, and devote the rest of the time to working on a commissioned series of sculptures in her studio. In order to accomplish all of this, she will likely need a camera, film, computer for processing her images, Internet provider, studio space, car, chisel, hammer, paints, and the list goes on. As her opportunities fluctuate, so will her costs. She may be asked to teach a course on sculpture rather than painting, or she could start to receive requests for portrait work in any of the three media.

PRICING YOUR WORK/VALUING YOUR TIME

Another area in which analyzing the costs of your project plays an important role is when it comes time to set the rates for your work or for your time. This is obviously a complex topic with numerous factors. Perhaps the most important will be your market, and an analysis of individual art markets is beyond the scope of this book. However, by knowing the complete financial picture of your project or practice you will gain an excellent starting point.

At a minimum, you (ideally) do not want to lose money selling your work. So assuming that you are aiming to at least break even, knowing the total costs of creating a work will give you a baseline. Selling a bronze sculpture for $20,000 when the materials, mold and cast alone cost $25,000 would be considered a poor financial decision.

Of course, this can get more complicated if you are creating something for mass production or mass consumption. But the basic principle remains the same. A filmmaker might need to spend $200,000 to produce her film (as a side note, when examining larger budget projects, make sure to factor in the interest you would have to pay on a loan—most of us do not have ready access to hundreds of thousands of dollars and may need to borrow money). She will then need to generate that amount through ticket sales or digital downloads. If she will incur additional expenses to help her reach that sales goal—say through marketing and advertising—she should add that to her total costs. Knowing exactly what her costs are will help her to set ticket prices and purchase prices, along with a thorough market analysis.

Similarly, knowing their costs will help artists whose primary sales are those of their time. Most often, this applies to performers, but teachers are another good example. If an

actor spends $20 to travel to a show and another $75 for a haircut and make up (assuming this is a low-budget production that only provides costumes), the actor would need to earn at least $95 as a performance fee. The script calls for the actor's character to speak French? Add another $30–$300 for a Berlitz or Rosetta Stone DVD on beginner-level French. Don't forget to factor in the hidden (or opportunity) costs as well—if the actor ordinarily teaches an introductory drama class at the YMCA for $100 on the day of the audition, he will need to include the loss of that $100 in the total cost as well. And so on. As we will discuss in the section on evaluating the costs of your overall practice, the same analysis can take place on a larger level. Knowing the costs of your arts practice will give you a target number for earnings.

At the same time, the reality is that sometimes your costs may exceed the realistic market price of the goods or services sold; that is a decision you will need to weigh up. For example, if the porcelain teapot costs more to make than you can sell it for, you can make up that deficit by making and selling more functional ceramic mugs.

THE LINK BETWEEN YOUR ART AND YOUR LIFE

Financial analyses for artists should not take place in a vacuum. There is no point in evaluating any of these costs if they cannot be tied to your life as a whole. In fact, this is one of the areas in which the disconnect between artists and economists is so prevalent. Unlike a more traditional business, most of us find that our art practices are inextricably linked to our lives. Quite often it *is* our life! This goes well beyond issues like one's choice of business entity (something that we address in Chapter 11), and directly to the heart of what makes artists unique as businesspeople—the creative practice can take place at all hours and in all settings. Some artists may work effectively in a predetermined time and place, whereas others need more flexibility. The line between "work" and "life" often does not exist or, if it does, is always changing.

For that reason, it will be very important for most artists to understand their complete financial picture. Are you supporting or supplementing your art practice with another source of income? Do you have to support other people aside from yourself? Do you have credit card debt, student loans, a car loan, or a mortgage? If so, your time and funds for your art may well be tied to factors that have nothing to do with your sales. An arts practice that is profitable in the sense that it earns more than it loses may still not be viable in the context of your overall life if it keeps you from meeting your other financial obligations!

None of these potential obstacles is a reason to panic or despair. In fact, many circumstances that initially appear to be obstacles can be turned into opportunities with a little planning and creativity—an inherent artist strength. As Julia Child often said, a creative

person can turn failures into successes, make lemonade from lemons. And it's far better to anticipate the obstacles ahead of time to give you the greatest number of options. So as you learn to evaluate the costs associated with your projects, practice, and time, you should extend that same analysis to your life as a whole.

IDENTIFYING YOUR COSTS WITH THE ARTIST'S COST TREE: WHY YOU NEED TO ACT

Now we understand why it's important to discover the costs of our arts projects and practices. The more important question is, how do we do this?

First of all, don't panic. As we emphasize throughout this book, every career improvement that you make will come from refining something that you already do, most likely intuitively. We are not asking you to run complex projections about future profits or to estimate what the purchase price of your raw materials will be four years from now. Instead, you simply need to know what everything you are currently doing costs.

More than anything else, this is an exercise in awareness and creative thinking. Later in the process people begin to categorize different kinds of costs or expenses, a very important function of accounting. For our purposes now, we are only seeking to identify your current costs, or those of a project you are about to undertake. Eventually you will be able to see the costs of your projects and practice very quickly. To begin to train yourself to do so, we recommend using what NYFA terms the Artist's Cost Tree, or ACT. While cost trees are often used to accomplish far more complicated tasks in a mathematical context, NYFA has designed ACT as a very simple method specific to the arts to visualize and identify all of the costs associated with a project or practice. The Artist's Cost Tree is built as a "bottom-to-top" structure. You begin by identifying the core project or practice that you wish to analyze— the roots and trunk of the tree if you will. The next step is to identify the largest or most important cost categories—these are the "branches." You will then move onto the third level, where each branch sprouts some associated costs ("twigs"). The final step is to identify additional costs that are related to each twig, or to continue the tree analogy, fill in the "foliage." For those of you who don't like to think in terms of analogies, the Artist's Cost Tree is essentially a cost identification structure built on multiple levels. Each successive level provides smaller cost categories for activities that relate to the preceding category. NYFA believes that the tree analogy is extremely helpful due to the chart's resemblance to a tree and to the actions that we need to take throughout the process—you will quite literally prune costs and remove stray branches.

You can do this on a computer or simply with a pen and paper. In any case, you will find that you need to revise a lot in the beginning just as you would with the early drafts of any creative work! If you want to have a record for future reference of the process of building

your first tree, from roots to leaves, you might want to "save as" each successive revision, labeling them v.1, v.2, etc. Or you could build trees for different scenarios, for example, with and without a big National Endowment for the Humanities grant for your filmmaking project.

Let's see how a cost tree functions in the context of a traditional artist's project. We will examine the case of a musician who wants to make a recording for commercial use, and we will refer to her project simply as "A Music Recording." This is the "root" of her tree, and all of her planning and cost identifications will flow from this broad category. If you look at Figure 5.1, you will see that we have planted her root at the bottom of the diagram.

Figure 5.1 also shows the second stage of ACT, the main cost branches. We have labeled these as "Audio Recording," "Artist Fees (Musicians)," "Printing & Production," and "Miscellaneous."

We need to emphasize that during the initial drafting phase you do not need to subject your choices to a rigorous analysis. In fact, you will be using little more than your own common sense. After you have constructed the first draft of your tree you will be able to visualize your project's cost structure better and can then revise and analyze each individual component.

Returning to our example in Figure 5.1, we made some basic assumptions about what the important elements would be for our musician in making a recording, and then chose the above categories for her. As obvious as it may seem, she will need an actual sound, or audio, recording of the music. This will be her first cost branch. The second assumption (her second cost branch) was that she would need to hire musicians to create the music on the recording. The next assumption was that she would need to produce some quantity of physical units of this audio recording—her third cost branch. Finally, she has created a catch-all

Fig 5.1 - Roots of Cost Tree

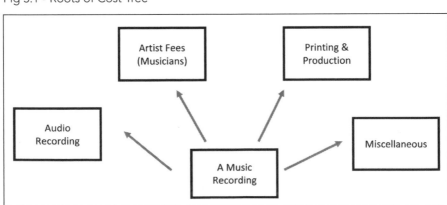

Figure 2

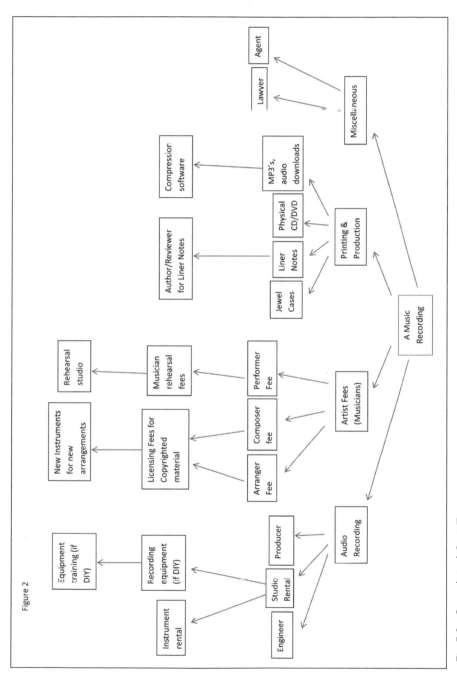

Fig 5.2 - Completed Cost Tree

branch, labeled Miscellaneous, to place costs that she identifies but which do not seem linked to her other categories.

Let's now take a look at how these categories will further sprout additional cost categories. Figure 5.2 shows a completed cost tree. Starting with the first major category, "Audio Recording," you will notice that it has led to three additional categories that seemed to flow logically from the first. If a musician is going to record some music, she will need a designated space to do this. She thus adds "Studio" as a secondary branch from the first category. Another necessary category arising from "Audio Recording" might be a person to operate the recording equipment, so our musician will add "Engineer" as another secondary cost branch. Finally, many records have a producer who offers guidance in the studio and helps to direct the engineers to get the sound that the artist is trying to produce, and she has created another secondary branch labeled "Producer."

As we continue up the Audio Recording branch and into its "foliage," you can see that the categories that we add start to reflect more detailed—and strategic—thinking about the project. The "Recording Studio" has in turn led to two additional cost categories, labeled as "Instrument Rental" and "Recording Equipment." As our musician continues to brainstorm her project's costs, she considers whether she will need to rent instruments to bring into the studio. Many studios have instruments already there, but some bargain studios do not, particularly home studios which have become increasingly popular as recording technology improves. If her music calls for an acoustic piano, she will need to factor in that cost. Similarly, technology has lowered recording costs to the point that some musicians make recordings as an entirely "Do-It-Yourself" (DIY) project. Our musician may opt to invest in buying or renting recording equipment depending on how long she anticipates the project will take and what type of sound she is looking to achieve.

The very last category in this branch relates directly to the DIY direction of the project—our musician may not have any experience with using recording equipment and may need a tutorial or a book to do so successfully. She therefore adds "Equipment Training" as her final cost category.

By the time she has reached this part of the tree, she is evaluating very specialized—not to mention hypothetical—costs. This is typical of the ACT process, especially in the early drafting stages. In this example, our musician applies a little logical thinking and also asks follow-up questions, which leads her from the basic project (a musical recording) to an essential component (the audio recording), to important components that will only materialize in certain scenarios (instrument or recording equipment rentals depending on the type of studio she uses), and finally to costs that are highly speculative and contingent on multiple other factors (equipment training in a do-it-yourself recording project).

The remaining branches in Figure 5.2 illustrate the same analytical process. She knows that she will need to compensate the musicians for their contributions, so she begins with "Artists Fees" as an essential component. She then further breaks down this category into "Arranger," "Composer," and "Performer Fees." Here is the first example of how cost categories can converge. Both composers and arrangers typically own any intellectual property they contribute. When a musician records a work protected by copyright, she will usually need to pay a licensing fee for the privilege of doing so, a topic we cover in more detail in Chapter 10. While composers and arrangers serve different functions, both may generate similar costs in certain scenarios. This happens twice in this example—a new composition or arrangement might call for a different instrumentation than what the musician usually works with. If the new instruments can be played by her existing group, she may decide to invest in these instruments. Following the Performer Fee branch, we see that she may need to compensate the performers for rehearsal time in preparation for the recording. Depending on how familiar the performers are with her material, rehearsal time could be a very important component in certain scenarios. Finally, our musician may have to rent space for this rehearsal ("Rehearsal Space"), but this is contingent on many categories that precede it.

Moving onto the last of her identified essential components, she has broken down the "Printing and Production" category into four additional important parts: "Jewel Cases," "Liner Notes/Design," "Physical CDs," and "MP3's & Audio Downloads." Several of these are fairly contained and do not lead to new cost categories. The "Design & Liner Notes" category may necessitate retaining a professional writer or designer to accomplish this, but that will depend on whether our musician feels comfortable writing the text or designing the album art herself. The category "MP3's & Audio Downloads" refers to making the recording available for purchase over the Internet. This may require that the musician take the additional step of purchasing compression software in order to change the original recording into a format more readily accessible to Internet downloads.

Our musician's final category is entitled "Miscellaneous" and into it she assigned those cost categories that she identified as being unrelated to the essential elements of the project. These included "Agent" and "Lawyer," and reflect her knowledge of the music industry (see Environmental Scanning in the Strategic Planning section). In many large record deals, an agent plays an important role in connecting the record label with the artist. And many artists, when presented with a recording contract, will retain an attorney to look it over and ensure that their rights and interests are adequately protected. However, she has placed them under miscellaneous because—despite these categories' prevalence in the recording industry—they may not be relevant to her situation, especially if she is self-producing the recording.

One quick cautionary note regarding the "Miscellaneous" category: keep it small! It is easy to start to throw numerous items into this section as it is, by definition, a catch-all. However, the entire exercise is about disciplining yourself to think logically and group similar costs into logical categories. Make sure that a cost is truly unrelated to other categories before placing it in Miscellaneous.

Pruning Your Tree

At this point, our musician has completed a rough draft of her cost tree for her recording project. In theory, every potential cost is accounted for, and she could begin to assign dollar amounts to each category and have a solid estimate of the true cost of this project. However, in order for her to get the maximum benefit from her cost tree, she needs to refine it. ACT is not designed to be completed on your first attempt—instead it is a method for carefully thinking through the details of your project in advance, and the revision process is essential. And the only way to do this is roll up your sleeves, shears in hand, and begin pruning.

Figure 5.3 represents our musician's "pruned" or revised tree. As you can see, she has made some significant changes, removed one major branch, and streamlined the upper

Fig 5.3 - Revised Cost Tree

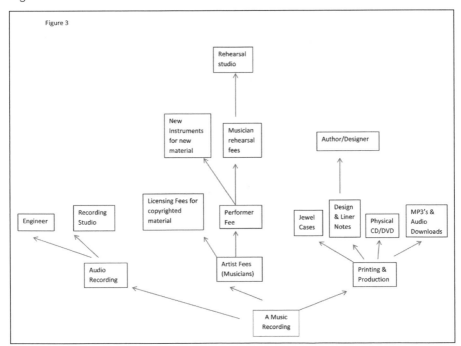

levels. This results in a far cleaner structure, and one that she can use as financial roadmap for her project.

Let's examine how she arrived at this improved version. The single most important step that she took in her revision process was not any of the actual changes she made to the diagram itself. Instead, she recognized that her first draft was too confusing and contained too many duplicate categories, and also that many categories did not reflect the realities of *her* project, but rather preconceptions of what a musical recording is supposed to include. To correct that, she began by outlining what she wanted on her recording, making it more personal.

Our musician is a singer-songwriter who performs songs that she composes. While she occasionally performs "cover" songs (well-known songs by other musicians), her goal for this recording is to document and promote her original music. She usually performs solo or with one or two accompanists. For her first album, she would like to record in both a solo and ensemble setting as she often writes songs with other instruments in mind. She will utilize a few new percussion instruments that she frequently must do without during a live performance. This recording will be entirely self-produced, and she is very confident in her ability to evaluate the finished product but does not have any experience with the mechanics of recording an album.

Knowing those details, it is apparent that she can remove certain categories immediately. For starters, she does not need to address any of the cost categories in the "Miscellaneous" branch. As she is self-producing this project, she won't be dealing with any outside ownership interests—it is doubtful that she will even enter into a contract with anyone (with the possible exceptions of her musicians, but most self-produced projects do not tend to use written contracts, perhaps unwisely). Similarly, because she is self-producing the recording she will not need an agent—musicians often enter an agency relationship when they are selling their services to a larger entity. As a self-producer in the production stages, she is a buyer rather than a seller.

She also made major revisions to the categories in the "Audio Recording" branch. Starting with the three essential components she identified up front, she has removed "Producer." This again relates to the fact that her project is self-produced and that she has a good sense of how she wants her finished product to sound. It also reflects the reality of many self-produced recordings: without significant resources at her disposal, there will be a certain lack of formality that attends numerous aspects of the project (for example, not using contracts, although as we noted in the legal section, contracts can be informal, without the expense of a lawyer). However, in our musician's case, not hiring a producer is both a creative choice and a financial one. Further up the Audio Recording branch, she has also removed all of the remaining categories that followed from the category "Studio Rental" ("Recording Equipment," "Equipment Training," and "Instrument Rental"). She removed

these after reexamining her project in the wake of the first draft of her cost tree. By acknowl-
edging that she has limited experience with recording techniques or technology, she recog-
nized that she needed to engage professional services in this area. As such, she has opted not
to pursue any of the costs associated with a "do-it-yourself" audio recording and will instead
find a full-service studio.

We should note that just because she has decided to rent a full-service studio does not
mean that her costs will be higher than a do-it-yourself approach—all she has done is lump
several services into one cost category. She still has ample opportunity to keep her costs
down even with a full-service studio. And this raises a good point about the allure of "do-it-
yourself" projects generally—just because the technology has become more affordable and
accessible does not mean that you should feel pressured to do tasks for which you would
have otherwise have paid someone more knowledgeable and experienced than you are. This
is yet another instance where hidden or opportunity costs play an important role. You may
save money hiring a professional if doing it yourself would require you to spend hours ordi-
narily devoted to earning money (or producing work). Remember the old adage, "penny
wise, pound foolish."

Moving onto the "Artist Fees" branch, we see that she has made major revisions here
too. First, she removed the two sub-branch categories for "Composer Fee" and "Arranger
Fee" because she is recording only her own compositions and arrangements and will not
need to hire anyone to do this for her. However, she has left room for the possibility that she
will record one or two "cover" songs by creating a category entitled "Licensing Fees for
Copyrighted Material" as the only category in that sub-branch. If she opts to record a cover,
she has designated a place for these costs if not, there are surplus funds that can be applied
to another area where she may have underestimated expenses.

Continuing along the "Artist Fees" branch, she has kept the branch for "Performer
Fees" largely untouched as all of those categories will likely come into play during her
project—she does intend to use other musicians and will need to pay them for their time,
both in the recording studio and for rehearsals. And depending on the number of musicians
she will use, she may need to rent extra rehearsal space. One change she did make to this
branch was to add the category "New Instruments for New Material." You'll notice that she
shifted this from its original placement as a contingent cost in the branch covering Compos-
er and Arranger fees. You should also note that a very similar category previously appeared
under the "Audio Recording" branch in her first draft. During the revision process where she
thought through her project in detail, she realized that having two categories for instrumen-
tal rental was unnecessary. After all, why should she pay for something twice? Given that she
hopes to work in some new percussion parts to her repertoire, she decides to use this record-
ing project as an opportunity to make a small investment in new instruments. She can then

provide these to whichever musicians she hires for the project, and bring these into the studio—it gives her more flexibility. It also demonstrates the power of visualizing and reworking costs that comes from using ACT. Her revisions identified both an area to save money (by avoiding duplicate expenditures) and an area for investment in her own "infrastructure" (adding to her collection of percussion instruments).

Finally, she made only a minor change to her third branch, the category for "Printing and Production." She has kept all of the sub-branch categories from her initial draft as they reflect ongoing needs of the project. She wants the packaging to reflect well on her music, so she will need to hire someone to design the cover art and labeling, and to write the liner notes (though another option would be to seek a company that presses and packages CDs and prints cover inserts). These are not part of her skill-set. She did remove the category entitled "Compression Software" which had been part of the "MP3's & Audio Downloads" category because, while having her music available for download is a very important part of the recording project, this probably falls under the "Audio Recording" branch as it is a technology issue. Even if the studio does not (or cannot) provide this format for her, she will not invest in the software to do it herself but will find someone with the appropriate expertise to do it for her. As such, the cost of transferring the recording into a download-friendly format can simply be folded into the "MP3's & Audio Downloads" category.

All that remains for her is a little research into price. She needs to look at what a studio will cost, what the percussion instruments go for, package deals for the physical production of the CDs, but such information is readily available with Internet access or the yellow pages. Once she plugs in these numbers, she will have an accurate picture of the true cost of her project. And that is an extremely powerful tool.

From here, she can begin to budget and strategize ways around financial obstacles. By examining her categories—and then breaking them down further, collapsing them and even moving them around—she has by necessity thought through the financial details of her project in depth. We address budgeting in greater depth in Chapter 6, but for now we'll note that the budgeting process will be far simpler now that she has taken such a rigorous approach to her cost tree. Furthermore, she can use the same process to discover the costs of other tasks that may be connected to her project. For example, if she intends to market and sell her recording, she will make another cost tree for her sales strategy. The details may change, but the process will not.

See Figure 5.4 for an example of a rough draft of an Artist's Cost Tree by a NYFA painter.

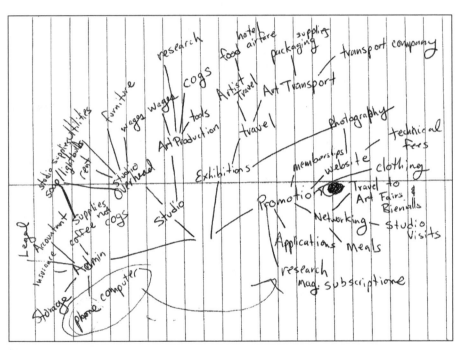

Fig 5.4 - Sample Cost Tree for a NYFA Painter

Building Budgets

In the previous chapter, the emphasis was on learning to see the bigger financial picture and identifying your current and anticipated expenses. If you have gone through the process of identifying the costs of your project or practice through the Artist's Cost Tree exercise, you have a good handle on cost identification. Now let's take the next logical step and begin incorporating this awareness into one of the core aspects of financial management, the budget. Budgets essentially translate your cost awareness and business strategy into dollars and cents numbers that you can use for setting goals and measuring your progress. Like other areas of finance, many artists shy away from budgets, as they find the details depressing or feel inadequate to the task. We encourage you to take a different view and consider that creating and examining a budget can reveal hidden truths about your project or practice. Budgets are powerful tools for communication, both summarizing the nitty-gritty details of a business and illuminating large patterns of activity. They provide perspective from the widest possible angle and help businesses manage their finances over time by planning, organizing, and investing time and assets. They are useful to both the business owner and other stakeholders as they provide a reference point for communication and strategizing. In short, a good budget can encapsulate and guide the financial strategy of your business. And your life, for that matter, especially since, as we mentioned earlier, an artist's work is often his or her life!

While profit may not be the primary goal of your practice, money still is an essential element, as it influences the materials with which you work, the scale of your work, the reach of your audience, and even the location of your business. Whatever your artistic goals, a budget (like the Artist's Cost Tree) will give you a clear-eyed look at your financial situation and will help you to analyze and shape your business model to best achieve your artistic goals. And similar to your artistic practice, your approach to budgeting should be thoughtful,

with a problem-solving mind-set. Spend the necessary time to focus on this task and be strategic—your business's finances should be as thoughtful and individualized as your art. A good budget will help you be informed and understand the financial implications of your business.

This individualized approach means that this section of the book will not include a "how-to" model. Instead, NYFA will provide a set of concepts and questions for you to keep in mind as you build your budget. How should you categorize and total your revenues and expenses and how do businesses typically create budgets? The best budgets are:

- Individualized: adapted to suit the needs and idiosyncrasies of the business
- Specific: capturing all financial data
- Summarized: with information grouped into meaningful categories
- Easy to understand
- Easy to adjust

LOOK AT THE PAST

The more specifically a budget reflects the activities of your business, the more valuable it is to you. Most budgets are based on past performance. When a business manager wants to project her likely revenues and expenses, the most common method is to review the actual revenues and expenses from the prior year. It is logical to assume that a business or other project will have a similar pattern of revenues and expenses in the future as it did in the past. These past "actuals" provide a realistic set of numbers to use as your future activity estimates.

Where might artists gather information for a budget? Most likely, in your desks, drawers, wallets, closets, and online banking accounts. The reason for this is that many artists' business finances are found in the midst of their personal finances, so this is the place to examine first. If you have been a practicing artist for the last few years, how much have you spent on materials, how much on research? What income have you generated? Dig out your receipts, tax filings, bank and credit card statements, and spend a full day recording and compiling all of the data that you've been generating for years.

For example, suppose that a painter has been working out of a rented garage for the past three years, and while she has never considered herself a business owner she has still been generating revenues and expenses, and filing them with her personal documents. To begin building a budget she starts by sorting these papers and looks for documents such as lease agreements, utility bills, and art supply and framing receipts. Now she has some "actuals" upon which to base her budget. Perhaps she will be surprised to learn that her utility bills

were so high and her framing costs relatively low. If she hadn't found these documents, her budget would not have reflected the financial realities of her artistic practice. Now, instead of investing in a framing square, she may choose to buy insulation for her studio walls.

CONSIDER THE FUTURE

This is probably the most abstract task that is required when creating a budget. Can you anticipate any financial changes for your practice down the road? What projects are you preparing for? Will you move or travel in the future? What is your lineup of paying gigs? Can you do a little quick research to anticipate the cost of these new financial projects? But don't worry too much about predicting the future; instead, try to construct a simple budget, one that is easy to edit, and remember to update your budget as plans change.

CONSTRUCTING YOUR BUDGET

In order to total your revenues and expenses and compile them into meaningful categories you first need to collect your data. Consider the resources you can use for this part of your budget plan. There are many services and tools that artists can use to track finances. It is possible to hire a professional bookkeeper, invest in a software program, or manage with simpler tools already at hand. If you are looking at software options, remember that there are also many choices available, and while most artists don't need state-of-the-art bookkeeping software, you might appreciate the design and usability of the program. There are programs that can simultaneously track your expenses, manage your budgets, provide payroll services, sync up with your online bank accounts, and track every last penny. These programs are powerful and often expensive. They also require upkeep to function properly and are probably best for an artist who has a large variety of projects, many revenue streams, and a continuously busy business operation (some examples include GYST, QuickBooks, or Quicken).

Consider a professional photographer who allows his larger clients to pay in installments. These can become very confusing to track if he has a large number of clients. If he also hires prop stylists (who are independent contractors), then the details he needs to track may soon become overwhelming. This photographer may decide to invest in software like QuickBooks to help him track the payments owed by clients in order to send them invoices appropriately and regularly. Furthermore, the software simultaneously tracks his payments to independent contractors so that he doesn't miss the deadline to file the appropriate 1099s during tax season. And the information needed to compile his taxes is ready for him to do himself or hand over to an accountant.

Other artists can function quite well with just a few plastic baggies, free or inexpensive spreadsheet software (such as Excel or Google Doc), and the occasional meeting with a tax professional. This could easily be true with the example of the painter working out of the cold garage. You should consider your needs and choose accordingly.

PICK A TIME FRAME

Some businesses track in extreme detail, projecting their revenues and expenses down to the day. This is the way many retail stores operate. Stores often track in such fine detail that they can predict activity and quickly adjust to any changes in buying patterns from year to year, or season to season. Those barcodes that are scanned at the cash register are linked to complex inventory management systems.

Most artists do not need to follow their revenues and expenses in such detail and will probably choose to track their financial activities by month or even year. For example, a musician with a full, although varied, schedule might track by the month, and a painter with one big show every year might find it more useful to account for things annually.

RECORD WHAT YOU KNOW FIRST

To construct your budget you must first collect your "actuals" (revenues and expenses) from previous years, as we discussed in the section titled "Look at the Past." During this collection process it is important to consider carefully what the boundaries of your practice will be. Many artists' business activities are intertwined with their daily lives. Do you have a home office? If so, what percentage of your total living area does it constitute? How often is your car used to transport art or instruments, and how much of your Internet bill can be considered business use? To answer these questions you have to measure usage. A word of caution: just because an expense has some relationship to your art does not necessarily make it a business expense. When considering what a business expense is, you might ask yourself, as an IRS auditor would, if you would reimburse an employee for that same expense.

This is also a good opportunity to hone your business philosophy: Do you run the type of business that provides coffee to its employees? How about lunch? Would your business provide top-of-the-line phone systems? How much research and travel is truly necessary to complete the project at hand? It is important to develop clarity around these issues so that you can more finely tune your business expenses to your goals, both financial and artistic. Figure 6.1 shows a sample budget for a performing artist, a puppeteer.

CLASSIFICATION OF EXPENSES AND INCOME

As you collect data on your expenses and income it is important to classify them correctly so that you can use this data later to your best advantage. For expenses you should use as many categories as are relevant to describe the purpose or type of expense that was incurred.

Budget Preparations for 2011

Projections for 2011 are based on 2010 actuals unless otherwise indicated by notes.

Revenue	2009	2010	BUDGET	Notes
Brooklyn Puppet Theater - Regular Gig	5,000.00	4,000.00	4,000.00	based on percentage of sales at door
Traveling Summer Show	400.00	4,000.00	4,400.00	Goal - up 10% from previous year
Other Performances/Collaborations	1,200.00	3,000.00	3,000.00	
Contractor Work - theater prop construction	100.00	1,200.00	500.00	only one small project lined up
Grants - Promised	-	2,500.00	2,500.00	two year community grant received for 2010 and 2011
Grants - Applications Outstanding		-	2,500.00	city grant application outstanding
TOTAL	6,700.00	14,700.00	16,900.00	

Expenses	2009	2010	BUDGET	Notes
Advertising and Promotion - Brooklyn Puppet	1,250.00	900.00	900.00	
Advertising and Promotion - Traveling Shows	500.00	1,000.00	1,100.00	Goal Adjustment - up 10% from previous year
Application Fees	200.00	400.00	400.00	
Car and truck expenses	1,000.00	1,200.00	1,320.00	Goal Adjustment - up 10% from previous year
Commissions and fees	200.00	300.00	300.00	
Insurance (other than health)	200.00	300.00	300.00	
Legal and professional	150.00	150.00	150.00	
Office Expense	54.22	77.00	77.00	
Rental or Lease - Vehicles and Machinery	400.00	100.00	100.00	
Research Expense	300.00	400.00	400.00	
Supplies - not COGS	2,300.00	2,000.00	2,000.00	
Travel Expense - Meals & Entertainment	600.00	700.00	770.00	Goal Adjustment - up 10% from previous year
Travel Expense - Travel	-	300.00	300.00	
Wages	-	200.00	200.00	primarily sound design for traveling show
Miscellaneous Expenses	64.00	41.00	35.00	fewer misc. expenses anticipated
TOTAL	7,218.22	8,068.00	8,352.00	

Profit/Loss				
	(518.22)	6,632.00	8,548.00	

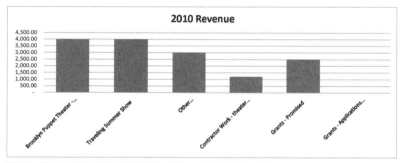

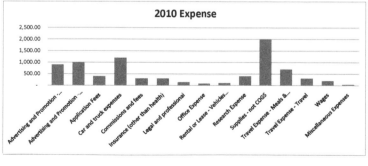

Fig 6.1 - Sample Budget for Puppeteer, 2011

A general list of expense categories can be found on the IRS Schedule C Instructions (see Figure 6.2). It will be easier at tax time if you have used these categories in your record-keeping. Remember to consider and classify whether your expenses are cost of goods sold (COGS), or the cost of services provided.

SCHEDULE C (Form 1040)	Profit or Loss From Business	OMB No. 1545-0074

SCHEDULE C (Form 1040)
Department of the Treasury
Internal Revenue Service (99)

Profit or Loss From Business
(Sole Proprietorship)
▶ Partnerships, joint ventures, etc., generally must file Form 1065 or 1065-B.
▶ Attach to Form 1040, 1040NR, or 1041. ▶ See Instructions for Schedule C (Form 1040).

OMB No. 1545-0074
20**10**
Attachment
Sequence No. **09**

Name of proprietor | Social security number (SSN)

A Principal business or profession, including product or service (see instructions) | B Enter code from pages C-9, 10, & 11 ▶

C Business name. If no separate business name, leave blank. | D Employer ID number (EIN), if any

E Business address (including suite or room no.) ▶
 City, town or post office, state, and ZIP code

F Accounting method: (1) ☐ Cash (2) ☐ Accrual (3) ☐ Other (specify) ▶

G Did you "materially participate" in the operation of this business during 2010? If "No," see instructions for limit on losses ☐ Yes ☐ No

H If you started or acquired this business during 2010, check here ▶ ☐

Part I Income

1 Gross receipts or sales. **Caution.** See instructions and check the box if:
 • This income was reported to you on Form W-2 and the "Statutory employee" box on that form was checked, or
 • You are a member of a qualified joint venture reporting only rental real estate income not subject to self-employment tax. Also see instructions for limit on losses. ▶ ☐ | 1

2 Returns and allowances | 2
3 Subtract line 2 from line 1 | 3
4 Cost of goods sold (from line 42 on page 2) | 4
5 **Gross profit.** Subtract line 4 from line 3 | 5
6 Other income, including federal and state gasoline or fuel tax credit or refund (see instructions) . . . | 6
7 **Gross income.** Add lines 5 and 6 ▶ | 7

Part II Expenses. Enter expenses for business use of your home **only** on line 30.

8	Advertising	8		18	Office expense . . .	18	
9	Car and truck expenses (see instructions)	9		19	Pension and profit-sharing plans .	19	
10	Commissions and fees .	10		20	Rent or lease (see instructions):		
11	Contract labor (see instructions)	11		a	Vehicles, machinery, and equipment	20a	
12	Depletion	12		b	Other business property . . .	20b	
13	Depreciation and section 179 expense deduction (not included in Part III) (see instructions)	13		21	Repairs and maintenance . . .	21	
				22	Supplies (not included in Part III) .	22	
				23	Taxes and licenses	23	
				24	Travel, meals, and entertainment:		
				a	Travel	24a	
14	Employee benefit programs (other than on line 19) . .	14		b	Deductible meals and entertainment (see instructions) .	24b	
15	Insurance (other than health)	15		25	Utilities	25	
16	Interest:			26	Wages (less employment credits) .	26	
a	Mortgage (paid to banks, etc.)	16a		27	Other expenses (from line 48 on page 2)	27	
b	Other	16b					
17	Legal and professional services	17					

28 **Total expenses** before expenses for business use of home. Add lines 8 through 27 ▶ | 28
29 Tentative profit or (loss). Subtract line 28 from line 7 | 29
30 Expenses for business use of your home. Attach **Form 8829** | 30
31 **Net profit or (loss).** Subtract line 30 from line 29.
 • If a profit, enter on both **Form 1040, line 12,** and **Schedule SE, line 2,** or on **Form 1040NR, line 13** (if you checked the box on line 1, see instructions). Estates and trusts, enter on **Form 1041, line 3.** | 31
 • If a loss, you **must** go to line 32.

32 If you have a loss, check the box that describes your investment in this activity (see instructions).
 • If you checked 32a, enter the loss on both **Form 1040, line 12,** and **Schedule SE, line 2,** or on **Form 1040NR, line 13** (if you checked the box on line 1, see the line 31 instructions). Estates and trusts, enter on **Form 1041, line 3.** 32a ☐ All investment is at risk.
 • If you checked 32b, you **must** attach **Form 6198.** Your loss may be limited. 32b ☐ Some investment is not at risk.

For Paperwork Reduction Act Notice, see your tax return instructions. | Cat. No. 11334P | Schedule C (Form 1040) 2010

Schedule C (Form 1040) 2010 Page **2**

Part III Cost of Goods Sold (see instructions)

33 Method(s) used to
 value closing inventory: **a** ☐ Cost **b** ☐ Lower of cost or market **c** ☐ Other (attach explanation)

34 Was there any change in determining quantities, costs, or valuations between opening and closing inventory?
 If "Yes," attach explanation . ☐ Yes ☐ No

35	Inventory at beginning of year. If different from last year's closing inventory, attach explanation . . .	35
36	Purchases less cost of items withdrawn for personal use	36
37	Cost of labor. Do not include any amounts paid to yourself	37
38	Materials and supplies	38
39	Other costs.	39
40	Add lines 35 through 39	40
41	Inventory at end of year	41
42	**Cost of goods sold.** Subtract line 41 from line 40. Enter the result here and on page 1, line 4 . . .	42

Part IV Information on Your Vehicle. Complete this part **only** if you are claiming car or truck expenses on line 9 and are not required to file Form 4562 for this business. See the instructions for line 13 to find out if you must file Form 4562.

43 When did you place your vehicle in service for business purposes? (month, day, year) ▶ / /

44 Of the total number of miles you drove your vehicle during 2010, enter the number of miles you used your vehicle for:

a Business _____ **b** Commuting (see instructions) _____ **c** Other _____

45 Was your vehicle available for personal use during off-duty hours? ☐ Yes ☐ No

46 Do you (or your spouse) have another vehicle available for personal use?. ☐ Yes ☐ No

47a Do you have evidence to support your deduction? ☐ Yes ☐ No

 b If "Yes," is the evidence written? . ☐ Yes ☐ No

Part V Other Expenses. List below business expenses not included on lines 8–26 or line 30.

48	**Total other expenses.** Enter here and on page 1, line 27	48

Schedule C (Form 1040) 2010

Fig 6.2 - IRS Schedule C

Selling, General, and Administrative Expenses

Just as a side note, most performing artists would be considered service-based businesses and will tend to have fewer COGS expenses. Additionally, it is often relevant to classify revenues and expenses to identify what part of your business generated or incurred them. Many businesses will use "Project" or "Department" categories to divide parts of their businesses into categories that are relevant for tracking or budgeting independently to the operations of the business as a whole. A sculptor who also sells preparatory drawings should define these two areas of artistic activity as different projects in her financial records. She can then track her revenues and expenses by project, allowing her to plan her next series of work as both a businesspeople and an artist.

BACK TO THE FUTURE—ADDING IT ALL UP AND THINKING AHEAD

Now you need to take what you know about your past and project it into the future. After collecting and organizing your business financial data into the relevant categories, total it all up. Take these total numbers by category and use them as the starting point for your budget. This will serve as a basis for your financial projections. Think carefully about your activity in the previous time frame and what, if anything, has changed for the future. If you think you will be able to generate ten percent more sales (or performance or teaching fees) in the coming year, add that percentage of revenue to the corresponding category of income. Remember that all of your activities have multiple implications to your bottom line! As your sales grow so will the costs associated with those sales. So as you add that additional ten percent of sale income you also need to add ten percent to your projected COGS or General and Administrative expenses.

Remember also to keep in mind that not all of these expense and income levels will remain constant, and you should understand the relationships between these categories. Some of your variable expenses might rise or shrink without affecting your income levels, while others you should actively link to income, possibly changing prices on your products or services as the costs of your materials rise and fall. A good rule of thumb is to be conservative in estimating income, but not in estimating expenses. Better to end up with a surplus than a deficit!

PERSEVERE

It is important to keep in mind that no one will be able to capture every little piece of relevant financial activity, but it is important to put a lot of effort into this process. Remember to focus on the details you know and understand. Don't be afraid to ask for help from friends,

Montioring and managing financial details is essential to managing large projects in the arts — Travis Sullivan's Bjorkestra (Artist as Entrepreneur Boot Camp participant) performs at The Blender Theater, NYC, September 2007.

family, collaborators, and professionals about the parts of the business you don't know. Smart business people know to ask for help and when to hire it. Beware of well-intentioned friends or family who are not familiar with accounting or law for artists and not-for-profits!

Again, we caution you to always aim to keep your miscellaneous expenses to a minimum. Having a large portion of your expenses fall into the miscellaneous category is an indicator that you lack clarity of vision. NYFA wants to stress how important it is to have perspective on your artistic activities and goals. Successful artists manage to be creative and explore possibilities while still having a clear sighted understanding of their ultimate goals.

STRATEGIZE

What have you learned from all of this hard work? Do you have expenses that are unnecessary to the ultimate goals of your practice or did you discover hidden costs? Have you identified new revenue streams or, conversely, ones that are unrealistic? Once you have a clear picture of your real and projected expenses and revenues, solutions often leap out at you, like our musician's decision to self produce a CD of her own compositions; or our artist's option of insulating her energy-inefficient garage and perhaps also lowering the thermostat and donning another sweater. Or our ceramicist who could throw a series of

Budget Preparations for 2011

Projections for 2011 are based on 2010 actuals unless otherwise indicated by notes.

Revenue	2009	2010	BUDGET	Notes
Gallery Sales - Sculpture	3,000.00	3,570.00	3,570.00	
Gallery Sales - Prints	1,150.00	1,450.00	1,740.00	Goal - up 20% from previous year
Contractor Work	1,700.00	2,020.00	2,020.00	
Stipend - Teaching	2,000.00	1,000.00	-	no current plans
Fees	-	20.00	20.00	
Grants/Fellowship	-	500.00	250.00	two applications outstanding
TOTAL	7,850.00	8,560.00	7,600.00	

Expenses	2009	2010	BUDGET	Notes
Advertising and Promotion	55.00	62.00	186.00	change studio plan - triple promotion allowance
Application Fees	55.00	100.00	100.00	
Car and truck expenses	32.00	56.00	56.00	
COGS - Labor	176.00	300.00	300.00	
COGS - Materials & Supplies - Sculpture	3,000.00	3,300.00	3,300.00	
COGS - Materials & Supplies - Prints	100.00	120.00	144.00	Corresponding Expenses up 20% from previous year
Insurance (other than health)	200.00	220.00	220.00	
Office Expense	54.22	33.00	33.00	
Rent or Lease - Business Property	5,400.00	6,000.00	2,000.00	change studio plan
Rental or Lease - Vehicles and Machinery	400.00	100.00	100.00	
Research Expense	15.00	50.00	50.00	
Supplies - not COGS	150.00	200.00	200.00	
Travel Expense - Meals & Entertainment	4.66	32.00	32.00	
Travel Expense - Travel	36.25	101.00	350.00	change studio plan
Utilities	300.00	300.00	75.00	change studio plan
Wages	380.00	400.00	400.00	
TOTAL	10,358.13	11,374.00	7,546.00	

Profit/Loss	(2,508.13)	(2,814.00)	54.00	

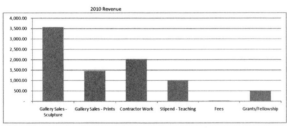

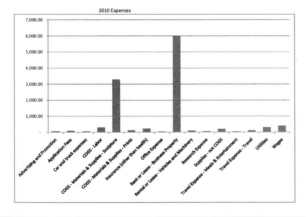

Fig 6.3 - Sample Budget for Artist Studio, 2011

revenue-positive, quickly produced, functional ceramic mugs rather than give up making beautiful porcelain pieces whose market price is less than the cost to produce them. Despite these simple examples, it is essential to spend time strategizing about your budget, component by component.

STRATEGIZING ABOUT YOUR BUDGET: AN EXAMPLE

In Figure 6.4, we have provided a sample budget for a studio artist, specifically a sculptor. As you can see, despite relatively careful management of his practice, he lost money in both 2009 and 2010. He analyzed his costs with a cost tree and then assembled a budget based on both years. He also set up a column for 2011 to see where adjustments could be made and how they would affect his bottom line.

The expense that jumps out the most is his studio rent, which was for a studio in the middle of a large city and accounted for over half of his total expenses each year. This had been a conscious decision, as he had originally leased the studio shortly after arriving in the city. His rationale had been that a central location would increase foot traffic to his studio and make it easier for contacts to stop by to visit. As he had gone to school in another state, he felt that increasing his interpersonal network was a high priority.

However, as he reflected on the decision two years later, he realized that some part of having a studio in a prime location had been motivated by his desire to "feel like an artist." He also began to recognize the ripple effect it had on other parts of his life and work. He had to work day jobs constantly to maintain this studio, and was feeling out of touch with his work when he actually managed to be in the studio. He also felt constant pressure to "network" to justify the expense of the studio, which further impacted his work.

As you can see from his budget, he played around with some different options on paper to see how they would impact his lifestyle and profitability. Whereas before he had tried to go to his city studio on weekends, he gave up this separate studio and found a "live-work" space, farther away from the center of the city, where the rents were much cheaper. As a result, he would be able to afford to take a month from his day job to concentrate solely on producing work or for participating in one of several residencies for which he applied. He also would have extra time in his home studio on evenings and weekends. The extra time he saved would also help his marketing efforts—he would be able to focus additional time on promoting his work and lining up potential venues for when he finished a particular body of work. Part of this would be necessitated by the fact that, without a city studio, he would have to put more time and money into promoting his work as it would be more difficult to get visitors at his new location (and was reflected in his budget).

He does have an opportunity cost here—there is clearly value to a good location, and he will have to work harder and spend more to compensate for that. His estimates for

promotional marketing may still have to be revised. But he did not believe that the move would have a significant impact on his networking activities, as he had already made a few contacts and the majority of these had not come from "foot traffic" but from becoming a more active member of the art community. His new budget reflects a different view of his practice—he realized that he didn't need the year-round studio to symbolize that he was really an artist and instead embraced a strategy that allowed him to focus on his artistic and productive goals. While his budget is still prospective for 2011, if his other calculations hold true he will see his practice produce a profit for the first time in his career.

TALK TO YOUR PEERS . . . FOR MANY REASONS

Other sections of this book highlight the importance of personal networks, and while NYFA does not recommend that you go out and ask your friends and peers about their personal finances, do not underestimate the value of your peers' advice. All artists have to deal with finances, and it might help to ask a few trusted friends to compare notes on expenses, pricing services, etc.

You should also consider possible cost-savings that might be gained easily from the occasional financial collaboration. There are simple collaborations like splitting shipping costs on an order of supplies, and there are other longer-term collaborations. Businesses sometimes work together to advertise their products, creating joint promotional materials that feature both companies' products. Artists do the same when organizing festivals or open studio events. We will discuss this in far greater detail in Section 5 on Fundraising, but we note the importance of analyzing the financial details in addition to the artistic considerations of any potential collaboration. Remember, all of these activities require funds and time. When you examine them with an eye toward building them into your budget, try to classify them as you go (for example, are these activities sales events or promotional?). Also, think strategically about how collaborative projects can keep expenses low and maximize effectiveness. The questions an artist asks when anticipating a gallery exhibition are shared when it is a group show as opposed to a solo one. These become the shared costs of collaboration. Create a budget that reflects your goals and that can help you to communicate clearly with collaborators. Remember that as an artist and a businessperson you should shape collaborations to fit the needs of your business.

A Few Financial Tips: Opportunity Cost and Savings

As we have encountered it a few times already, let's take a moment to discuss in greater detail the concept of opportunity cost and how it factors into your considerations about the overall cost of your project or practice. While opportunity cost is a notoriously tricky concept (even professional economists have trouble with this sometimes), most accepted definitions explain it as the revenue that your resources (capital, materials, skill-sets, etc.) would have generated in their next-best use. Put differently, what else could you have been doing?

There are several classic examples of how opportunity cost operates. Perhaps the easiest way to calculate this is with actual money, which is obviously one kind of resource. Say you want to invest $100, and you find a mutual fund that you anticipate (or at least hope) will grow by ten percent annually. After one year, you will have earned $10, right? Well, not so fast. You could just as easily have invested this same amount in a government bond that would guarantee you a four percent return annually ($4 in this case). An economist calculating opportunity cost would tell you to subtract that $4 from the $10 you earned on the first investment, because that $4 represents the cost of foregoing—or giving up—the opportunity to invest in the bond!

Another common example used to illustrate opportunity cost is college. If somebody decides to attend a two-year trade school, the price of tuition might be $10,000 per year. However, if that person could have otherwise worked a full-time job that pays $30,000 per year, the opportunity cost of foregoing the job must be added to the total cost of tuition. In this instance, the cost of college is actually $60,000 more than just the tuition. This is one reason why opportunity cost is sometimes used interchangeably with the term "true cost." The true cost of college here is $80,000—the $20,000 in tuition plus the $60,000 in lost wages (opportunity cost).

Of course, the calculations in the college example are actually a good deal more complex than we have made them out to be. If someone attends a trade school, this person is most likely looking to enter a profession that requires specific training or a certification from that school. The argument here is that the training is an investment in the future, which does not preclude its being an opportunity cost. An even more likely assumption is that this profession pays more per year than whatever job the student gave up, and will thus result in a long-term gain. Otherwise, why give up the job in the first place when there is little or no financial gain?

And here is where opportunity cost is both vital and impractical for most artists. As we emphasize throughout this book, becoming aware of the costs of your project or practice is an absolutely essential element of making it successful. In the sense that opportunity cost helps you to envision all of the costs involved—the "true cost" function of opportunity cost—it is serving an important role. However, when opportunity cost is measured in monetary terms, as it really must be in a financial context, it can dictate decisions that are entirely unrealistic for most artists.

Looking back at the college example, suppose that the trade school is a music program training musicians to be professional educators. After graduation, the musician is looking at probably embarking on a career where even the top salaries rarely reach six figures. And suppose that this same musician made a choice to attend music school over law school, where graduates frequently start their careers with salaries over six figures. Has he just made an irrational choice? If the decision is evaluated monetarily, of course he did. It's a simple calculation. But if his dream is to spend his days teaching music, immersing himself in his passion as opposed to earning more money in an occupation that is merely a job to him, the choice to attend law school would be just as irrational.

If you are an artist, the second choice makes total sense to you. You may have had many experiences throughout your life where others told you that you were wrong to pursue your art, and that you should instead pursue something more "stable." Most likely these objections were based on some kind of opportunity cost calculation. Perhaps that is why you picked up this book! And that is why we are suggesting the following approach: acknowledge that opportunity cost exists, but also recognize that the passion and joy that drive you to make art have a significant value. For most artists, this value far exceeds any financial gain that they could attain in a different career. Perhaps another way to consider this is to recognize that there is an opportunity cost to forgoing what you love to do. Job satisfaction and happiness may not be easily quantifiable, but they are every bit as important as those costs that are quantifiable.

A NOTE ON SAVING: BUILD YOUR OWN GUGGENHEIM FELLOWSHIP

If you have done any research into grants and awards, you have heard of some of the big ones like the Guggenheim Fellowship or the MacArthur "Genius" award. You might have imagined just what you could accomplish if you were to receive a large amount of money to devote to your art in any way you saw fit. What if you could guarantee yourself one, not immediately, but rather in ten years—what would that be worth to you? This is not a hypothetical question. For most artists, this is possible with a little saving and a concept known as compound interest. Let's look at a few examples.

If you could deposit $100 on the first day of the year into a bank account that paid an interest rate of five percent per year at the end of each year, but were unable to deposit any additional money for the next 5 years, how much money would you have in the account at the end of the fifth year? Well, using "simple" interest, you might expect the bank to pay you five percent of $100, or $5.00 per year, so you'd have a balance of $125 at that point.

Fortunately, because of *compound* interest, you'd actually do much better, because the five percent is calculated based on the new balance after adding each previous year's interest payment. So, if you just left the money in the account, in year two you'd be paid five percent of $105, or $5.25. In year three, you'd receive five percent of $110.25, or $5.51. By year four you'd get $5.79, and when year five ended you'd receive $6.08 and have a total balance of $127.63, not just $125.00. Admittedly, the additional $2.63 isn't much these days, especially spread over five years, but it actually represents a significant gain in your return on the $100 you invested in the account, since you've now earned an effective annual gain of not just five percent, but almost 5.53 percent. And it's actually even better than our basic example shows, because many banks do the compounding calculations *daily*.

Now, what if you could set aside $20, $30, $50, or more each month in that account? After all, just by foregoing a "deposit" of $1.50 a day to the gourmet coffee "bank" by skipping a macchiato leaves you $45 at month's end to deposit into your bank. That's $540 per year. For sure, trying to calculate how those monthly deposits compound is a major effort even if you're a whiz with spreadsheets. Thanks to the web, however, there are sites that do it for you. One of those is *www.financialcalculators.com*, where by clicking "The Value of Compound Interest?" under "Investments," you can see how any amount of money will grow over any number of years.

Carol Ross, *Vault 3*, 2003.

THE BEST SAVINGS ACCOUNTS

Once you're ready to start a savings program, where do you go to find the institution that will give you the best deal? More often than not it won't be the bank down the street, but the one that's out of state and that you deal with online, by phone, and by mail. Sure, you won't have the convenience of stopping by to cash a check, but with the free ATM withdrawals that many online banks offer, you can simply mail checks you wish to deposit and get your cash from the ATM. If you have a regular job, you can easily request a payroll deduction that is sent automatically to your bank—a painless way to save since you never see the money! When determining the best bank account for you, pay attention to more than the interest rate being paid. Does the bank require a minimum balance to obtain that higher rate?

Are there monthly account fees, or a minimum balance, to maintain the account? Do they offer fee-free ATM withdrawals? How many ATM withdrawals can you make each month? A leading website to find the best accounts is www.bankrate.com. On their homepage find "Checking and Savings," then "Find a Money Market Account/Savings Rate," and you'll see a list of institutions that often pay much higher interest rates than competing banks. Be sure the one you choose offers depositor insurance through a U.S. government agency so your money is protected in case the bank fails.

TAKE CHARGE OF YOUR FINANCIAL PRESENT AND FUTURE

This section is all about learning or reviewing a very basic "language" that you need to put and keep your financial house in order. We've all heard people speak about "assets" and "liabilities," "budgets" and "savings," but too many of us don't get much further than hoping that the check we wrote to pay the monthly interest and principle on the credit card bill doesn't bounce. This, as countless studies have shown, is a very stressful way to live and counterproductive to having a successful career. We want the profitable artist to be conversant in the language of finance—it really is quite basic and manageable—in order to take charge of this fundamental part of life. Learn the language; use it to deal with financial realities; use budgeting as part of the planning process you have embraced to empower your life and artistic practice. After you have answered many of the same questions we ask in other sections—who, what, when, where, why, how—this time in numbers instead of words, you can tackle the Artists Cost Tree, armed with a new language and rich information with which you can shape and control your financial future.

A REPRESENTATIVE SAMPLE OF FINANCIAL RESOURCES FOR ARTISTS

Bankrate.com
A listing of different interest rates for banks, insurance, CDs, and much more.
www.bankrate.com

The Freelancer's Union
Offers healthcare and dental options, as well a 401(k) retirement plan, to individuals working full-time as freelancers. Insurance options vary depending on state.
www.freelancersunion.org

Financial Calculators.com
A collection of financial calculators for different uses.
www.financialcalculators.com

Internal Revenue Service—Information for Individuals
Forms, definitions, FAQs, and office directory
www.irs.gov/individuals/

Mint.com
Free online software that organizes your personal finance by bringing together different bank accounts, providing budgeting, and categorizing your transactions.
www.mint.com

Moneychimp
Financial Advice and financial calculator
www.moneychimp.com

The National Association of Personal Financial Advisors
Database of financial advisors. Searchable by region and by income category.
www.napfa.org

TurboTax
Online affordable tax services
www.turbotax.com

The U.S. Small Business Administration
Articles and online tools for a variety of financial and business topics; listings for local offices.
www.sba.gov/

Art and the Law

8

Introduction to Artists' Legal Issues

Law is simultaneously one of the most important and most intimidating topics that we will tackle in this book. Why so intimidating? In part, this may be due to the fact that, by the time most artists require the services of an attorney, they are already in trouble. A dispute has occurred, and the artist's work, finances, and even basic freedoms may be at risk.

Further adding to the tense circumstances that lead to artists' legal issues, the law is often perceived as a complex jumble of terms totally disconnected from everyday conversation. Contracts seem to needlessly complicate matters, not to mention that they are written half in Latin and in such small lettering as to have coined the phrase "fine print." Contracts also anticipate the worst possible human behavior, and the language itself can inject a note of distrust into an otherwise good (and informal) working relationship.

Another area of the law that concerns artists, intellectual property (copyrights, trademarks, patents, etc.) can make most standard contracts appear relatively straightforward. Intellectual property is the intersection of legal thinking and creative thinking, and it is not always a happy meeting.

Finally, choosing a structure in which to run your project or practice has numerous legal implications—is it a corporation dedicated to producing commercial arts events, or a sole proprietorship seeking fiscal sponsorship in order to put on a free photo exhibition? Different business forms will affect your potential liability, taxes, and day-to-day management and accounting practices.

Because these issues are usually complicated (and seemingly not much fun), many artists choose to ignore them. This is unfortunate for several reasons. First, like an individual's physical health, legal issues exist and affect your activities on a daily basis regardless of whether you choose to acknowledge them. At a certain point, problems can mount so that the entire structure breaks down. Just as a patient who has waited until the last possible

moment to seek treatment faces painful procedures and huge bills, so too a delay in seeking legal assistance often increases the expense and impact of a legal problem. The other reason it's unfortunate is that a little "preventive care" can go a very long way toward avoiding problems. In fact, rather than simply viewing the law as something that must be dealt with before it gets worse, artists can use it as an important way to guard their rights and realize revenues and funding to which they had not previously known they were entitled!

SECTION STRATEGY

Like the finance section of this book, our goal is for you to become more comfortable with the basic concepts behind common legal issues facing artists. The three main areas we will focus on are contracts, intellectual property, and choosing a "business entity." We also want to provide you with a simple overview of some common legal terms, especially in these core areas. Finally, we will provide you with a list of helpful resources where you can either explore these topics in more detail, or find people and organizations with specialized expertise and an interest in working with—or providing assistance to—artists and legal issues in the arts.

Disclaimer: Nothing in here constitutes legal advice. If you have specific concerns, consult a lawyer; this is just an overview.

Contracts

Despite their seeming complexity, contracts do not have to be intimidating. They can be written in plain English, may be simple or complex, and may or may not be necessary in a given situation. What contracts are really supposed to do is to help people manage their working or personal relationships (a classic example is a prenuptial agreement). A contract tells the story of the way the relationship is going to look or work; the who, what, when, where, why, and how of the relationship.

That said, what is a contract? At its most basic level, a contract is an agreement between two or more people to do or perform something, or provide something whether it be goods or services. A contract can be verbal or written, formal or informal; even agreements written on cocktail napkins can be considered a valid contract in a court of law in certain instances.

So, why do people need contracts? This is an important point—people need contracts for certainty. A contract is supposed to make sure that everyone who is a party to the contract, or everyone who is participating in the working or personal relationship that is the subject of the contract, knows what to expect from the other parties participating in the contract and what is to be expected of them as a participant in the contract. In other words, contracts exist so people know what roles they are playing or supposed to play and what roles others are playing or supposed to play in a given relationship.

Contracts, whether verbal or in writing, are legally binding and are enforceable in a court of law. What follows is a list of requirements to make a contract legally enforceable.

CONTRACT ELEMENTS: OFFER

In order for a contract to be legally binding, certain requirements (or elements as they are known in the legal world) must be present. The first of these elements is an offer. One person must propose to make a deal, and that deal must then be communicated to another person. For example, when an artist communicates the price of his work, that is considered an *offer*. That is, the art is being offered to a buyer at a certain price. It is an offer to make a deal with the potential buyer for a certain price. An offer remains open until it is accepted, rejected, retracted, or it expires. An offer must also contain the terms that identify and define the scope of the agreement. For example, if someone listed studio space for rent, the listing would contain the terms of the rental, which would most likely include the address of the rental space, the price or rent, the duration of the rental, and possibly any restrictions on the rental (such as no dogs allowed in the studio space). The terms of an offer must be specific and definite, which means the offer must include details. Someone cannot rent studio space if all the landlord did was say to them, "I offer to rent you studio space." The person to whom the landlord has offered the space does not know what the actual offer is. One needs the details in order to decide whether to accept or reject such an offer.

ACCEPTANCE

This brings us to the legal concept of acceptance. Acceptance occurs when the person to whom an offer is made acknowledges that they accept that offer. This means that the person accepting the offer also accepts all the terms of the offer. So, the dancer, studio artist, or actor who was looking for studio space above accepts the rental price, the duration, the location and the restriction that the space is not dog friendly. The person seeking studio space must communicate his acceptance to the person who made the offer. For the art buyer mentioned above, he must communicate his acceptance of the price of the artwork. If the artwork is being offered for $1,000, then the buyer must communicate his or her willingness to buy the artwork for the $1,000. This can be accomplished verbally or in writing.

COUNTER OFFER

Suppose the listed rent for the studio is $500. The actor, dancer, or studio artist decides she wants to let the space, but at the rental price of $425. He or she has not legally accepted the offer because he/she has changed the terms. This is what is known as a counter offer, which, in turn, now may be accepted or rejected by the landlord. Or if the potential art buyer offers the artist $895 instead of the asking price of $1,000 for the artwork, that is a counter offer which may be accepted or rejected now by the artist.

CONSIDERATION

In order for a contract to be legally binding, there must be what is known as "consideration" in legal terminology. Consideration is something of adequate value that is given by one party in the contract to another in return for the other party's promises. In legal parlance, consideration is the bargained-for exchange between the parties.

Consideration may take the form of money, property, or services. Adequate value does not necessarily mean fair market value and is judged at the time the bargain was struck. To take our studio example, the consideration would be the price of the studio space. The landlord wanted $500 a month for the studio space. The $500 is the consideration in this contract because the landlord is basically promising to rent the space to our dancer, artist or actor. The actor, artist or dancer, gives the $500 in consideration of, or in exchange for, the landlord's promise to rent out the space. Similarly, the artist gives the painting in exchange for receiving whatever the agreed upon price of the painting is.

COMPETENCY, CONSENT, AND LEGALITY

Aside from offer, acceptance, and consideration, there are several other fundamental elements that must be present to make a contract legally binding. The first is competence. This means that each party to the contract must have the legal capacity to enter into a contract. Minors under the age of eighteen cannot enter into contracts. Also, people who are incompetent because of mental illness or disability cannot enter into contracts. If minors or other people who are not legally competent to enter into contracts do so, those contracts can be rescinded or voided by a court.

Another element is the concept of consent. Consent means that each party of the contract agrees to the contract terms. Interestingly, one does not have to know what a contract says to consent to it. If you sign a contract, you are legally presumed to have consented to the terms. This is why it is so important that you know what you are signing. If you do not understand the terms of a contract you are expected to sign, consult an attorney, so you understand what role you are required to play and what role others are required to play according to the contract you are about to sign. Finally, for a contract to be legally enforceable, it must involve legal activity. For example, two drug dealers signing a contract not to sell drugs on each other's turf would not be a legal contract.

STATUTE OF FRAUDS

Without a written agreement, it can be difficult to determine exactly what was agreed to. Written agreements allow for greater clarity and confidence about the actual terms of the

A good contract involves a meeting of the minds between contracting parties — Judith Brodsky (Founding Director, Rutgers Center for Innovative Print and Paper), *How Does the Brain Work*, 2011..

contract. While oral (spoken) contracts are sometimes valid and enforceable, there are several types of contracts that are required to be in writing. The legal rule in this area is called the "Statute of Frauds."

Some of the contracts that must be in writing are only tangentially related to the arts (for example, rules related to executors of estates of a deceased person). Others are more relevant. A promise conditioned on *marriage* must be in writing. An example is, "He promised me the lead in his Broadway show if we got married." Any agreement that cannot be performed and completed *within one year*, according to its terms, must be written. For example, a promise to perform at a Las Vegas venue for a period of two years must be written. The purchase or sale of *real estate* requires a written contract. This does not include a lease, unless the lease is for more than one year. This is important for entertainment companies or not-for-profits considering the purchase of real estate. The sale of *goods worth $500* or more requires a written contract. For example, if a theater or production company buys equipment for taping shows or programs and that equipment exceeds $500, you need a written contract. *Suretyship* agreements must be in writing. A "surety" is someone who promises to pay the debts of another person. This could be applicable if your entertainment busi-

ness needs some sort of bailout and a benefactor comes in and promises to pay the company's debts.

If a contract is covered by the Statute of Frauds, the contract must: be in writing; identify what the contract covers so it is reasonably understood (for example, the purchase of costumes); specify the essential terms of the agreement (e.g., price and quantity of goods to be sold, 100 costumes for $100 each); and be executed or signed by all the parties to the contract.

COMMON CLAUSES IN CONTRACTS

There are many types of contracts in the arts and entertainment. Many of the clauses in a contract are there to outline the roles that the parties are supposed to play. This means that many of the rights and responsibilities outlined in a particular agreement will be unique. For example, in an artist's performance contract, there will most likely be clauses covering rehearsals, the dates and time of a performance, payment, and dressing rooms, which would not appear in another type of contract. However, there are also certain common clauses that may appear in any kind of contract. A list of some of the clauses and their explanations follow:

- "Whereas" Clauses
- Merger and Integration Clauses
- Indemnification ("Hold Harmless") Clauses
- Non-Waiver Clauses
- Arbitration Clauses
- Attorney's Fees Clauses
- Choice of Law and Choice of Forum Clauses
- Severability Clauses

"WHEREAS" CLAUSES

"Whereas" clauses usually appear in the beginning of an agreement. They are basically a list of the parties' intentions, which begin with the word "Whereas." For example, the Commission Agreement between the theater company and the playwright above may start with something like this: "Whereas the theater company intends to commission a four part play about the four seasons and whereas the playwright agrees to write a four part play about the four seasons, Now therefore, the theater company and the playwright agree as follows . . . "

MERGER AND INTEGRATION CLAUSES

The purpose of the Merger and Integration Clause is to prevent any of the parties to a particular contract from later claiming that the agreement does not reflect their complete

understanding of the agreement. Once the parties enter into a contract, this clause prevents them from altering or adding to the contract with later, outside, or unwritten agreements. The Merger and Integration Clause also prevents a party from claiming that the agreement is not consistent with prior agreements. This is why it is so important to understand what you are agreeing to when you sign a contract. This section will usually contain a declaration that the signed agreement constitutes the "entire" agreement between the parties. This is also why it is so important to know what the specific terms of a contract into which you may enter say and mean.

INDEMNIFICATION ("HOLD HARMLESS") CLAUSES

First, what does indemnification mean? When one party agrees to "indemnify" another, it means that one party will pay for losses the other party may suffer. Basically, these clauses transfer liability (legal financial responsibility) from one party to another. They are also known as "hold harmless" clauses. Here is an example: "Party A agrees to indemnify and hold harmless Party B for any losses Party B may suffer as a result of Party A's failure to perform any of the rights, responsibilities, and/or obligations of this Agreement." Usually, a party agrees to pay money in a hold harmless clause; for example, a party may indemnify another party for things like professionals' fees including attorney's fees, judgments and settlements. Indemnification does not usually extend to acts of fraud, criminal activity, and in some jurisdictions, negligence.

NON-WAIVER CLAUSES

Suppose that a theater company enters into a Commission Agreement with a playwright for the four plays with themes centered around the four seasons. According to the Commission Agreement, first drafts of the plays are supposed to be delivered in the order of Spring, Summer, Fall, and Winter on March 21, June 21, September 21, and December 21. However, the playwright does not deliver the Spring installment on March 21 as promised and agreed to in the signed Commission Agreement, but instead delivers the first draft of Spring on April 1, about ten days late. The theater company accepts the delivery of the Spring draft on April 1 instead of March 21, apparently excusing the lateness. However, just because the theater company allowed the playwright to be late the first time does *not* mean they have waived their right to timely delivery of the Summer, Fall, or Winter drafts on the dates delineated in the Commission Agreement, and the playwright must comply with the delivery dates. There-fore, non-waiver clauses protect a party who excuses another party from not complying or straying from the terms of a contract. Such a clause might read, "The failure by one party to require performance of any provision shall not affect that party's right to require performance at any time thereafter, nor shall a waiver of any breach or default of this contract constitute a waiver of any subsequent breach or default or a waiver of the provision itself."

ARBITRATION CLAUSES

Many contracts now include clauses that specify any disputes will be resolved through arbitration. Arbitration is a way for parties who are in dispute to settle their matter privately and out of court if they cannot settle the matter themselves. Each party still has their own legal counsel in an arbitration, both parties contribute to the administration costs of arbitration (which can be quite high), and the discovery process (the process of gathering evidence) is considerably shortened in arbitration.

ATTORNEY'S FEES CLAUSES

Many contracts have a clause specifically stating that in the event of litigation, the losing party will pay the winning party's attorney's fees.

CHOICE OF LAW AND CHOICE OF FORUM CLAUSES

These clauses specifically identify either which state's law will interpret the meaning of the contract, or where any suit based on the contract must be filed. The contract might state, "This contract will be governed by the laws of the State of New York." In that case, New York law about various issues will be used by whatever court hears the case, even if that court is not in New York, and the underlying events did not take place in New York. These clauses may also designate a specific "forum" where any litigation or arbitration must take place in the event of a dispute. This is important because you may be signing a contract sitting in an office in New York or Texas, but if a forum selection clause identifies California as the place where any litigation or arbitration will take place, then in the event of a dispute or lawsuit, only a California court can hear the case, even if this is very inconvenient.

SEVERABILITY CLAUSES

Without a Severability Clause, if one provision of a contract is invalid, a court may rule that the entire contract is invalid. A severability clause is important to a contract because it "saves" all other provisions of a contract in the event that one of the provisions is deemed invalid or illegal. Such a clause might read, "If any provision of the Agreement is held unenforceable, then such provision will be modified, and all remaining provisions of this contract shall remain in full force and effect."

SOME FINAL THOUGHTS ON CONTRACTS

The purpose of this section has been to give you some basic knowledge on the legal requirements of contracts and to give you some explanation of common contract language. This is by no means a comprehensive course in contract law, and certainly does not cover the kinds

of sophisticated contracts that creators in the arts and entertainment business encounter on a regular, if not daily, basis. This is why it is important to consult with an attorney who can protect your interests in a contract negotiation and in the drafting of a contract. At the very least, he or she can clarify the meaning of contract terms and what your rights and responsibilities will be under any legally binding contract you sign. Never sign a contract without understanding what it says, what is expected of you, and what will happen if either you or the other party does not perform. It can be easy to get lost or intimidated by the length and language of a contract. Never forget that there is a bigger picture in all of those words. It describes an agreement, and the goal is to eliminate confusion so that everyone knows his or her role. If you understand the details of the agreement into which you are entering, then you will be able to understand the contract. Don't be afraid to ask questions at any stage of the process—the clearer an understanding that exists between parties, the better the contract. And again, if you are entering into a contract that is in any way confusing or involves important issues, get a lawyer involved.

Intellectual Property

Intellectual property is one of the most important areas of the law for artists. For artists, intellectual property can be both a source of revenue, and a significant financial burden that may influence artistic decisions as the artist attempts to avoid legal pitfalls. Understanding how intellectual property both protects and restricts you is therefore very important.

What is intellectual property? The World Intellectual Property Organization (WIPO) defines it this way: "Intellectual property (IP) refers to creations of the mind: inventions, literary and artistic works, and symbols, names, images, and designs used in commerce."

Intellectual property results from something that springs from intellectual or creative efforts in which someone can assert an ownership and proprietary interest in the resulting artwork. Owning intellectual property is similar to owning physical property in some ways—like physical property, you can keep it to yourself, sell it, lease it, divide it, and allow others to use it, on terms you control.

But intellectual property is different from tangible, physical property in some very important ways. It is easier to understand how to protect physical property. You can put a lock on your door or a fence around your yard. You can take a rare family heirloom and put it in a bank safe-deposit box. If someone breaks the lock, jumps the fence, or drills into the safe, you can call the police, and there is no question that the law protects you and your property in these examples. Often, intellectual property is embodied in a physical object, but it is not the same as that object. If you write a novel, and someone steals the manuscript, he has stolen your physical property. That manuscript itself may not be worth a great deal of money (especially if you can just print out another). But if he *publishes* the novel without your permission, he has stolen your intellectual property and potentially done you great financial harm. Intellectual property laws are designed to protect you from the latter kind of harm.

There are three major types of legal protections for intellectual property: copyrights, patents, and trademarks. All three of these protections are rooted in federal law and, in most cases, have international protections as well due to treaties that the United States has entered into with other countries (or international bodies). Another method of protecting intellectual property is through trade secrets, but these do not enjoy the same kinds of protections that the other categories do—trade secrets are more an indirect protection for valuable business knowledge rather than true intellectual property.

A trademark typically protects brand names and logos used on goods and services. A copyright protects an original artistic or literary work. A patent protects an invention. For example, if you invent a new kind of vacuum cleaner, you would apply for a patent to protect the invention itself. You would apply to register a trademark to protect the brand name of the vacuum cleaner. And you might register a copyright for the TV commercial that you use to market the product.

Most artists deal with copyright law. Copyright law protects the vast majority of what artists produce. It covers musical compositions, paintings, choreography, and literature (in addition to a host of other categories). In some cases, especially for artists with defined businesses, distinct brand identity, and/or marketing/branding strategies, trademarks will also be a relevant form of protection. Artists almost never use patents, which are far more applicable to industrial designs and processes, and rarely use trade secrets, which are much more applicable to product designs, especially products that are difficult to reverse-engineer.

A LITTLE HISTORY AND THEORY BEHIND INTELLECTUAL PROPERTY LAW

Knowing something about the theories that guide intellectual property law can be helpful in understanding how we have come to have the rules we do. In a sense, all property, physical or intellectual, is created by law. Not the things themselves, but the *rights* we have in relation to those things, depend upon laws. To "own" something is simply to have the right to buy it, sell it, use currency or methods to exchange it, give others the power to do so on your behalf, choose who will receive it when you die, and so on. You can go to court to assert or defend your legal rights, and the court's decision will ultimately be enforced by the full power of the state. Many decisions about what the law will protect and allow are driven by practical considerations as much as social values.

The U.S. Constitution gave Congress the power to pass laws protecting copyrights and patents, and Congress did so. The clause in the U.S. Constitution upon which federal intellectual property protections are based reads: "The Congress shall have power . . . [t]o *promote the progress of* science and *useful arts*, by securing for *limited times* to *authors*

and inventors the *exclusive right* to their respective *writings* and discoveries." The U.S. Constitution, Art. I, § 8. Congress subsequently passed laws regulating copyrights and patents. Many years of court decisions have interpreted those laws, which have changed over time. The purpose of protecting intellectual property, from the point of view of the Founding Fathers, was to create incentives for creators to create, and for inventors to invent. The "writings" language has spawned federal copyright law, and the "discoveries" language did the same for patents (trademarks are based on a separate federal [congressional] statute).

For many artists, intellectual property stirs strong emotions. Artists' creations are extremely precious to them, and rightly so. This goes well beyond the economics involved and touches upon issues of recognition/credit, as well as the ability to control how the rest of the world treats their work (for example, not destroying it, or not using it for something that the artist considers offensive or inappropriate). The law protects some of these concerns and not others, and artists who understand just what their rights are will be in a better position to address some of their individual concerns up front through contracts. It is harder to do that when something has already happened. By understanding what you can or cannot protect, you may avoid some unpleasant situations regarding your project or practice.

COPYRIGHT

A copyright exists in all original works of authorship once it is "fixed" in a tangible medium of expression. That means that you have a copyright in anything you create as long as it is set forth in a form that can be reproduced (such as writing, a recording, etc.) and you do not need to register the work with the Copyright office.

The federal copyright law is found in Title 17 of the U.S. Code (a "title" is just a group of laws related to the same topic), and extends protection to "original works of authorship fixed in any tangible medium of expression, now known or later developed, from which they can be perceived, reproduced, or otherwise communicated, either directly or with the aid of a machine or device." The statute goes on to further define what categories of works are protected:

- Literary works
- Musical works, including any accompanying words
- Dramatic works, including any accompanying music
- Pantomimes and choreographic works
- Pictorial, graphic, and sculptural works
- Motion pictures and other audiovisual works
- Sound recordings
- Architectural works

These eight categories cover most of what artists produce, although courts have had to sometimes do a little bit of creative interpretation to figure out into exactly which category a particular form of art or artwork fits. Copyright protection for computer programs usually treats such works as "literary works," but sometimes as a visual arts work or a motion picture/audiovisual work).

ELEMENTS OF "COPYRIGHTABILITY"

Not all creative works qualify for copyright protection. In order for a work to qualify for protection, it must satisfy a few requirements.

Originality

The first requirement is that it be an "original work." However, this is not a qualitative judgment or a judgment of importance. The amount of originality required is fairly minimal; courts have said that a work must include "a modicum of creativity" to qualify for copyright protection. Words or notes combined in a way not done before will qualify, even if nothing "original" is being expressed. For example, one area of unresolved controversy is about the creative quality involved in copy photography; it is typically considered more creative to photograph three dimensional work (sculpture) than two dimensional (works on paper, canvas, panel).

Copyright does not protect "ideas" as such, but rather, an original expression of what may be a familiar idea. One cannot copyright the *idea* of "a play about star-crossed teenage lovers from warring families," although the text of both *Romeo and Juliet* and *West Side Story* could be copyrighted. Nor does copyright law protect any procedure, process, system, method of operation, concept, principle, or discovery.

"Fixed in any tangible medium of expression"

In addition to being original (an easy requirement to meet for the work that most artists produce, although more complicated for those whose works incorporate the work of others), to be copyrightable, the work must be written down, videotaped, recorded, made into a piece, or notated in some way. If an artist has an idea but has not "fixed" it (expressed it in some way), it will not receive copyright protection. This can be especially important when artists share ideas with others, who may then use them to create their own works. The person who had the original idea that was never "fixed in any tangible medium" will not have any remedy.

You should note that facts are not subject to copyright, even if you "discovered" this fact. Also, words, short phrases, slogans, symbols and other identifiers are not usually protected by copyright unless they are very distinct. However, if those slogans or symbols

are used to identify you and your works, they may be protected as a trademark. Similarly, systems, methods, devices and ways of doing something are also not protected by copyright (which includes recipes) but they may be protected in limited circumstances by patent. Also, although we mentioned that a dictionary may be protected by copyright, that copyright is very "thin" because it consists almost entirely of information that is common property and does not contain any original authorship. Thus, standard calendars, tape measures and rulers, and lists or tables taken from public documents, are not protected by copyright, although the selection and arrangement of such information may (arguably) be protected by a thin copyright but, in such cases, the copying has to be nearly exact.

Derivative Works

A "derivative work" is a new work based upon the work of another. Of course, artists are frequently inspired by the works of others, and influenced by them. A "derivative work" goes further. Examples include a screenplay adapted from a novel, or a new arrangement of a piece of music. A derivative work is itself copyrightable, though creating one may require permission from the copyright holder of the original work (if that work is copyrighted, rather than part of the "public domain"). A copyrightable derivative work must include sufficiently new, original material by the new author. Minor additions to or rearrangements of the original work won't be enough.

WHAT KINDS OF PROTECTION DOES COPYRIGHT GIVE TO AN ARTIST?

The owner of the copyright in a work—usually, at least initially, the artist who creates it—has a variety of rights. Broadly speaking, copyright owners have the exclusive right to do, and to authorize others to do, any of the following:

To reproduce the copyrighted work in copies or phonorecords;

To prepare derivative works based upon the copyrighted work;

To distribute copies or phonorecords of the copyrighted work to the public by sale or other transfer of ownership, or by rental, lease, or lending;

In the case of literary, musical, dramatic, and choreographic works, pantomimes, and motion pictures and other audiovisual works, to perform the copyrighted work publicly;

In the case of literary, musical, dramatic, and choreographic works, pantomimes, and pictorial, graphic, or sculptural works, including the individual images of a motion picture or other audiovisual work, to display the copyrighted work publicly;

In the case of sound recordings, to perform the copyrighted work publicly by means of a digital audio transmission.

Some of these terms have special meanings in the copyright law context. The U.S. Copyright Office includes the following definitional note in its publication *Copyright Basics* (*http://www.copyright.gov/circs/circ1.pdf*):

"Sound recordings" are defined in the law as "works that result from the fixation of a series of musical, spoken, or other sounds, but not including the sounds accompanying a motion picture or other audiovisual work." Common examples include recordings of music, drama, or lectures. A sound recording is not the same as a "phonorecord." A phonorecord is the physical object in which works of authorship are embodied. The word "phonorecord" includes cassette tapes, CDs, and vinyl disks as well as other formats.

A copyright owner can make commercial use of the copyright by selling or licensing any one or more of the rights listed above. Someone who has written a novel, for example, can transfer the publishing rights to a publishing company (in return for royalties), and also sell the right to make a screenplay from it to someone else. The holder of a copyright in a song could license many different musical groups to perform or record it. If you sell a work of art, you are only selling the physical object, and unless the terms of the sale agreement make clear that you are also selling your copyright in that work, you continue to retain the copyright in that work because you have only sold the actual physical property, not the intellectual property, in the work of art. Moreover, when you are licensing something (e.g., you license your photograph to be used once in a magazine), it is possible to tailor what rights you grant to the licensee (for example, the magazine can only run the photograph to illustrate a particular story, but cannot use that photograph to advertise itself or to use the photograph to illustrate a different story).

SPECIAL RIGHTS FOR VISUAL ARTISTS

Traditional copyright law generally does not provide for any continuing rights in the artist-creator if all rights are transferred to another. For example, after the sale of a painting, all rights relating to that painting generally belong to the new owner, not the artist-creator. Unless the terms of the agreement with buyer so state, the artist would have no legal right to have his or her name associated with the work ("attribution"), nor to protect the work from what the artist might consider misuse or damage ("integrity"). In Europe and elsewhere, these rights are sometimes called "moral rights." The Visual Artists Rights Act of 1990 (VARA) provides in a limited way for some moral rights for some visual artists only. This is set out in the copyright statute at Section 106(a) as follows:

Rights of Certain Authors to Attribution and Integrity
(a) Rights of Attribution and Integrity—Subject to section 107 and independent of the exclusive rights provided in section 106, the author of a work of visual art —

(1) Shall have the right—

(A) To claim authorship of that work, and

(B) To prevent the use of his or her name as the author of any work of visual art which he or she did not create;

(2) Shall have the right to prevent the use of his or her name as the author of the work of visual art in the event of a distortion, mutilation, or other modification of the work which would be prejudicial to his or her honor or reputation; and

(3) subject to the limitations set forth in section 113(d), shall have the right—

(A) to prevent any intentional distortion, mutilation, or other modification of that work which would be prejudicial to his or her honor or reputation, and any intentional distortion, mutilation, or modification of that work is a violation of that right, and

(B) to prevent any destruction of a work of recognized stature, and any intentional or grossly negligent destruction of that work is a violation of that right.

VARA has introduced the concepts of attribution and integrity to U.S. copyright law.

In a well-publicized Los Angeles case, the artist Kent Twitchell, who painted a mural on the side of a building, argued that, when the building owners painted over his mural, the destruction of his work violated his moral rights under VARA.

VARA protects only a limited number of mediums; specifically, paintings, drawings, prints, sculptures, still photographic images produced for exhibition only, and existing in single copies or in limited editions of 200 or fewer copies, signed and numbered by the artist. There are also numerous other exceptions to this act, and an artist should not assume that his/her work is automatically protected. Like everything discussed in this chapter, this is simply a guide to let you know what the basic legal framework is, and we encourage you to research any and all of these topics in greater detail. If you are entering into a contract either for the commission or sale of a work of visual art and have concerns about your "moral rights," you should consult an attorney! However, VARA has introduced the concepts of attribution and integrity to U.S. copyright law, at least for visual artists, and may indicate future developments in moral rights for other artists as well. You should also be aware that, if you are selling your works abroad or creating a work commissioned by a foreign entity, your work may be protected by the more robust "moral right" available in other countries.

WORKS MADE FOR HIRE

The copyright in a work ordinarily belongs to the person who authored or created the work. However, in some cases a company, organization, or even another individual, will hire an artist to create a work and whoever does the hiring will be considered to be the "author" and

owner of the copyright. Works created under these conditions are known as "works made for hire," and some special rules apply to them.

A "work made for hire" is "(1) a work prepared by an employee within the scope of his or her employment; or (2) a work specially ordered or commissioned for use as a contribution to a collective work, as a part of a motion picture or other audiovisual work, as a translation, as a supplementary work, as a compilation, as an instructional text, as a test, as answer material for a test, or as an atlas, if the parties expressly agree in a written instrument signed by them that the work shall be considered a work made for hire . . . "

Because a work created by an "employee" is automatically a work made for hire, while a work created by a non-employee is not (unless there is a written agreement), there is frequently a dispute about whether the creator was an "employee" or an "independent contractor." Unfortunately, it's not always easy to tell. Some of the important factors courts consider are how much control the commissioning person or entity had over the artist's work (location, tools, etc.), over the artist him- or herself (schedule, manner of payment, ability to assign other work and responsibilities), tax issues (whether taxes were withheld as for a salaried employee), and finally whether the work produced fits in with the commissioning party's regular business.

If the creator of the work is determined to be an independent contractor, the work will be "for hire" *only* if it falls into one of the categories set out in Section 101 the statute (listed above, in part), and if there is a specific agreement between the two parties.

This is an issue that frequently arises in the arts world, as so many works are collaborative and so few employment relationships are formal. You should also be aware that, where more than one artist creates a work with one or more other artists, and they intend to create the work as collaborators, the resulting art work is considered a "joint work," pursuant to Section 201(a) of the Copyright Act, and all the cocreators own an undivided interest in the entire work regardless of the actual amount of their contribution (unless there is a written agreement setting forth the terms and scope of each coauthor's respective ownership in the resulting work). That said, where one entity merely contributes ideas, money, logistical support, or other assistance, it is not considered a sufficient contribution into a "joint work." Thus, for example, if an entity commissions a work and pays for its creation, that entity is not technically a coauthor; instead, the artists retain 100 percent ownership in the copyright over the resulting work.

Quite often this is a case of simple economics—very few artists can afford salaried employees, and many musical ensembles, dance companies, and theater groups are comprised of independent contractors. Because of the often ambiguous employee status of many artistic colleagues, knowing the rules about works for hire beforehand can save a lot of time and hard feelings later. It also emphasizes why contracts can be an important part of collaborative artistic arrangements. If you request a contract from the outset, you can address these potentially thorny issues before any misunderstanding or conflict arises.

TERM OF COPYRIGHT

Just how long the copyright on a work lasts depends on when it was created. For works created on or after January 1, 1978, the term is for the life of the author, plus seventy years (if there are multiple authors, the clock starts after the last one dies). In the case of an anonymous author or of a work made for hire, the copyright lasts either ninety-five years from publication or 120 years from creation, whichever period is shorter. If you are trying to determine if a work falls into the public domain, that can get a little more complicated as the law (and the copyright term) has been changed several times in the past hundred years. You will need to investigate what laws were in effect at the time, and whether subsequent changes to the law have affected the calculation (legislation has extended the copyright life of many works).

REGISTRATION

As mentioned above, an artist owns a "copyright" in his or her work: the moment that the work is "fixed" in either a phonorecord (as defined above) or a copy, copyright applies. Although no registration of the work with the Copyright Office is necessary, there are several reasons why registering your copyright is advisable from the standpoint of using the court system to protect your copyright. It establishes a public record of your copyright, is a precondition for beginning a lawsuit based on infringement of your work, and it allows for the collection of statutory damages (a set amount of damages for each instance of infringement) and attorney's fees, which are frequently far greater than the actual damages the owner suffered. You do not need to affix the copyright notice on your work in order to protect your copyright (although it is advisable from the standpoint of putting the world on notice that you own a copyright in that work).

Registering your copyright is fairly simple. You need to complete an application form, pay a filing fee, and submit a "deposit" of your work—that is, a copy of the work in question. For more detailed information, go to *www.copyright.gov*.

USING OTHER'S WORK LEGALLY

If you want to use someone else's work, you need their permission unless the work is not protected by copyright. Works that are not protected by copyright because they are not covered by intellectual property rights at all, or if the intellectual property rights have expired, are said to be in the "public domain." Virtually anything that we commonly regard as a masterpiece—in the sense that it has withstood the test of time—is in the public domain. A general rule of thumb is that works created before 1923 are in the public domain. The works of Michelangelo, Bach, and Shakespeare are all public domain, and that means that they are fair game from an artist's perspective. You can perform them or create a

derivative work based on them and it is allowable. Moreover, documents and publications created by the federal government are not copyrighted and are also considered to be public domain works. Beware that translations of works in the public domain may be copyrighted; when in question use one created prior to 1923.

If a work is still protected by copyright, however, you will need to obtain a license from the owner if you want to use that work in any way (e.g., perform the work, use it to create a derivative work, reproduce the work). As with any economic transaction, the parties can usually come to an agreement about the terms and scope of the license. However, artists can sometimes encounter problems with copyright owners who either do not wish to license the work under any circumstances, or will only do so at a price that is prohibitively expensive for the would-be licensee. In that case, the copyrighted work is off-limits subject to a few exceptions that we will discuss below.

COMPULSORY LICENSES

Section 115 of the Copyright statute provides an exception to the general rule that you must get permission from the copyright owner in order to use a work, specifically for certain musical works:

"In the case of nondramatic musical works, the exclusive rights provided by clauses (1) and (3) of section 106, to make and to distribute phonorecords of such works, are subject to compulsory licensing under the conditions specified by this section."

What this means is that, rather than negotiate with the composer of a song, if you want to make a recording of the song (sometimes known as a "cover") for an album, you can simply pay a set royalty fee and have a license to use the work for that purpose. There are considerable limitations to this—it cannot be used for broadcasting purposes, it does not include soundtracks, and it does not include sound recordings, meaning another recording of the song. It is for your use to record only. You have the right to make your own arrangement, but it must not alter the "fundamental character" of the original work, and it cannot be protected as a derivative work without the permission of the original copyright owner.

These compulsory licenses are also known as "mechanical licenses." Most mechanical licenses in the United States are handled by the Harry Fox Agency (*www.harryfox.com*). Other forms of compulsory licenses exist, but the mechanical license is the most commonly used by artists, especially musicians.

CREATIVE COMMONS

A "creative commons" license is a licensing scheme created by an organization known as Creative Commons, which offers a variety of licenses that allow for flexible use and exchange of copyrighted material. These were designed with Internet use in mind, and essentially allow artists and other copyright owners to share their materials more freely. Owners can

opt for a variety of licenses, most of which allow others to use their materials for free, although often require some sort of attribution right.

One interesting twist to a creative commons license is that owners can restrict those who use their materials to create derivative works to the same terms. This means that the new derivative work would also be available to others for free. Creative Commons licenses are based off of U.S. copyright law, so you will want to investigate how the license is treated by a foreign jurisdiction if you intend to use this license outside of the country. More information on specific licenses is available at *www.creativecommons.org*.

FAIR USE

There are certain circumstances in which you may use the protected work of another artist without his or her permission. This is known as "Fair Use." Before we discuss the specifics of Fair Use, we need to clarify the nature of this concept—it is usually known as the Fair Use "Exception," and it is a legal defense to a copyright infringement claim, not a license to use the work of others.

Section 107 of the Copyright statute defines Fair Use:

"[T]he fair use of a copyrighted work, including such use by reproduction in copies or phonorecords or by any other means specified by that section, for purposes such as criticism, comment, news reporting, teaching (including multiple copies for classroom use), scholarship, or research, is not an infringement of copyright. In determining whether the use made of a work in any particular case is a fair use the factors to be considered shall include—

(1) the purpose and character of the use, including whether such use is of a commercial nature or is for nonprofit educational purposes; (2) the nature of the copyrighted work; (3) the amount and substantiality of the portion used in relation to the copyrighted work as a whole; and (4) the effect of the use upon the potential market for or value of the copyrighted work."

Unfortunately, there is no clearly defined safe zone for what constitutes fair use—it will be determined on a case-by-case basis, with reference to important prior cases. The statute itself does give some guidance, however, through the four-pronged test it sets up.

First Prong

"The purpose and character" prong clearly favors noncommercial use, and courts also favor uses that are for nonprofit or educational purposes, or criticism, commentary, or analysis. For example, it would be hard to parody a work without referencing the work itself. Because the original worker would probably not license his or her work for a critical parody, the fair use defense is available because, otherwise, parodies would always be infringing.

Second Prong

The "nature of the work" prong tends to give less protection to works that are factual in nature because, as mentioned above, facts are not copyrightable. If a work is very "factual," then society is improved if those facts and factual works can be freely discussed and circulated. On the other hand, if the original work is more imaginative, then this weighs against finding that the secondary use was "fair" as opposed to an unauthorized derivative work.

Third Prong

The "amount and substantiality" prong is tricky, as the emphasis is clearly on the amount of the original work copied, not the new work. The courts look more kindly on an insubstantial or "de minimis" amount copied, but there is no set length or amount that needs to be copied. The analysis is also qualitative, as taking a small piece can still be significant depending on that piece's importance to the original work (whether it goes to the "heart" of the original).

Fourth Prong

This prong is an economic analysis that looks at how the new work will impact the older work, and whether the new derivative work would be considered a "market substitute" for the older work. If there is little to no impact on the older work's market value, then this would weigh in favor of finding that the new derivative work made a "fair use" of the prior work. On the other hand, if the new work competes with (takes away sales from) the original work, or simply permits the artists from avoiding the need to obtain a license and pay royalties, then this weighs against finding a fair use.

TRADEMARK

Trademarks are one of the three types of intellectual property protected in the United States, and are managed by the United States Patent and Trademark Office (USPTO), although trademarks are also protected by individual state laws. The USPTO defines trademarks as:

"A trademark is a word, phrase, symbol or design, or a combination thereof, that identifies and distinguishes the source of the goods of one party from those of others."

The term "trademark" is used often interchangeably to cover "service marks," which serve the same function as a trademark but cover the provider of services instead of goods. Thus, a trademark can be anything that serves as a source identifier, ranging from a name (e.g., "Disney"), to a symbol (Mickey's ears), to a color (the specific blue that represents a Tiffany's jewelry box), or a phrase ("Raindrops on roses and whiskers on kittens" used to identify the movie *The Sound of Music*).

Most artists will have use for trademarks only if they want to protect a name or symbol for commercial use to identify themselves or their works. The decision to do so may be influenced by the artist's branding strategy (see __15_ for a discussion on branding). Like other forms of intellectual property protection, a good deal of the protection offered by trademark is for the benefit of the consuming public.

As with copyright, you do not need to "register" your trademark in order to have a protectable interest in your name or marketplace identifier. Instead, you can protect your interest in the mark by using it in commerce. However, registering your mark with the federal government (or even a state government) provides numerous advantages, including creating a legal presumption that you own this mark and you have the exclusive right to use the mark in connection with the goods/services listed in the registration.

The decision to award a trademark is based on limiting confusion in the marketplace, and the USPTO will be examining any trademark application with that goal in mind. When a trademark application is rejected, the most common reason is that it would cause confusion with a mark already in existence, and the main criteria for confusion are (1) that the mark (or phrase) itself is similar, and (2) that the market is similar. There would be less conflict between a fashion designer's mark and an eye surgeon than there would be with two fashion designers. Before you select a trademark, it is a good idea to search the PTO's electronic database, named TESS, which allows you to search what trademarks already exist: *http://tess2.uspto.gov/*

However, there are many other reasons that a mark may be rejected. The USPTO lists four common reasons:

"[The proposed mark is]:

- descriptive for the goods/services
- a geographic term
- a surname
- ornamental as applied to the goods"

These are the reasons that you cannot trademark your name, for example, or a generic business description like "Graphic Designer" or "Dramatic Actor," because you cannot monopolize such a common name. Furthermore, a trademark application is much more complex and expensive when compared with a copyright application, and while you are not required to have an attorney, many choose to retain one. However, once you have a trademark it can be renewed perpetually, and if you have developed a legitimately original mark that is a core part of a branding strategy, a trademark can be a valuable asset to your business.

PATENT

Patent protection is an extremely powerful form of protection which is available to inventors. We will only briefly touch on it here, as it is rarely applicable to artists. The U.S. Patent and Trademark Office defines patents as follows:

"A patent is an intellectual property right granted by the Government of the United States of America to an inventor 'to exclude others from making, using, offering for sale, or selling the invention throughout the United States or importing the invention into the United States' for a limited time in exchange for public disclosure of the invention when the patent is granted."

There are two main types of patents: utility patents and design patents. Utility patents cover "any new and useful process, machine, article of manufacture, compositions of matter, or any new useful improvement thereof." Design patents, on the other hand, can be granted "to anyone who invents a new, original, and ornamental design for an article of manufacture." Design patents can be thought of as protection for artistic but functional works, whereas copyright covers nonfunctional artistic works.

Unlike a copyright, securing a patent is a time-consuming and often expensive process (frequently requiring the services of an attorney). Once secured, however, the owner of a patent has what is sometimes referred to as a "limited monopoly" on the new invention. The patent owner has the sole right to use the invention, but it is time limited (a utility patent lasts for twenty years and a design patent lasts for fourteen). The rationale behind patents very clearly shows the balancing act between the interests of society and that of the inventor (creator). The "bargain" in exchange for a patent is complete disclosure so that society may benefit from the knowledge or discovery. In return, the inventor gets complete control over her product.

In certain, rare instances an artist may qualify for patent protection, in which case he or she should consult with a patent attorney about whether it makes sense to pursue.

TRADE SECRETS

If the intellectual property you want to protect is not a good candidate for any of the traditional intellectual property protections, another option is keeping it as a "trade secret." As the name implies, this means that you keep the process or recipe that you use to make your product secret. A classic example of a trade secret is the recipe for Coca-Cola, which remains a well-kept secret. A recipe is a good candidate for trade secret protection because it is extremely hard to reverse-engineer, as opposed to a computer or other piece of technology (these may not be easy to reverse-engineer, but it is doable for those with the proper training and skill).

Suppose that a painter has a special way of mixing paints to produce a particular texture, or a singer has a way of breathing that allows him to sing with a unique tone. It is unlikely that either of these would be good candidates for patent, copyright, or even trademark. But if the artists in question want to keep their techniques from becoming widely used, they can just opt to never disclose how it is done. If they involve others in the process, they may want to get them to sign a confidentiality agreement, because there is not a lot of well-developed federal law protecting trade secrets (there are some options in state law, depending on the state, and some federal laws that protect against outright theft).

The downside of a trade secret is that if someone figures it out, there is not much the artist can do to protect it. However, it is unlikely that the artist could have protected the technique or recipe in the first place, and a trade secret offers some small protection. Furthermore, if you can manage to protect it then it is yours indefinitely!

Business Law

Earlier on, we talked about how it might help you to think of yourself as a business and to borrow business strategies and approaches, incorporating them into your project or practice. Choosing a type of business structure is just taking that thinking a step further. For many, however, it may prompt the question, "What is a business structure anyway, and how does it pertain to an artist primarily concerned with creation?"

A business structure is a legal entity—the means by which you conduct your art business. It is the "what" and "how" of your business. The "what" refers to the type or category of legal entity that you choose for conducting your art business, and the "how" refers to the way that you run your business so as to meet the legal requirements for that kind of entity. Don't worry. It is not as intimidating as it sounds, and there are many advantages associated with each type of business structure available to you. Ultimately, artists choose a framework that best suits their needs: your business structure should simply be another tool at your disposal. And while you may not be accustomed to thinking of yourself as a legally recognizable business, you should realize that if you intend to make money as an artist, or if your art is generating income, you have a business already!

There are many considerations that go into choosing a business form. Certainly, the IRS will be interested in how much income you make from the sale of your art or services, which might impact the type of business structure you choose. Other factors include what types of commercial activities you are currently conducting, how many people are involved, how complex you want or need your organization to be, how much money you generate from your art business, and whether the business is primarily for-profit or not-for-profit.

Please note that the explanations below are meant to give you a general legal framework and cannot replace a personal consultation with an attorney or other professionals,

like accountants, who can help you in assessing what is most appropriate for your individual needs. We just want to start you thinking about different options.

SOLE PROPRIETORSHIPS

If you are an artist, for example, a painter or a freelance musician who works alone and sells artwork or services without ever having chosen a type of business structure, you would be considered a "sole proprietor." This means that although you have not formally chosen a business structure, the law views you as a sole proprietor merely because you sell your art or services in the marketplace.

So, what does it mean to be a sole proprietor beyond working without any official legal entity? Essentially it is someone who owns an unincorporated business where the person and the legal entity are one and the same. An advantage of a sole proprietorship is that it is the cheapest and easiest type of business structure to form, as it is based on the individual's intention to have a business. Depending on your state and local governments, there are generally no legal formalities required, meaning that there are no forms to file or fees to pay to government agencies for the right to conduct business as a sole proprietor. However, this may not be true for all municipalities and states, and you should consult an attorney in your geographic area to find out if you need to take any specific steps, or visit the official website of the state in which you intend to work and look for information on starting or running a business.

Another advantage to being a sole proprietor is that there are no corporate formalities required by law or contract. By "corporate formalities" we mean that there is nothing you are required by law to do or perform on a day-to-day basis to manage your business. For example, you do not need to have a board of directors or other managers besides yourself, and you alone can make all business decisions, good or bad, regarding your operations.

PERSONAL LIABILITY

Most people are familiar with the term "liability," the presence of which basically means that you can be held legally responsible if something goes wrong. For example, suppose a potential buyer comes to visit your studio, trips over a canvas that you left on the floor and breaks her hip. In addition to negatively impacting your sales, she could sue you for her hospital bills and other damages (obviously it is more complicated than that and many other conditions apply, but that is the basic concept). Similarly, you might be liable for penalties associated with a contractual obligation. With personal liability, a court could ultimately order your assets, such as your house, seized in order to "satisfy" the judgment. Because a sole proprietor is not considered legally distinct from his or her business, he or she is *personally*

liable for everything that may go wrong in the business. The sole proprietor's assets are not protected in any litigation arising from the course of business, nor are the sole proprietor's personal assets out of the reach of the business' creditors. This is perhaps the most significant aspect of choosing not to establish a corporate identity.

In the law, there is a concept known as "the benefits and the burdens." This phrase basically means that along with the benefit, or privilege, of legally being able to do something, there are burdens or responsibilities associated with that same activity. For example, as a sole proprietor, you are able to enter into and sign agreements without any oversight from another person. This is a benefit of being a sole proprietor. The burden of being a sole proprietor has to do with the liability.

FICTITIOUS NAME

In many jurisdictions, if you are a sole proprietor conducting your business under a name different than your own, you will need to register this name as your fictitious name. It is also known as an "assumed name," "trade name" or "doing business as" (d/b/a). The reason for registration is that the government requires you to put the legal name of your company on all government forms, like IRS tax filings. In some states, you must file with a state office and in others with your local county clerk. If you are planning to use a fictitious name, consult with a lawyer in your geographic area to find out the specific procedures required.

TAXES

Simpler taxation is one advantage of being a sole proprietor. A sole proprietor simply reports all business income or losses on his or her individual income tax return (usually, IRS form 1040), but he or she has the responsibility of withholding and paying all income taxes on his or her own. This is something that an employer usually does for an employee, but because, as a sole proprietor, you are also your own employee, the IRS requires you to withhold and pay all taxes for yourself. You can, however, deduct your legitimate business expenses (see Chapter 4 for definitions of financial terminology). If you have other employees in your sole proprietorship, you may need to get a tax identification number from the IRS. However, while doing taxes as a sole proprietor is comparatively simple, you also have fewer tax options available. For example, you cannot defer income to another tax year, and you must pay taxes on income earned from your business in the year it was earned.

PARTNERSHIPS

Suppose that you and two colleagues decide to start a business promoting artistic talent. You divide your promotion business into three areas in which one person will manage the

careers of performers, one will manage the careers of visual artists, and one will manage the careers of literary artists. You each then go out and retain some performers, visual artists, and writers to represent. Though you might not have recognized it, the promotion business that you just started is considered a legal entity, known as a partnership (or general partnership) under the law. The IRS defines a partnership as a relationship in which two or more people carry on a trade or business, with each partner contributing money, property, labor or skill to the business, and with each partner sharing in the profits and losses of the business. There are three basic types of partnerships: the general partnership, the limited partnership, and the limited liability partnership.

GENERAL PARTNERSHIP

General partners share equal rights and responsibilities for the management of the business. Each partner represents the full partnership individually, meaning that each partner has the right to enter into contracts with someone else on behalf of the full partnership (i.e., the other partners), even if the other partners were not aware of the contract or obligation in any way.

In our example of the promotion business above, the partner who is representing artists decides to take out a five-year lease on office space in the business' name without discussing it with the other partners. Because the partner took out the lease on behalf of the business, the other two partners are also bound by the lease. This is one reason that tension can develop between partners. The fact that one partner independently entered into a five-year lease may not be such a problem (except, obviously, for the lack of communication with the other partners), if all the partners in a general partnership were not *personally liable* for all the debts of the partnership. If the business starts losing money and the partners decide to the close the business two years into the lease, all the partners will still be personally liable for the remaining three years on the lease. This is a similar disadvantage to what we saw in the sole proprietorship: all partners are personally liable for the debts of the partnership and can all be sued because they have formed no separate corporate entity.

Taxes

Although the partners face personal liability for the debts of the partnership, a general partnership does not pay income taxes as a business. Instead, it enjoys what is known as "pass-through" taxation. The profits of the partnership *pass through* to the partners, who include the profits on their individual returns. This pass-through status is usually seen as an advantage because the tax bracket applicable to the business's profits may be higher than the individual partner's tax bracket. Also, the profits of the business are not double-taxed as they are with a C Corporation, which we will discuss later. In any event, it is prudent to consult with

an accountant for your business to help you determine what the best tax strategy for your business is. Even though the partnership itself may not have to pay taxes, the IRS requires a partnership to file an annual informational return to report the income, deductions, gains, or losses from the operation of its business.

For tax purposes, partners are not considered W-2 employees. Instead the partnership must deliver copies of Schedule K-1 (IRS Form 1065) to the partners by its designated filing date. Again, professionals, such as an accountant and a lawyer in your geographic area, can advise you with respect to state and local tax requirements and assist with IRS questions as well.

LIMITED PARTNERSHIPS

In a limited partnership, there are two types or classes of partners: the general partner and the limited partner. The limited partners can limit or restrict their liability on par with the extent or the amount of his or her investment in the business. However, at least one partner in the limited partnership must take on general partnership status, which means that that person will be personally liable for all the debts and obligations of the business. Because this general partner bears such a large burden, the general partner retains control of the business, while the limited partners do not have the right to manage or control the day-to-day operations of the business. To form a limited partnership, the business must register as such with the secretary of state in the state where the partnership is formed, which process will most likely require a filing fee.

LIMITED LIABILITY PARTNERSHIPS (LLP)

In a limited liability partnership, individual partners will not be personally liable for certain wrongful acts of other partners. To the extent an individual partner's liability is limited depends upon the applicable state's laws governing a given LLP. Many states limit protection to tort claims only and do not protect one partner from another partner's own negligence or incompetence or to the partner's involvement in supervising wrongful conduct. In some states, an individual partner will not be personally liable for the debts and obligations of the limited liability partnership. Also, some states do not recognize this type of business structure, making it essential to consult an attorney to advise you with respect to the applicable laws in your geographic area.

Unlike the general partnership, there are more formalities associated with the limited liability partnership. Generally, states require that you file a form disclosing the name of your business, address, name of the partners and proof that the LLP has purchased an

adequate amount of liability insurance. Many states require that the name of the business include the LLP designation. Again, each state differs, so you will need to consult a professional to find out what you need to do in your city and state.

TAXES

For tax purposes, the IRS considers a limited liability partnership to be a general partnership. This means that partners in an LLP will be able to pass through profits and losses to their own income statements in the year that such profits and losses were realized.

C CORPORATIONS

A C Corporation, or "C Corp," is the most common type of corporation. The C Corp is a unique legal entity that is entirely separate from those who form it. C Corp's are also formed for-profit (as opposed to not-for-profit corporations, which we will discuss shortly). To incorporate a C Corp, one must file a Certificate of Incorporation or Articles of Incorporation with the applicable state. The C Corp's Articles of Incorporation state the purpose(s) of your business, outline how it is going to run and include details, such as the number of directors of your C Corp and the types of shares it will issue to shareholders. Most states require that a C Corp include "Inc." in the name. One must also pay filing fees, which vary from state to state, so as always, consult a local attorney in your area for specific advice.

LIABILITY

Because the C Corp is a legal "person" distinct from its owners, unlike the sole proprietorship, it has a separate business and tax identity from that of its owners, who are commonly referred to as "shareholders." The fact that the corporate entity is separate from the shareholders means that shareholders are not personally liable (i.e., personal assets are not in danger of being taken, except under very limited circumstances—see the section below on LLCs for liability information applicable to all types of corporations) if the C Corp goes bankrupt or gets sued, which is one advantage to establishing a C Corp. In addition, a C Corp can own property, engage in business transactions, and sue other businesses, just as if it were an individual.

However, there are more formalities associated with the C Corp. Beyond filing the Articles of Incorporation, a C Corp must also issue shares of its stock to shareholders, who then own a portion of the C Corp. Also, it must establish a Board of Directors that meets regularly to govern the business and elect officers, such as Chief Executive Officer, to manage its day-to-day activities. Like a person, the C Corp must file its own income taxes with the IRS and state. Check with your individual state to find out what and how you report the C

Corp income, or better yet, consult an attorney and/or an accountant to assist you with tax matters. Also, income reporting for a C Corp may be on a more regular schedule than the once-a-year filing for personal income.

SOME ADVANTAGES OF A C CORPORATION

If the C Corp is adequately funded, or "capitalized," and proper corporate formalities are followed, the shareholders should have liability protection from the corporation's debts and obligations.

Corporations can utilize corporate benefit health plans, which often offer better retirement options and benefits than those offered by noncorporate plans.

100 percent deductible health insurance may be offered for all employees, as well as group term life insurance up to a specified amount per employee.

If a stockholder dies or wishes to sell out, the corporation still continues.

It is easier to raise capital as a corporation than as a sole proprietorship or partnership, and the corporation can treat grant money as a capital contribution.

Corporations offer employees incentive stock plans.

Corporations have a flexible tax year and can defer income.

DISADVANTAGES OF A C CORPORATION

Double taxation, meaning that, besides paying corporate income taxes, any dividends to shareholders are taxed again at the applicable tax rate.

Formalities and regulations must be followed very closely in accordance with the laws regarding incorporating in a specific state and can take more time and effort to maintain. Failure to do so can create a situation where shareholders may be held liable.

C Corps have higher start-up costs than a sole proprietorship or partnership.

The corporation cannot pass-through losses to owners or shareholders.

It is not easy to distribute profits to owners.

C Corps are costlier to maintain than a sole proprietor or partnership because of formalities like Board of Directors meetings, annual meetings, minutes of meetings and notice of meetings, all of which increase professional-services costs for legal and accounting.

S CORPORATIONS

An S Corporation ("S Corp") is formed in the same way as a C Corp, by filing as a corporation in a state. Like a C Corp, S Corps are required to have the same corporate formalities of a Board of Directors, officers, and shareholders. Since they are separate legal entities from their shareholders, S Corps also shield or limit shareholders from personal liability in the

event of a lawsuit or bankruptcy. To become an S Corp, the company must make an election to be taxed under Subchapter S of Chapter 1 in the Internal Revenue Code.

TAXES

In general, S Corps do not pay any federal income taxes. As in a Partnership, an S Corp's income or losses are divided among and passed through to its shareholders, who must then report the income or loss on their own individual income tax returns. This means that income is taxed at the shareholder level and not at the corporate level. Because of this, the S Corp is said to be taxed only once or be subject to single taxation. This is different from a C Corp, which is subject to double taxation because the IRS taxes corporate profits, as well as dividends distributed to shareholders individually.

However, there are certain requirements and restrictions on S Corps. To be considered an S Corp, an already existing *domestic* corporation or LLC, which has decided to be taxed as a corporation, must elect to be treated as an S Corp. In other words, there is no foreign ownership of S Corps. An S Corp may have a maximum of one hundred shareholders, and those shareholders must be U.S. citizens or residents. Also, the profits and losses of the company must be divided proportionately among the shareholders according to their respective interest in the company, and S Corps can only issue one class of stock.

LIMITED LIABILITY COMPANIES (LLC)

A limited liability company (LLC) is a popular choice of business structure because it blends elements of partnership and sole proprietorships (depending on how many owners there are) and corporations. However, it is neither a partnership nor a corporation. Instead, its owners are "members," not shareholders or partners.

Generally, the formation of an LLC requires Articles of Organization and an Operating Agreement. Articles of Organization act as a charter for your LLC, supplying certain basic information of the new company and include the following: the name of the business, address of its principal offices, its purpose and the term, or how long the business intends to operate, the name of a registered agent who can accept delivery of forms for the business, and the names of the founding members, or owners of the LLC. An Operating Agreement, which may be a very basic document, outlines the day-to-day governance of the LLC, as well as profit sharing and ownership.

LIABILITY

The LLC requires fewer corporate formalities than a corporation. There is no requirement for LLCs to take minutes, have meetings, or record resolutions. Like other types of corporations, an LLC affords limited liability to the owners. However, also like other types of

corporations, the protection from liability may not apply in cases where there is fraud, misrepresentation, or wrongdoing on the part of its owners or members, or where a member has given a personal guaranty for a debt. This varies from state to state, so remember to consult with an attorney regarding what the limited liability concept covers in your city and/or state.

TAXES

One other advantage to the LLC is that owners have the right to elect the pass-through taxation option, making the LLC comparable to a partnership or sole proprietorship in this respect. LLCs may also have an unlimited number of members, and members can be individuals, corporations, or other LLCs. As opposed to S Corps, non-U.S. citizens may own LLCs.

One important difference, and perhaps a disadvantage of the LLC versus other types of corporations, is that it cannot exist forever (unlike a corporation). It either dissolves upon the death of a member or is limited according to state law.

Each state has its own LLC statute, so if you want to operate your entertainment or art business as an LLC, you should consult an attorney for the appropriate forms, filing fees and other required formalities in your state. New York, for example, requires that LLCs publish in two local newspapers for six weeks to complete the formation process. Many states also impose a franchise tax on LLCs.

NOT-FOR-PROFIT CORPORATIONS (NFP)

Many artists believe that not-for-profit corporations, or NFPs, are more important in the arts and entertainment world than any other business form. This is not necessarily true, so if you skimmed or skipped the last two sections, we would encourage you to go back and reread them, because most people who start businesses do so to make money or "for profit."

That said, there is potentially a great deal of value in setting up your arts project or practice as an NFP. A good working definition of an NFP is a corporation formed for purposes other than to make a profit, specifically, for charitable, religious, educational, scientific, or public purposes. However, just because an NFP is formed as a not-for-profit business does not mean that an NFP is not allowed to make any money; quite the contrary. It is still a "business" that needs to make money to stay in business. An NFP can make money from its own charitable efforts and activities, as well as from efforts and activities that are unrelated to the NFP's purpose. When an NFP makes a profit (or, more specifically, takes in a surplus of funds), it is required to retain those funds for self-preservation, expansion, or to further its public purpose (mission). This money, however, may not benefit any individual. There are no shareholders.

TAX-EXEMPT STATUS

Interestingly, just because an organization incorporates as an NFP in a certain state does not automatically give it tax-exempt status in any state. This is a critical point, because an organization can go through the incorporation process and still be denied 501(c)(3) status (recognition under the section of the tax code allowing operation as a non-profit) by the IRS. After an organization incorporates under the NFP law of its state, it must then apply for 501(c)(3) status, or an "Application for Exemption." It can take months to receive a response from the IRS, which may request more information regarding your company or issue an outright rejection. If you are ultimately successful, you will receive a letter indicating the corporation's tax-exempt status. For a state-tax exemption, usually all that is required is that you incorporate as a NFP. However, this is not true for some states, so consult an attorney in your area to find out what the law of your state requires.

The incorporation process itself is similar to that for a for-profit corporation in your state of incorporation. Generally, it is less expensive to incorporate as a NFP than as a for-profit corporation, but you are still required to file Articles of Incorporation with the Secretary of State. Also, like corporations, NFPs are considered a separate and distinct legal entity and can enter into contracts, own property and enjoy the same limited-liability protection as for-profit corporations. As stated above, however, no NFP can be organized for private gain. Also, if the NFP ceases operations, it must distribute any remaining assets, just like a for-profit corporation must do. Furthermore, many of the same corporate formalities are applicable to NFPs as those required for for-profit corporations. For example, the founders of an NFP must appoint a Board of Directors or a Board of Trustees, which oversees governance of the organization.

NFPs may have and pay employees and the Board of Directors for the work they do for the organization, but salaries must be within industry standards for a particular job. In other words, no one working for an NFP is supposed to be overcompensated, enriched, or receive special treatment in any way. For example, NFP Boards of Directors must act in the best interests of the organization and cannot take low-interest loans from the organization or engage in business transactions that would be favorable to any one particular Director. NFPs should take note of this as the Attorneys General in most states conduct oversight of the NFPs.

SOME FINAL THOUGHTS ON BUSINESS ENTITIES

The above is a quite general overview of the types of business entities from which you may choose when starting your arts-related business. The type of structure you choose for your business depends upon many different variables, such as how much money you have

available to devote to your business, how many people are involved, what is the product you are bringing to the marketplace, how do you want to grow, how is the business being capitalized, etc. Which legal entity or structure you choose is a business decision with legal consequences that is best decided with the advice of an attorney and an accountant. We also encourage you to seek out these and other professionals in your geographic area who may be willing to help you structure your business on a pro bono basis and work toward your success in bringing your skills, talents, and passion to the marketplace in a way that is most beneficial and profitable to you.

A REPRESENTATIVE SAMPLE OF LEGAL RESOURCES FOR ARTISTS

Business and Legal Forms for Graphic Designers, Tad Crawford and Eva Doman Bruck, Third Edition, Allworth Press
47 business and legal forms for graphic designers.

Business and Legal Forms for Theater, Charles Grippo, Allworth Press
Explains legal agreements in theater, why they are needed, and provisions.

Creative Commons
A non-profit website that offers artists, educators, authors, and scientists unique copyright licenses.
www.creativecommons.org

The New York State Bar Association's Entertainment, Arts, and Sports Law Section (EASL)
A group of legal experts offering presentations on cutting edge legal issues in the arts, publications, and pro bono clinics and speakers.
www.nysba.org/easl

Find Law
Vast Internet resource for law. Codes, statutes, significant cases, summaries, and a searchable database on all topics including finding legal assistance.
www.findlaw.com/

Legal Guide for the Visual Artist, Tad Crawford, Fifth Edition, Allworth Press
Legal advice including copyright cases, online registration procedures, and laws governing artist-gallery relationships.

Starving Artist Law
Self-help legal information for artists and writers.
www.starvingartistlaw.com

Volunteer Lawyers for the Arts (New York)
Organization that offers pro bono legal services and referrals for artists, in addition to seminars and online resources.
www.vlany.org

List of other Volunteer Lawyers for the Arts Organizations by state and metro-area:
www.vlany.org/legalservices/vladirectory.php

The Writer's Legal Guide, Tad Crawford and Kay Murray, Allworth Press

Stanford University Libraries—Copyright FAQs
Copyright and fair use questions answered.
http://fairuse.stanford.edu/Copyright_and_Fair_Use_Overview/chapter0/index.html

Negotiation

Go to your local library or bookstore, or simply browse the Internet, and you will find any number of books and articles on negotiating. Good negotiators can be highly paid professionals, each with his or her own style and methodology or they can be savvy amateurs; likewise there is no one right approach used by all. Negotiation is part of our lives in large and small aspects all the time. Therefore, in this chapter our goal is to demystify the process and to give you some practical guidelines that you can adapt to fit your personal style because ultimately you will need to negotiate in a way that suits your needs and personality.

Let's begin by outlining a few main points that we would like you to take away from this chapter:

- **The Process Doesn't Need to be Mystifying**: What is a negotiation? Is it a group of businesspeople and lawyers in suits seated in a boardroom for hours on end? Is it a painter and a dealer or a screenwriter and a producer discussing compensation? Sometimes. But just as often—and just as legitimately—it is two artists collaborating on a piece of artwork, perhaps a composer and a poet, or a lighting designer and a sculptor. There is a give-and-take to these relationships that is integral to successful art. We encourage you to consider this approach as a model, because a collaborative give-and-take represents the spirit of good negotiation (and a good working relationship). You negotiate every day and in every aspect of your life.
- **Recognize that It's an Opportunity to Build Social Capital**: Negotiating can be an opportunity to build what is often referred to as "social capital," a term long in existence with a myriad of definitions, all of which focus on social relations that have production benefits. We use it to apply to the good that comes of building solid rela-

tionships, both professional and personal. Social capital translates into trust and good-will, and just as you earn it through a good negotiation, you can spend it someday as well. Social capital can accumulate through careful usage, but it also can quickly evaporate if a relationship is neglected.

- **Negotiation Doesn't Have to be Adversarial**: You are negotiating *with*, rather than against, someone. Try to put negotiation in the context of an artistic relationship and approach it as collaboration rather than something adversarial. If you can step back from the idea that you need "to win," there is no need to be confrontational (thinking of the person with whom you are negotiating as an adversary who needs to be vanquished). Rather, think of him/her as a partner, as someone with the same ultimate goal in mind—successful collaboration.

- **"Zero-Sum Thinking is Limiting"**: We urge you to free yourself from the burdens of any preconceptions that you have about what it means to negotiate. We live in a society in which many stereotypes cast negotiating as a "zero sum game" with winners and losers. Try to avoid that attitude. The commonly used term "win-win" has an unfortunate battle connotation in its counterpart—"lose-lose"—that we seek to avoid.

- **There can be Long-term Benefits**: By viewing negotiation as an opportunity to build social capital and stronger relationships, you give yourself a chance to create future transactions and interactions that will be more valuable. This goes beyond just your relationship with the other party and extends to the wider community. Artists should consider the impact that their actions can have on their long-term reputations. A "winner-take-all" attitude might secure a short-term gain, but it will be at the expense of your reputation and subsequent professional relationships. A collaborative approach may help you to broaden the pool of future collaborators. In other words, if you use your accumulated social capital wisely, it grows and will help you to grow.

Five Guidelines for Your Negotiations

With the backdrop of viewing negotiation as an opportunity for successful collaboration, let's take a look at five guidelines that you can use to help you in future negotiations. Again, we want to emphasize that these are only guidelines—not rules. You should adapt them over time as necessary so that you can truly own your approach.

1. **Separate what you believe from what you know, and know as much as you can.**

Information is an important asset in beginning any negotiation. Many of us operate in the world informed more by what we believe than what we actually know. This is risky—beliefs are aspirational, shaped by our hopes and desires rather than the facts. Knowledge means having the facts, so it is essential to be disciplined and dispassionate about examining the

facts surrounding any subject of negotiation. Previously in this book we have referred to gathering knowledge with regard to strategic planning and goal setting as "environmental scanning." Disciplined fact-finding preparation for a negotiation process is similar.

This book has emphasized the need to be organized and even creative with how you gather information related to your project or practice. A negotiation is no different. In particular, you will want to know the facts, such as:

- Yourself (what do you ultimately want, what are your "nonnegotiable," and where does this project, negotiation, or relationship fit into that bigger picture)
- The situation in question (if you are collaborating on a work, everything related to the intended finished product)
- The other party's information (what information does the other party have, or upon what are they relying for guidance)
- The timing (what deadlines are you facing, any dates by which you must reach an agreement)

2. **Just because you can does not mean that you should.**

Some power is best left unexercised. You might be able to get something from a negotiation by exercising your own leverage or power—for example, forcing the other party to accept your terms. However, this might not necessarily be to your advantage in terms of the long-term relationship (or even for the specific negotiation). This gets back to knowing what you want to accomplish from a negotiation. Having a good grasp on exactly what you need to achieve will keep you from overreaching, possibly jeopardizing reaching a satisfactory agreement.

You can draw an analogy to your own artistic choices. When you create a piece of art, whatever your medium, just because you have the ability or technique to create something does not mean that doing so will lead to a better work. Bigger size does not necessarily make a sculpture a greater piece of art any more than more notes make a musical composition more satisfying. These are simply tools that the artist has at her disposal.

Taking the same approach in the context of negotiation just applies that judgment in a new sphere. Like your art, you need to approach a negotiation in a disciplined and self-controlled way, carefully exerting leverage to your advantage only where necessary. It is another form of mastery of yourself, of who you are, of what you want, and what you know.

3. **Understand the benefits (what will you get), but also understand the costs (what it will cost you).**

We have the ability to make choices in our lives. If you are frustrated with your job you can tell off your boss, or if an acquaintance does something to upset you, you can give in to the

urge of speaking as harshly as you like. That may cost you your job, the relationship with that acquaintance, your accumulated goodwill, or even your reputation. In the context of negotiation, you may have a lot of "star power" that you can leverage to strike a deal that is overwhelmingly in your favor. You may have a great deal of social capital that you have accumulated from years of relationship building/maintaining. But think through what the consequences could be. This is where envisioning the negotiation as a collaboration can help. It forces you to think through the relationship with the other party and to weigh the advantages of a one-time win against what it may cost you later.

4. **Keep a little mystery.**

This is another way of saying that exercising self-control and restraint is an important tool in an effective negotiator's toolbox. Bear in mind that a stronger relationship is possible with every new negotiation, and relationships can benefit from a little mystery. You don't have to tell everyone everything (even close friends). Having honesty in a relationship does not mean that you have to say everything. Instead, you need only share the information that relates to the negotiation.

On a practical level, it is wise to keep your own counsel. Remember, just because you go into a negotiation with a collaborative spirit doesn't mean that everyone else will do the same. This is one of those areas in which artists can be more vulnerable than others because artists often have a natural tendency to share. Oversharing is not an effective negotiating tool. Remaining patient will help to counterbalance that tendency. Remember the advice above, "Separate what you know from what you believe." While trust is good, unquestioning belief in the goodness of others is potentially risky.

5. **Know when you'll walk.**

Finally, remember that there could be a time where circumstances or timing dictate that you walk away from a negotiation. That is why understanding exactly what you need and want from a negotiation is essential. You need to *identify* your "must-haves" so you can know what you can accept and what you absolutely cannot accept. Like any collaboration or relationship, there are times when those involved are simply too far apart to work together. This is not necessarily a bad thing.

If you are unable to resolve an impasse over one of your "must-haves," recognize that this collaboration may not work right now. While you will want to conclude your negotiation in an as open and communicative way as possible, you have to accept your time to walk.

Remember, effective negotiation takes time, patience, and practice. The benefits of approaching this carefully are well worth the effort.

Selling and Promoting Your Work

Marketing and Networking

In this section of *The Profitable Artist*, we will look at two major topic areas related to selling your work: marketing and networking. First, a disclaimer: this is not a book on marketing, which is a highly specialized field of study. What we offer here is an overview of some of the basic principles of marketing, combined with the experiences of many of the artists NYFA has worked with over the years. We are going to provide suggestions that have worked for other artists.

The best marketing that any artist will do for his or her project or practice will be a highly individualized effort—your "product" is usually deeply personal. In some cases, dancers, musicians, and actors for example, the product may actually be *you*. Furthermore, any realistic examination of marketing art needs to take into account an important issue. That is, that the vast majority of artists are unlikely to have the resources, financial or otherwise, to mount a major marketing campaign. Because of this, we want to present basic principles that will be both palatable and feasible!

We will also examine two core elements of a successful marketing campaign: branding and promotion. Many people associate branding with large, corporate marketing strategies, but it is vitally important to small businesses and individuals as well. Promotion, too, plays an integral role in marketing on any scale. While promotion can refer to several different and often overlapping activities, in the context of artist marketing techniques we refer to creating promotional materials that will assist you with your marketing campaign. Next, we will look at some of the practical issues of selling your work such as pricing. Finally, we will touch on networking, which will play a vital role in your marketing efforts and in virtually every other aspect of your professional and artistic life as well.

YOUR MARKETING GOALS AND WHAT MARKETING CAN DO FOR YOU

The American Marketing Association defines marketing this way: "*Marketing is the activity, set of institutions, and processes for creating, communicating, delivering, and exchanging offerings that have value for customers, clients, partners, and society at large."*

Generally speaking, marketing can assist two broad aspects of your arts project or practice: (1) sales and (2) audience. For our purposes, "audience" can mean visibility, notoriety, website hits, or numbers of people who come to view your work.

Revisit your vision and goals, as well as your definition for success, to determine whether you need to engage in marketing. If your goals are purely internal and not about audience or sales, then the marketing section of this book may be less relevant for you. But if you are seeking to increase your reach—however you ultimately define that—you will benefit from a thoughtful marketing strategy. Simply put, most patrons and fans won't actively seek *you* out. You will need to formulate some kind of plan to connect with them, to bring yourself to their attention!

We also want to take a moment to acknowledge that there will always be outliers, or artists who attain truly incredible success in any number of ways. This is often aided by luck and happenstance as much as by talent and hard work (which is not to belittle their work or talent in any way). To build your model based on the experiences of a Denzel Washington or an Andy Warhol is probably a mistake, as you simply cannot design that kind of success. The strategies we present here are ones that have proven successful for a wide variety of artists in different capacities, as well as ones used in the broader business context.

Researching Your Market

Like every other aspect of professionalizing your project or practice, in your marketing efforts resources will be one of the major challenges. You will need to make tough decisions about how to allocate these effectively, so you have to know the "five W's"—*who, what, where, when,* and *why.* We have already addressed the what (your art); you also need to figure out whom you are trying to reach, why you want to reach them, how and where to do so, and when.

Unfortunately, it is not only expensive, but also probably unrealistic for most artists to do a comprehensive study of their market. This is something that professional market research firms do at significant cost that requires a large sample to be accurate. Therefore, you will have to be creative to get useful information. But this is not an impossible task as we shall see below.

Your best strategy is to start by asking yourself questions. *Who* are your clients or audience members? *How* would you describe them? *How* do they interact with art? *What* are their interests? Even if you are at the very beginning of your career, you have likely had some chance to exhibit or perform publicly, interacting with people who have seen, heard, or read your work. Based on this experience, you should be able to develop a composite sketch of a typical member of your audience, that is, who likes your work and why they like it, to help you define what you do from the public's perspective.

Many artists are uncomfortable with the notion of being classified as part of a particular discipline or genre, or with having any labels put on them whatsoever. This is understandable, as independent thinking is one of the universal traits shared by artists. Nevertheless, regardless of whether or not an artist wishes to be labeled and categorized, it happens externally. Good market research depends on your being dispassionate—just

because you don't like the information you uncover does not make it any less valid, and trying to ignore it only means that you lose the opportunity to turn it to your advantage. Remember, a market is ultimately a segment of the larger population that is more likely to engage in some activity that you find desirable (usually purchasing your work or a ticket to your performance).

Let's take an example. Suppose that you are a poet, that you have just published a collection of your work, and that you have budgeted $1,000 to spend on marketing this book to the public. Suppose further that the majority of people who have read or reviewed your poetry would label it "experimental." Finally, suppose that you have learned that 20 percent of the general public enjoys and sometimes purchases books of experimental poetry, another 20 percent can't stand it and will not buy it under any circumstances, and the remaining 60 percent is indifferent. How will you spend that $1,000? Do you use it to make that portion of the market that likes experimental poetry aware that there is a new book available in the genre? Do you try to convince that portion that doesn't like it that your work is not, in fact, experimental poetry and that they should be more open-minded? Or do you focus on the remaining 60 percent because that is the largest number of possible buyers and hope that you can find a way to intrigue them?

This example obviously oversimplifies the analysis. But the point remains that knowing how people perceive your work will shape your marketing strategy, whatever your goals are—going with the "safe" segment or trying to seduce former nonbelievers or convincing the large body of indifferent ones to join the ranks of the 20 percent who are fans. Most importantly, seek feedback whenever possible—from friends, family, colleagues. Occasionally schools and local arts organizations will give artists opportunities for structured criticism and feedback, usually for a small fee. If you have the chance to participate in an open studio's "crit" event, a battle of the bands, or a staged reading, take advantage of it. These are invaluable opportunities for market research (not to mention a great way to gain new fans and contacts).

Once you have a better sense of how you are perceived as an artist, your options for effective market research expand immeasurably. To make your research effective, next you need to build a profile of your target audience member (if you have not done so already), and then identify how to reach these people. To do both in a way that is cost-and time-effective, you should take advantage of research and information that has already been done rather than starting from scratch.

There are lots of ways to do this, but one of the easiest is to start by looking at and asking questions about some of the most prominent and successful names in your field or genre, as well as other established artists with whom your work shares some common features. Where do these artists exhibit, sell, or perform? Do they have a national or interna-

tional reach, or are they more concentrated regionally? Much of this information you can find from their websites—look at tour schedules, press clippings, or other event listings. None of this guarantees that these galleries, venues, or newspapers that feature these artists will be interested in you, but it is an indicator that there is a market there to support the kind of work that you do. It also narrows a virtually unlimited field quite a bit; then you broaden the search within this defined field.

Once you have widened your search to include both the artists that are identified with your genre, the venues/outlets that work with them, and the press that cover them, you can get a more complete picture of your audience. Ticket prices at these venues or sales prices of art are a good indicator of the income bracket of your target market. Check the venue websites for event photos for obvious demographics about the people who are attending the events (for example, age, gender, and dress, e.g., hipster or business suits). Advertisements on the site also give clues about your potential audience's tastes. If the artist or venue has a blog or fan page, read any articles about openings or performances. See what is said about the turnout and reaction, although that should be read with caution as most artists/venues will put a positive spin on every event. Perhaps more importantly, you might find quotes from audience members who are identified by name and "google" them for websites or social media profiles. You can also enter a few specific keywords or phrases into an Internet search, with the addition of "organization," "group," "association," and/or "society." You may discover that there is an interest group that caters to your genre in particular. Organizations like College Art Association, Poets & Writers, Chamber Music America, and many others that serve as advocacy or service groups for specific disciplines and media have often prepared research papers, surveys, and studies on the fields they serve. Some have sophisticated websites with search features, and others have online discussion forums where members of this artistic community exchange questions and opinions about all sorts of topics. And almost every organization holds an annual event where many of their members come together, perhaps to address a specific topic but more likely just to network, socialize, and support the organization.

Of course, there is no substitute for actual research in the field. If you have identified an artist or venue that you think is in your genre, go to the venue and observe an event. Most gallery openings are public events. Interact with the other attendees who look like patrons or collectors and see if you can find out why they chose to come to this event (not the ones who came for the free glass of wine!). Do they know the artist personally? Is this venue a favorite spot for them and do they come to every event regardless of who the artist is? How did they hear about this event? Do they like the work and what other kinds of art and artists do they like? These kinds of conversations are easy to have and quite acceptable at any art event, and do not have to be done like a survey. This is good networking practice at any rate

and may yield useful market research. Remember, for most artists the percentage of the population that will be interested in your medium and genre will be relatively small, so you can actually gain meaningful information from a small gathering.

Once you have identified some of the characteristics that your audience members share, learning how to reach these people will be an easier task. It is possible that someone has already done the research for you, or at least provided some valuable leads. For example, the U.S. Census publishes all of its results online in an easily searchable format. Even though the Census is only done every ten years and communities may change there is still much valuable information. You can select a zip code, city, county, or state and get a detailed breakdown of the residents. Some of this data includes the residents' income levels and employment status, age range, commute time, education levels, ancestry, immigration status, and countless other categories. You can view all of this information at: *http:// factfinder2.census.gov/home/saff/main.html?_lang=en.*

If you wonder how this information helps you, let's look at a few examples of how you can use a free resource to your advantage. Suppose that a photographer documents the lives of recent immigrants to the United States, and wants to self-produce an exhibition. His goal is to generate significant audience traffic at the exhibition to document for use in producing future shows, and he is flexible as to the location. He might choose to examine Census data in the category "Nativity and Place of Birth." A subcategory there also shows the percentage of the population (and raw numbers) of those residents who entered the United States in the past ten years—in other words, recent immigrants. If he finds a region that has a high percentage of residents in the recent immigrant category, he might well decide to connect with a local arts or community organization to hold his exhibition there to engage the local community on a topic that is relevant to them. This is an audience who is likely to be interested in his work and among them may be potential buyers.

Or consider the case of a theater company in Chicago that is looking to expand its international touring options. It makes contact with a theater company in Latvia that similarly wants to tour the United States, and the two companies agree to book joint performances in each country. In selecting potential venues, the company's manager might check the Census to see if there were any areas where a percentage of the population had Latvian ancestry. A key point to remember is that individuals self-identify as a particular ancestry, which is an indication that they see at least part of their identity as that ancestry and may be interested in events that are associated with it.

Effective research means using a combination of sources and strategies, from common sense to government studies to Internet research on individuals. In the examples above, the photographer would probably want to do some further research into the community to see if there was an organization that helps recent immigrants acclimate to the larger

society, or funders who identify with that community such as the Institut Ramon Llull that only funds Catalan artists and performers. Likewise, the theater company should contact the Chicago Latvian Cultural Center for additional information and contacts. A phone call or site visit could yield detailed information about the communities the artists are seeking to engage. Moreover, reaching out to Latvian cultural communities in other cities might indeed yield invitations to perform. There is no one formula, but identifying how people perceive you as an artist and then thinking creatively about this genre will help you to reach a possible target audience.

15

Branding

On the broadest possible level, a brand is what the consumer (or audience member, critic, patron, etc.) first identifies with you or your product. It can be a logo, but is most definitely not limited to logos alone. Perhaps it's a little alligator that promises comfortable clothing. Or maybe it's the "lips and strut" that Rolling Stones fans adore. Whatever your brand, it is your opportunity for dictating the first impression people have of your project or practice when you make contact with them. Whether this is in person, on the Internet, through the mail, or in advertising, your brand communicates your message.

Branding is not without confusion and even a little controversy. Two questions usually arise for artists who are considering branding. The first is, are branding and artistic integrity mutually exclusive? Understandably, some artists may resist the notion that they need to conform their creativity to a brand. The other is, can you brand anything? If you are an artist with a solo practice or a specific project, are either of these activities candidates for branding?

The short answer to both questions is yes and no. Some marketing experts would argue that, if you don't brand yourself, others will do it for you. As mentioned above, society tends to categorize people whether they like it or not (for example, you are a "country singer" or a 'beat poet"). By creating your own brand, you are simply putting this categorization under your control where it properly belongs. Furthermore, the best brands are authentic and maintain the artist's integrity, which is something that will ring true for almost every artist. As for as the feasibility of branding yourself or your art, individuals are excellent branding candidates. If you can brand water, you can most certainly brand a theater company. When people refer to an artist's "image," they are really referring to the artist's brand, at least for those artists who are branding themselves rather than just their art.

However, it is also worth noting that for some emerging artists who have not found a "voice" or sense of identity, branding may not only be lower on their list of priorities, it may be very difficult to do. As we will discuss, your brand must reflect your identity to be effective. In other words, until you have a sense of yourself as an artist, it will be difficult to brand effectively.

Let's start by examining what defines a brand, and what are the most important elements of a branding effort. Branding is notoriously esoteric, and while it is easy to identify a strong brand when you see it, explaining why it is strong is often difficult. Three concepts make up any successful brand: *Authenticity, Consistency*, and *Clarity*. This holds true for individuals as well as for products. Satisfying these concepts in turn translates into two gains that every artist will appreciate: Loyalty and an Emotional Connection. Let's now unpack each in greater detail in terms of how they apply to artists.

AUTHENTICITY

Authenticity goes to the heart of both the branding and the artistic processes. However you choose to present your work or yourself to the public, it needs to represent something that is there, that is real. What kind of artist are you? What makes you unique? Most importantly, what do you want people to think, feel, or associate with your project or practice? When people see your brand, it must accurately reflect the essence of your art project or practice. If it does not, the consumer or audience member will sense the disconnect and the brand will fail.

The following are seven questions designed to help individual artists brand themselves in a way that preserves both authenticity and integrity:

- What are your personal values?
- What do you love to do?
- What do you hate to do?
- What are you great at?
- What are you especially proud of?
- What things are important to you?
- What are you known for?

Use the answers to these questions to check against whatever branding you develop for yourself. If there is something that you hate doing, make sure that stays out! You do not want to become associated with something that you don't like to do, and a branding campaign can help you to begin steering your career toward activities you prefer. Some examples of authenticity in branding might be a jazz musician who plays in the bebop style

of the 1950s and dresses in suits and hats that evoke that era. Is this genuine? Hopefully yes—he might be emulating his heroes, or part of what attracted him to the music initially might have been not just the artistic brilliance of the jazz masters but the entire culture surrounding the style. If it is just an act because he thinks that is what the audience wants and he doesn't really like it, it will show. Or a photographer who runs a business specializing in artistic renditions of weddings might cast herself as a maverick romantic. And she may well be that, and her photography will reflect her own flair for the drama and sentiment. Her photographs will stand out from the artists who are merely looking for a paying gig on the side, but are indifferent to or disdainful of romance. If you are seeking to brand your work as separate from yourself, ask those same questions but as if your work was a person. While that may seem unnatural, it will help you to identify and establish those elements of your work upon which you can build a brand. For example, describe yourself as a "photographer whose love of things romantic permeates all at which she aims her viewfinder."

CONSISTENCY

Consistency is the essence of branding, which is not to imply that you cannot be creative and flexible at the same time. But once you have chosen a look for your brand, you want to stay with that so that the consumer will be able to easily identify your work. This is as basic as finding a font that you like, that you feel best resonates with your project or practice, and then sticking with it on every piece of promotional material (websites, flyers, business cards, stationery—everything that you use). These are sometimes referred to as "touch points," meaning any place where you might connect with your audience/consumers.

There are some very practical reasons for maintaining consistency through touch points. When you distribute postcards for an event, these will likely have your website address on them. Someone might see your postcard briefly, or might hold onto it for a few days and then lose it, and still remember your website. If that person goes to the site and sees an entirely different look, he may be confused or even think he is looking at the wrong site. In the advertising world, it is said that a consumer must hear a message at least three times for it to sink in. So if you are planning three gallery openings and want to promote your brand, make sure to keep it consistent for at least those first three!

CLARITY

Clarity is the final part of the branding puzzle, and deals with how you will actually get noticed. Branding is a chance to both position yourself in the market and to differentiate your work in an often crowded field, but it is not a gimmick—it is who you are, what you do, and why you do it—the "w's" again). Are you an artist who makes murals that comment on

contemporary politics? Are you a classical cellist who interprets the work of a rock compos-
er? Every artist has strength, and how you present this to your audience clearly is the essence
of branding. You are telling the audience or consumer what they are going to get when they
come to see your work.

CREDIBILITY

Credibility is what these three elements of branding add up to; credibility is the goal of every
branding campaign. This means that your audience believes in you, your work, and your
project. Perhaps even more importantly, they trust you. Do not confuse this with predicta-
bility. You are not locked into making the same work over and over again. Your audience
may trust that you are entirely unpredictable, as that might be part of your brand. But your
brand will have become a credible entity to them, leading to the true benefits of successful
branding, loyalty, and an emotional response.

LOYALTY

Brand loyalty is the ultimate reward of a successful branding campaign. At the extremes,
brand loyalty is illogical. It is why consumers will pay almost twice as much for Advil as
Ibuprofen and four times as much as a chain pharmacy brand, even though they are exact-
ly the same drug. In a slightly less extreme example, it is why a consumer on the road will
drive an extra few miles out of her way in order to eat at a "name" fast food chain rather
than a local diner, or why certain consumers wait in long lines for their favorite brand of
coffee instead of going to the shop next door and getting served sometimes tastier coffee
immediately.

 In the arts, brand loyalty can mean that those artists with very successful or popular
brands sell out books before the print run has even begun, help make movies popular
despite terrible critical reviews, and command prices on their work in the tens or hundreds
of thousands of dollars. While these are extreme examples of star-power branding, brand
loyalty can impact artists with less notoriety and can even help emerging artists. Loyalty
may translate into repeat customers/audience members, as well as more recommendations
(friends of friends).

EMOTIONAL CONNECTION

Engendering an emotional connection between your audience and your brand is really just
an extension of brand loyalty. More specifically, it is why people are loyal to a particular
brand. They know what they expect to feel after experiencing your art. Bliss, awe, wonder,
comfort, edginess—whatever the particular emotion they identify with your brand, you
need to be mindful of consistently delivering that. The emotional connection is at the heart

of loyalty. It is the reason people pay more, drive farther, and wait longer. The most effective brands have captured these emotions so well and so consistently that your audience may experience them before they have even experienced your work. A lofty, but admirable goal!

SOME FINAL NOTES ON BRANDING

It can be difficult to measure the success of a branding campaign when you are an individual artist trying to brand yourself or a project—most methods for measuring success with branding are for large corporate campaigns that take place over a long time and with millions of consumers being exposed. Most individuals, even very successful ones, don't have the resources to measure the success or failure of their branding efforts with any statistical accuracy. But you can take stock of it on a practical level. Do you feel like you have built a loyal, passionate following since the inception of your branding campaign? Do you have more fans, and has this translated into larger attendances at shows and gallery openings? Do you see the same faces at your exhibits, performances, book talks? Are your sales up since before you "launched" your brand? Have you received more roles or other opportunities, and have they been of a higher quality?

Social media might be one of the ways that you can track the impact of your brand (we will discuss social media in more depth shortly). If you can create a successful community for your followers—perhaps on your website or blog, or through a Facebook fan page— you can follow the conversation among your fans after they have interacted with your brand.

There is no "best practices" for building a brand—it is as highly individualized as every other part of your practice. But you can ask yourself the seven questions designed to help you arrive at authenticity in your brand—being true to yourself is the best practice. And despite the emphasis on consistency with branding, do not be afraid to adjust things until you are entirely comfortable with the brand you have designed for yourself. Consistency without authenticity will not help you. It is far better for your own comfort, art, and ultimately your entire marketing campaign that you make a necessary change rather than stay with something that does not feel right for you for the sake of consistency. Your brand is there to help sell your practice, and not the other way around.

And finally, we want to reemphasize that branding, like any aspect of marketing, is simply an option for artists. If none of your goals will be served by what branding can do for you, don't spend your time and effort on it.

Promoting Your Art and Your Message

Promoting your work and your message will require knowledge of fundamental public relations and marketing tools as well as a good grasp of your media environment. Media tools such as press releases, media alerts, advertisements, blogs, and websites serve to increase your reach as well as tailor your message to the audience of your choice. Knowing where to put these tools to use is an indispensible skill as well, since traditional and digital media attract different audiences and often require the use of different media tools.

TRADITIONAL AND DIGITAL MEDIA TOOLS

Prior to the Internet Age, the most common media used to reach out to an audience were newspapers, magazines, television, and radio. These are still—no matter what your favorite blog might say—very viable ways to gain exposure. Local and regional alternative weekly newspapers and events guides are a great way to get the word out about upcoming shows, gallery openings, and other public events. Local television and radio spots, too, can be used with great effect to target a desired audience in a given locale.

Today, though, the web gives us a dazzling array of outlets and methods for communication. E-mail, blogs, news websites, and social media can all be used to help your work gain exposure. What follows is a list of commonly used promotional materials—both traditional and digital—and some general considerations for creating them.

WEBSITE

Your website is the single most important tool that you will use to promote your project or practice. Not only will it be the first significant point of contact that most people will have

UN FILM DE ISABEL SADURNI

VUE

AVEC NESTAN NIJARADZE
et les voix de
DENIS ROUSSEL, ANTONIA MALINOVA et STEPHANE RUSSEL

A promotional poster from an independent film, *Vue*, 2004. Filmmaker: Isabel Sadurni (Artist as Entrepreneur Boot Camp participant). Featuring Nestan Nijaradze.

PHOTO BY Kristine Potter

with you and your work, but it is a space that you can construct to match your brand, personality, and goals, or anything else that is important to you. It is like having your own gallery, concert hall, or library. And as technology improves, the cost to design and maintain a website goes down. We will discuss some of the essential elements and other considerations that artists may want to consider in designing their sites. Finally, we will provide some potential resources at the end of this discussion for building and hosting sites.

A website is actually a collection of linked web pages, each of which is has a specific role and identity in the larger site. Despite the range of options available, most sites share a common layout and vary only in the specific content. This is partly due to the way that the technology has developed (i.e., structurally, websites are organized by their *homepage* and built out from there), and partly because viewers have come to expect that certain basic requirements will be met when they visit the site. For example, most artist sites will not have all of the information on the first page, requiring that the viewer scroll down. Instead,

viewers expect to have accessible links at the top of the homepage taking them to separate pages for the artist's personal information or background, samples of the artist's work, and the ability to make contact. In the case of more commercially-oriented artists, viewers will also expect to see links to a page describing the products or services the artist provides, and a way to order these. A note of caution: the Internet is unforgiving to those who make their viewers work too hard. As easy as it is to access your site, it is just as easy to click away.

There are some specific types of pages you will likely want on your site. The first is what is frequently known as an "about" page. Here, you will answer the questions: who are you and what do you do? This is an appropriate place for either an artist or mission statement. You will also want to add your biography or perhaps even your résumé, although many artists put their résumé and/or bio on a separate page for aesthetic purposes. Some artists include a photo or headshot here as well. The basic idea is to give the viewer everything they need to know about you personally and professionally to help contextualize your work.

Another essential element is a page showing your work. This could include anything from a small gallery to your entire portfolio if you are a visual artist. Musicians might include a track from their latest recording, or a broad sampling of their compositions. Most performers will want to have video footage of their work, if that is the most appropriate medium (e.g., dance numbers, theater performances, or a film clip), or photographs at a minimum. Literary artists will include samples of their text, either directly in the body of the site or as a pdf file (or photographs from a publication). This may be the first time the viewer has ever encountered your work, so remember that when selecting what you display. These viewers might simply be curious observers, but they could also be potential clients, funders, or collaborators. You will likely want to post what you consider to be your strongest work.

One important question that arises in reference to putting samples of your work online is, what kind of access do you want to give your viewers? Do you want people to be able to download your work (and thus have a permanent copy of it), or do you only want them to be able to experience the content while they are directly interacting with your site? There are various ways to protect your materials—for example, you could embed a video from a site like YouTube which does not allow downloads, or link to a photo-sharing website with similar restrictions or just use thumbnail size images. Some sites offer internal control mechanisms. Ultimately, it is extremely difficult to protect everything you put up on a website, as ways to circumvent technological protections are invented as quickly as ways to protect it, so you need to accept some risk of your work being appropriated if you choose to put it up on your website. And the level of risk obviously varies by discipline, as even the

most innovative cyber-criminal will be hard-pressed to download a large-scale installation piece (although there are certainly copyrightable elements at risk, not to mention commercially exploitable ones too in that example).

Is the risk worth it? That is an extremely difficult decision and will vary from artist to artist. Some of that will depend on the nature of your business model. If you hope to make the majority of your income from selling large numbers of copies of your work, your concern over protecting your intellectual property will be higher. Conversely, if the majority of your income will come from live performance or from selling an original piece and limited numbers of physical copies, you will likely be less concerned. If the print copy of your book is beautifully illustrated, it is unlikely that a pdf file of the text available online will hurt the sales of the book and in fact may even serve to whet the appetites of would-be buyers.

We discussed intellectual property rights in more detail in Chapter 10, but we should note that, from a business perspective, just because you have the right to protect your work does not mean that it is always in your best interest to do so. A relatively common sales strategy is to offer something for free in the beginning to develop a market for your product. Once the market is there, you can begin to charge for either existing content and services or for new/premium ones (taking the latter approach can help keep from alienating your base). The Grateful Dead famously allowed their fans the freedom to record and trade the band's materials, which may have led to the Dead's legendarily loyal following. Many artists find that their concern over protecting intellectual property corresponds with their notoriety, with emerging artists being far more concerned with exposure than exploitation. We make no recommendations on what is right for you—simply be aware of the issues, opportunities, and dangers that surround putting your work online.

Another staple of an artist's webpage is a "contact" option. If people like your work and are interested in following up with you (possibly for a commission or a gig), give them a way to do so. Some artists simply list an e-mail or phone number, whereas others have a separate page where they may put a contact form where the viewer submits his e-mail and perhaps his name and any other information the artist requires. There are advantages and disadvantages to both approaches, as making your contact information public puts you at risk for "spam" or other privacy issues. But it also makes it simple for people you do want to contact you to do so. Conversely, while a form may weed out undesirable communications, protect your anonymity, and give you more information about the person who is contacting you, it also adds a layer of complication which cuts down on both desirable and undesirable communications. Ultimately, you need to balance the privacy risks with the degree of access you offer your fans.

Try not to have a "Press" option on your website unless you have current clippings; the heading "News" can include listings of exhibitions and press.

Many artist websites also offer a page for selling materials, or a virtual store where visitors can purchase copies of prints, download high-resolution photographs, songs, and videos, or in the case of artists offering services, book the artist for an event. These functions can be integrated into the contact page (a good choice if the artist is just selling a small amount of works upon request) or the page with the artist's work (in which case there may be an icon that says "Purchase Now" and links to a separate form for purchasing). We will discuss some of the options for online payment systems below.

Aside from these basic elements expected of an artist's website, the design is up to you. Look at a lot of sites and note the elements that you like and dislike, that you think are effective and ineffective. Think about the look and feel of the site as well as its functionality. How do you want the visitor to experience it? Your website is also a place where you will want to communicate your brand. That means that the fonts, colors, language, slogans, and logos should match your other materials (for many artists, the website will actually help to establish their brand as it will be the consumer's first interaction with the artist). And you should consider what you want the visitor to feel—do you want it to be a relaxed environment where visitors can browse through your work at their leisure? Do you want to attempt to guide the visitors and have your work arranged as a slideshow in a particular order? If there are certain effects that you usually incorporate into the presentation of your work, such as lighting or sound, you may want to try to work those into your site as best you can.

Beyond the branding and style issues, there are some practical considerations that will shape the design process.

Goals of Your Website

The goal of almost every website is to be user-friendly so that visitors will 1) stay on your site for a reasonable length of time and 2) return frequently. These metrics can translate into higher advertising revenues for commercial sites, but they also are of considerable importance to artists. The more time that someone spends on your site, the more exposure he or she receives to your work, and repeat visitors usually mean fans. You should consider things like the size of the font (is it large enough for those with poor eyesight?), the contrast between the font color and background color, and the amount of text and other material you have put on each page. Just as you don't want too much text crammed onto one page, you also don't want your viewer to have to click through countless pages in order to access otherwise related pieces of information. Another pitfall is overreliance on technical bells and whistles. The more data that is stored on a page, the longer it takes to load. Also, certain website platforms cannot be supported by all web browsers, or require that the visitor download special plug-ins to view it (websites that are built on "Flash" fall into that category).

Your website may be a work of art, but if your fans cannot access it then they will never get to *your* art.

While top-end organizational websites can cost hundreds of thousands of dollars, yours will not. The costs of your site will likely be the domain name, the web host, the design, maintenance, additional Internet services that your site uses, and the amount of space you need. Most domain names can either be registered for free or for just a few dollars. A domain name is simply your website address (for example, www.nyfa.org is NYFA's domain name). It is wise to reserve a name that is easily identified with your project or practice, ideally the actual name if at all possible. You will typically reserve that name for a year to two years at a time—quite often, the domain name is part of a package offered by a web host. Web hosts are companies that allow you to physically have a site on their server, storing the files that make up your web page and offering an interface with which to manage or control your site. Most artists work with hosts that specialize in individual web pages, as prices are usually pretty economical. Web hosts typically offer different service packages that vary in terms of the length of time, the amount of storage you have, and shared use of host-wide resources and applications (for example, certain e-commerce applications). Many web hosts also offer templates from which you can design your own site or, for a premium, actual site design services.

Making Your Site Your Own

Customization is where websites can start to get expensive. While there are many free or low-cost templates available, if you have a very specific idea of how you want your site to look and function, chances are that you will need the services of a website designer or programmer who is familiar with the programming language upon which the pages are built. Many people offer these services, and you would be well-served to shop around a little. Ask to see other sites he or she has built. One suggestion is to look at other sites from artists in your discipline and see if any stand out to you. If there was a site designer, there is usually a credit at the bottom of the page, and you can follow up with the designer. Just keep in mind that the more specialized the service, the greater likelihood that you will have to pay more for it. As a corollary, more complicated sites tend to have more details that can go wrong. If you hired someone to design your site, you may have to pay them for repairing any problems or for significant updates. The largest risk is becoming dependent on the customizer; if they move or go out of business you have to start over from scratch.

Logistics

Finally, one additional expense may be for additional storage space and bandwidth. Think of websites like real estate. Even if Internet space is cheaper than physical real estate (and has

fewer restrictions), it still costs something and if you want a bigger place for your work, you'll need to pay for it. Websites are stored on servers that have size limits as to the amount of data they can hold, just like your computer can only store so many files. Every photo, video, or audio clip that you put on your website is a file, and longer clips or better quality files tend to be bigger. This also affects how much bandwidth your website uses, as numerous visitors downloading larger files from your site takes up a lot of bandwidth. These are additional reasons—beyond copyright security issues—that artists will embed video clips from a site like YouTube rather than actually storing the underlying file on their own site. They may not have the budget for additional space or bandwidth. Still, most artists do not encounter such problems unless they are experiencing a huge amount of web traffic and downloads, as the amount of storage and bandwidth offered by a typical web host is more than sufficient. If and when artists do incur this variable expense, most view it as a positive development.

We should also touch on one of the ways to offset these expenses. For most websites, the main source of revenue—other than sales—is advertising. As we mentioned above, most Internet advertising is based on quantifiable statistics like the number of unique hits that your site gets, how many other sites link to yours, and the length of time that people spend on your site. This is obviously an oversimplification, and sites that rely heavily on Internet advertising, as well as major Internet advertisers, have much more complicated formulas for calculating the value of an advertisement on a given site. For most artists, the main issue will be how the advertising impacts the visitor's experience. Does the amount of advertising revenue justify disrupting the look and feel of the page? Artists tend to be more concerned about this, justifiably, than other businesses. After all, an important aspect of art is how it is presented, and many arts businesses are selling their aesthetic as much as a physical product—a large blinking banner ad that has no relation to the color and design scheme can detract from an otherwise carefully planned page. Because of this, some artists are very selective about what kinds of ads they allow on their site, if any. They make an effort to seek out smaller companies or individuals who are selling a product that has some relation to their work (for example, a paint company advertising on the site of a respected painter, or a drum company with a drummer), and who would also have an interest in running an advertisement that would not only appeal to the site's visitors, but will not negatively affect site visits in the long run.

PRESS RELEASES

A press release is one of the traditional methods for individuals (or entities) to interact with the media. Also referred to as a news release or press statement, this is a communication (either in writing, or recorded on video or audio) that is designed for members of the news

media. The objective is to make known some item that the author claims is newsworthy. While press releases can follow numerous formats, remember that your "audience" is first and foremost the news media, so you will need to provide a certain baseline amount of accessible information in order to be considered seriously. Most press releases follow this format:

1. In bold at the top left of the page, you will type either "FOR IMMEDIATE RELEASE" if you want the story to be heard as soon as possible or "HOLD FOR RELEASE UNTIL" followed by a date if you are not yet ready for the details to be known

2. A headline (one that will catch the attention of the media person reading it)

3. City, State where the events take place, just like in a newspaper article, indented with the first paragraph

4. Start with the classic who, what, when, where, and why, and—in a few short paragraphs—tell your story exactly as you'd like it to be heard by the people you'd like to hear it

5. A paragraph or two of what makes the event/person newsworthy along with the "obligatory quote" from someone familiar with the work/person and has something positive and interesting to say

6. Boilerplate. For artists, this might be your biography, mission statement, or artist statement.

7. Addresses and contact information. Sometimes CONTACT: is at the top of the page under FOR IMMEDIATE RELEASE:

8. Centered at the bottom of the release are either three pound symbols ("###") or the word END between hyphens ("-end-") to indicate the end of the release. If your release goes beyond one page (this should only happen rarely), indicate so by typing "more" between hyphens ("-more-") at the bottom of the page

Additionally, you should include your logo, if you have one, at the top of the page. If you have no logo, create an attractive letterhead on which to print your release.

Once you are finished, you want to find out how the newspaper, magazine, website, etc. prefers to receive press releases. This can be found out with a simple phone call or by following a "Press" link found at the bottom of most webpages. If your release is picked up by a media outlet, you have essentially received free advertising. However, media representatives who receive press releases deal with dozens, hundreds, or more of these submissions if they work at a major media outlet. Try to keep their perspective in mind as you write—they are looking for *news*. Unless you are a celebrity, your own life story is not news. If your release is simply a biography and a link to your website, chances are it won't end up

in the media. Reporters or editors who review press releases will look at the submission from the public's perspective, not your perspective. Avoid hyperbole or other language that unreasonably exaggerates your importance or that of your project or event. The best press releases communicate the writer's message while still reading like a standard news story. Below is an example of a press release layout:

FOR IMMEDIATE RELEASE:
Contact:
Contact Person
Telephone Number
E-mail Address
Website address

Headline

City, State, Date—Opening Paragraph with who, what, when, where, why.

The following two or so paragraphs will explain what makes your event or work unique and why people should be listening. Always include the "obligatory quote." That is, a quote from someone who knows you, your work, or something about the event, and has something interesting and positive to say about it.

For additional information, please contact (name, contact info).

Artist bio, short summary of artist's history, an interesting fact or two (i.e., your boilerplate).

MEDIA ALERTS

Media alerts are similar to press releases. They are sent to the same outlets and used for the same end: to gain media attention. However, a media alert is used either when little notice can be given to an event (for instance, an impromptu public performance) or when the intention is to create a sort of suspense in the mind of a media professional reading your alert (for example, if your poetry reading will have a special guest whose name is recognizable).

Media alerts answer the questions *what, when, who, where, why* in a direct way. Those words are listed on the page's left side and answered briefly on the right, after a colon. Like a press release, media alerts should be on letterhead, say "FOR IMMEDIATE RELEASE" at the top left, and have a headline. The main body of the media alert will look something like this:

What: Name of your event

When: When the event will take place, should be taking place soon

Who: Name of your organization, your name, who will be headlining, etc.

Why: Why are you holding the event, who does it benefit, essentially: who cares?

You should end your media alert with contact information and the traditional three pound symbols also used in press releases.

ADVERTISING (MATERIALS AND ADS)

Advertising generally falls into two categories, paid and unpaid. Paid advertising can take place through any number of media—newspapers or other printed publications, radio or television spots, banner ads on websites, billboards, and even skywriting. Unpaid advertising is often limited to events listings in more traditional forms of media, or to putting your materials up in any space for which you don't have to pay, such as community bulletin boards or empty walls (although that may or may not be legal depending on the location).

Unlike press releases, you have a lot more flexibility with how your advertising looks, at least in relation to the publication or medium where you want to place your ad. When you are paying for it, you are in the driver's seat because, with the possible exception of public radio and television, media depends on advertising revenues to survive. As an advertiser, you are the "buyer," so to speak. For unpaid advertising, you usually are not dealing with an intermediary anyway. An exception to this would be free listings, but there are usually so many restrictions on how and what you can submit that it would be a stretch to say that you are actually generating promotional materials.

This is not to imply that you have total flexibility with how you design your advertisements. Different mediums will exercise varying degrees of editorial control over your content. Most will not allow (or are prohibited by government regulations from publishing/transmitting) material that is considered pornographic, profane, derogatory, hate speech, or extremely violent. And even when your materials don't run afoul of media regulations, many mediums won't print/air ads that they believe their audience would find distasteful. Finally, there are also numerous regulations surrounding political advertising. This can pose a problem for many artists whose work deals with "controversial" themes. But these are content issues, not design issues. Most of the design restrictions on paid advertising are either physical or economic. If you want a full-page ad, or you want it in color, that will be more expensive. The text and visuals you put in your ad may well be determined by your budget. Similarly, ads that run on television or radio usually take place within certain time limitations so as to work with the station's programming. Typical slots are thirty seconds for television, and ten to thirty seconds for radio. If you are looking to incorporate certain phrases or samples, you will need to measure how much time reading or showing those will take and adjust accordingly.

Like other aspects of marketing, advertising is a highly specialized industry and the specifics of it are beyond the scope of this book. Most artists do not tend to invest in large advertising campaigns because they lack the resources, or because they are seeking to

promote their practice which is unlikely to translate well into a thirty-second TV slot. Our suggestion is that if you have a product or project that is designed for a mass market and would benefit from a large-scale advertising campaign, such as a film or Broadway musical, retain a professional to do this for you.

However, most artists will be engaging in very limited paid campaigns (if at all), and if you fall into that group you will probably end up designing your own materials. The main guiding factors for designing your advertising materials will be maintaining the consistency of your brand, as well as what will appeal or entice your target audience. Look at the considerations that went into building a brand, particularly at the questions about authenticity in Chapter 15. Ask yourself those questions again before drafting any materials. You should also reexamine the goals of the campaign. Are you trying to generate interest in a specific product, your work generally, or an event? Structurally, examine the length or duration of the materials to see if that matches what you know about the attention span of your target audience. Consider the type of language you use—will it be understood by everyone? You will also want to make sure that you have communicated all of the information that the audience needs to know. If you are going to the trouble of taking out an advertisement, you don't want your audience to have to search for the date, location, or website.

MEDIA (PRESS) KITS

A media kit (sometimes referred to as a press kit) is a packet of informational materials given out to media professionals to drum up publicity. It is a good idea to have a media kit assembled at all times in hard copy and digitally and available upon request, but it is especially important for when you have a specific event approaching. Most media kits should contain the following, most of which you have already developed in other contexts:

- Artist Bio (for more information on good bios, see Chapter ___ on Applications)
- Sample Work (CDs, digital files, hardcopy images, etc.)
- Press Clippings
- Contact List/Business Cards

Additionally, media kits specifically distributed for an event should include a Press Release and any other information tailored to the specific event.

E-MAIL

While e-mail is not what most people consider to be social media, we will discuss it briefly as it can be an important way in which artists utilize technology to disseminate their message. There are three main functions that e-mail serves for artists: (1) direct communi-

cation, (2) blanket communication, and (3) notification/organization. Let's briefly examine all three and how they work for you.

Direct Communication

The most common use of e-mail is as a direct communication tool and is the default method of communicating in most professional contexts. While the content is a matter of individual preference and professional norms, we have collected a list of tips and warnings from successful artists who conduct most of their business via e-mail. We use Microsoft Outlook and Gmail as references because those are two of the most common e-mail "platforms" currently.

Add an e-Signature

Most e-mail services allow you to automatically add your title and other relevant info at the end of the message, below your signature (or in lieu of it). If you use Outlook, for example, go to the "Tools" section of the menu bar, then select "Options," then "General," then "E-mail Options," then "E-mail Signatures." In Gmail, clicking on the "Settings" option in the upper right hand corner of the page will take you right to it. It's like having a virtual business card appear on every message and can provide valuable info to clients and contacts who may not have bothered to enter your information into their phone, rolodex, or computer. You also have the option to include website links, Twitter feeds, slogans, and depending on the sophistication of the e-mail program, logos and almost anything else that you want people to see.

Is Anybody Home?

One of the obvious advantages of e-mail as opposed to regular mail is that it is instant (or close to it). The downside of that speed is that people expect answers more quickly as well. If you know that you will be away for a period of time—or if you just need a break—you can add an "auto-response" that will be sent to anyone who contacts you, immediately informing them that you are away and will not receive their message until a certain date. If you have an assistant or business associate to whom you would like to refer them in the interim, you can put those instructions in the message as well. Just like with your e-mail signature, you can add this through the "Tools" section of Outlook, or the "Settings" section of Gmail.

Sleep On It

Some e-mail programs (notably Outlook) give you the ability to set a permanent delay on your messages. This means that, even though you push "Send," the message will remain in your Outbox unsent for whatever period of time you specify. You can think of this as being like a broadcast delay on live television—stations typically impose a delay even on live transmissions to give them time to edit out profanity or anything else that they do not want on

the air. Not every e-mail system gives you this option, but for those that do it can be a very valuable tool. Once you have sent an e-mail it is out there forever. Everyone has had an experience where he sent something he later regretted to a potential fan, client, or funder— which is easily forwarded to any of their contacts too. And sometimes it's just a case of having pushed Send too early or accidentally (how many e-mails have you received from others with a subject heading that says "Oops, forgot the attachment"). With the amount of e-mail clutter most people experience, everyone prefers to receive one message rather than several if it can be done.

Don't Do It Twice

Many e-mail providers give you the option of creating message templates. If you think about the kinds of messages that you send during any given month, you will probably notice that there are certain patterns. Even if you vary the language slightly, there is a basic format to confirming meetings, introducing yourself or your project, thanking someone for his or her time, acknowledging the receipt of a document, and so forth. By creating templates for these different categories, you will save time in your individual communications. This is not to say that you should be sending form e-mails, but you can certainly have some basic templates that you adapt as necessary. If you send a lot of e-mails, saving yourself twenty to thirty words per message can add up over time and give you that much more time to be working on your art.

Just a quick side note here, even if you don't know how to add these options, you can usually figure out how to do so by observing patterns common to most Internet and computer software designed for mass market usage. If the function that you want to add or adjust will apply to everything you send out, it is likely under a heading like "General Options" or "Account Settings" or something similar. If you don't find it there, almost every program has a help section with a search function, and you can often find step-by-step instructions on how to add the feature you want. Just google "How to use Gmail, Outlook, etc." to find a selection of free help and/or tutorials.

Blanket Communication

One of the important tools that you can get from e-mail is the ability to send messages to thousands of recipients in one action. This means that you can send the equivalent of an online postcard advertising your performance or opening in a fraction of the time (and at a fraction of the cost) that it would take you to send the same audience a regular postcard. This is sometimes referred to as an e-mail "blast," which means that you have aggregated a number of potential recipients into an electronic mailing list. Depending on the size of your recipient list and how many mass messages you anticipate sending, you may either manage it yourself through your e-mail account (all major e-mail providers have an option for build-

ing recipient lists), or subscribe through an e-mail service that specializes in this function and allows for easier management, which includes specifying times that the message will be sent, generating previews, dividing recipients into subcategories, and subscribing and unsubscribing people without your direct input.

There is some important etiquette involved with e-mail blasts. You will want to get the recipient's permission before sending him or her any mass messages! You can give people an opportunity to subscribe to your list directly from your website, or put out sign-up sheets at your concert, performance, or opening. Unsolicited mass messages are considered "spam," which can sometimes lead to penalties from your e-mail provider if they receive reports of spam activity on your account. Perhaps more importantly, spamming defeats much of the purpose of a mass e-mail, which is to keep your fan base interested and engaged in your work. Unsolicited mass e-mails only alienate potential fans. Create a group address so the recipients do not receive an e-mail that has dozens of e-mail addresses for the first several inches of the message, or list most recipients in bcc.

Another question related to distribution lists is volume. How much is too much? Sending out too many message updates can create fatigue with your audience—you don't want them to groan every time they see your name in their inbox. One approach is to break your list into subcategories, thus ensuring that your fans only receive relevant messages. If your next show is in Des Moines, Iowa, do you really need to send an invitation to fans that live in Fairbanks, Alaska, or Tallahassee, Florida? However, some artists simply want their fans to know that they are actively performing or producing; whether or not these people can realistically attend or participate in some way (highlighting just how vibrant your career is may be a funding strategy). One solution is a regularly scheduled newsletter which includes all of your news for the month, week, quarter, or whatever period you deem appropriate. This gives your fans a more complete picture of your project or practice, but puts your communication on a predictable schedule and conditions your fans to expect it (and hopefully look forward to it). As long as you don't overdo it, you shouldn't run into any unhappy recipients—people know to expect messages when they sign up for an e-mail distribution list. Also, don't necessarily interpret some people unsubscribing as an indictment of you in any way—some attrition is normal. If it seems to be a consistent pattern, however, then you may wish to reevaluate your approach.

E-mail as a Tool for Notification and Organization

Another important role that e-mail can play is to help keep you (and your fans) organized through notifications and other tools that are built into many e-mail programs. Most social media requires that you use an e-mail account for registration and contact purposes. When someone contacts you through the social media site, you receive an e-mail letting you know

that this has occurred and that you should check your message. Because so many people use e-mail as a first-line of contact, you can centralize your different online presences in one account. Your e-mail becomes a sort of virtual alarm clock.

The major e-mail programs like Outlook and Gmail also have calendar applications that allow you to add events (technically, Google Calendar is part of your Google Account and not just your Gmail account). You can then set the program to send you an e-mail reminder before the event begins (you determine how much notification time you need). It is also possible to make your calendar public, or to share it with specific people. Some artists will set up a calendar specifically for their shows or other art-related events, and then make it public. This gives those fans who want to actively participate in your project or practice the ability to easily track important dates.

SOCIAL NETWORKING SITES

While the true importance of social networking lies in incorporating technological applications to further your own marketing and networking goals, we will give a brief overview of several of the major networking sites that are dominant today. The emphasis will be on those elements that apply to your larger marketing strategy.

Facebook

Facebook is one of the largest social networking sites. Like other sites, Facebook is based upon you starting a homepage or "profile." Users then create a personalized profile that can include photos, descriptions of the user's interests and activities, professional and educational histories, contact information, and other personal information including relationship status.

Facebook is built on a system of layered access. Your profile is publicly accessible (and even searchable on the web), but you can set the level of access that other people have to your profile. You add other users to your internal network as "friends," who then have greater access to your information. The primary method of communicating to your wider network is through a "status update," where you can post a short message, links, photos, or videos. Friends receive notifications of each other's status updates through a function in your account known as a "newsfeed." Other users on the network—even those who are not your friends—can "tag" you in a post, video or photo. Tagging means that they mention or identify you and specifically link your Facebook profile to your name. You will receive an e-mail notification if that happens, and you have the option to "untag" yourself if you choose. Users can also communicate with friends and other users through private or public messages and a chat feature.

In addition to having personal pages, users can start community pages or online groups. These can be based around a specific activity (for example, a crochet-lovers page), or even an event (a band's upcoming international tour). The idea is to allow the creation of a "mini-network" that exists within the larger one. Users can also create "fan pages," which is a popular feature among artists. Unlike profiles, pages are designed for public access, like websites.

Given Facebook's popularity, many artists decide that it is good practice to have a page or profile as it is another free tool to disseminate their information, promote events, or more online gallery space.

Twitter

Twitter is another one of the world's largest social networking websites. Like many others, users must start a "profile" page. Twitter users can then post short messages of no more than 140 characters, called tweets. Tweets are automatically displayed on the user's profile page and are publicly visible, though users can restrict access to people in their immediate network, sometimes known as their followers. If another user subscribes to your Twitter feed, he or she has become a follower and will receive updates when you tweet.

Like most social networking sites, getting started is very easily done from the site's homepage and just involves creating an account with a name, password, and e-mail account. Your username is known as a "handle" in Twitter parlance. Twitter gives you the option of customizing your homepage, so you might want to take care to customize it with your brand in mind, or simply images of your work.

Because you can link virtually anything in a tweet, you can use it as a straight promotional tool (publicizing your shows, exhibitions, workshops, news of awards, etc.). You can also use it to link other events and news of interest. The basic idea behind a site like Twitter is that it provides instant access to your followers, which can in theory be an unlimited number, so your responsibility is (1) either to be so interesting and/or important personally that people feel like they get something out of just knowing more about you, or (2) to provide your followers with valuable insight, information, or entertainment. Organizations can have Twitter accounts as well—NYFA has one and regularly posts updates about organizational activities but also news of awards and applications that will benefit artists.

Other Social Networking and Sharing Sites

Other popular sites, which allow you to share your work and connect with likeminded individuals are: Tumblr.com, a micro-blogging site similar to Twitter but with more of an emphasis on personalization and media sharing; Flickr.com, a site which allows people to connect via photos—be they events, artworks, or portraits; Foursquare.com, a site which

connects people through their "check-ins" at venues like restaurants, bars and events spaces. At the time of this writing, Google has just launched a new networking site called "Google+" that combines elements of other social networking sites, and integrates existing Google features. Time will tell whether Google+ becomes a significant competitor of Facebook and Twitter, and it only serves to emphasize the need for artists to remain aware of shifts in online technology and to diversify their online resources.

TARGET NICHE MARKETS

We cannot overemphasize this. If a station or program focuses on the kind of work that you do, you are much more likely to get an announcement aired. Niche programming is most often staffed or hosted by people in your community who have a genuine interest in that art form, and in the advancement and public awareness of that art form. They may even be interested in doing a feature on your work or event as well. Like other areas of the media, this often comes down to personal relationships and contacts. As we discuss in Chapter 18 on Networking, you will want to find a way to interest your media contacts in what you do, and that starts by showing an equal interest in them and their work. If you are going to reach out to the host of a local radio or television show covering your discipline, make sure that you have watched or listened to it first. You can learn a lot about the hosts—and their tastes—by doing so. If you see another local artist being mentioned or profiled, go to that artist's show or performance. And if the host offers a chance for you to interact on their program, make sure to take it (for example, participating in a contest or call-in segment). The more specialized the programming, the smaller the audience, which in turn means that the host is usually under some pressure to demonstrate that he is actually reaching the target audience (this is important to the station's advertisers, and in the case of public radio, sponsors, and other funders). Your interest and participation is actually helping the station and the host and can lead to a sort of mutual investment in each other.

You should also not underestimate the importance of public access programming. While it is true that such programming typically has a smaller viewership than other programming (and often runs at odd hours), those people that do view it are usually local people who have an interest in the subject matter or in the hosts and other participants in the show, or both. Engaging viewers/listeners who are passionate about your discipline and take an interest in local events is an excellent strategy for emerging artists, or for artists seeking to enter new markets, as this audience is more likely than the general population to come to your show, book signing, or opening. Ultimately, that is the goal of any good marketing campaign—you want to connect with the passionate members of your target audience. While a feature write-up in the *New York Times* is great, it is a little like winning the lottery.

Promotion of one's own work is an important feature of successful social media use —
Naomi Reis (Artist as Entrepreneur Boot Camp participant), *Vertical Garden (Weeds)*,
acrylic and ink on mylar, 53 x 35 inches, private collection, New York, NY, 2008.

You can gain valuable exposure and new fans through much smaller outlets as well, and have a better chance of influencing your press coverage.

MEASURING YOUR RESULTS

One of the most important questions related to any of your marketing efforts will be to ask yourself "how effective am I?" As we discussed in Chapter 15 on branding, this can be diffi-cult to track accurately because most artists do not work with a large enough fan base to generate meaningful statistics; furthermore, they lack the resources for a comprehensive study. However, with social media and other online outlets like blogs and websites, there are ways to track the effectiveness of your marketing (and networking) activities. Even if there are still some gaps in the measurement process, you can still obtain important raw data for later analysis.

There are a number of programs available for tracking important statistics about websites, such as the number of hits each page receives, how long the average visitor spends on the site, and the geographic location of the visitor—Google Analytics is one of the most well-known, and it is free, but there are others that offer similar services. Most of the differ-ences depend on what kind of site needs to be tracked (Google Analytics has limitations with very large sites), how you want the information presented, and how much you want to customize the program, which depends on your comfort level with computer technology. Ultimately, any program you choose will be inherently limited by the kinds of information that is available—even if you could get names and other data associated with each IP address that visits your site, there is no way to know if someone from an entirely different demo-graphic is using the computer. Nevertheless, there is still a lot of useful information. In addi-tion to the categories listed above, you can find out about what sites referred your site, whether the individual hits were from repeat or new visitors, and even what kinds of search terms led visitors to your site.

Like with your market research, your own analysis will make this data useful. If you are a musician who regularly blogs about your performances, and you notice a spike in the amount of visits to the post about a certain show, that alone is valuable. You can investigate whether this activity came from one source or many. Perhaps you advertised the show on another website, and the majority of the new visits originated from that site. That would suggest that your advertisement was at least partly successful. However, you should compare that to real world results as well. Did you sell more tickets than usual? If there was no appre-ciable difference in audience numbers, you might want to further examine the original data. It's possible that most of these new visitors were from a different region of the country, which may change your assessment about the success of advertising on that site—that

depends on your goals. But regardless of what you conclude, you will have learned some-
thing important about who your advertisement reached and what it achieved. If you moni-
tor this consistently for each blog post, you will continue to gather information on who is
reading, where they are from, what other sites they like, and how your content, a new brand,
or a new advertising campaign impacts your visitors.

Google Analytics can be integrated into some of the popular social media sites like
Twitter and Facebook (there are some restrictions with Facebook in that you cannot put it
into a personal profile page, but you can into a fan page). This means that you can gather
detailed information on your proficiency with social networking. On a more basic level,
some of this information is offered by the networking sites themselves—for example, count-
ing the number of friends or fans that you have, or the number of "likes" and comments that
you get for each post. In some ways, this kind of personalized information can tell an artist
much more about the effect of his marketing through social media. But tracking programs
go many steps further in terms of offering artists non-anecdotal information that lends itself
more to statistical analysis.

Sales

So your networking and marketing have been successful, and now you have a client (or clients) who want to purchase your art or your services. Congratulations! But remember, as we discussed in Chapter 6, you actually need to get paid. This does not have to be a complicated process, but you still may want to put some thought into the mechanics since it seems to be problematic for many people. Specifically, how will you price your work, how will you receive funds, and what other kinds of paperwork and administrative details do you need to consider to ensure that this aspect of your arts business runs smoothly?

If you intend to use your website to make sales—and web-based sales is often a major part of an artist's revenue—you will likely need a method for clients to pay for an item or a service by credit card. The overwhelming number of online transactions that take place do so via credit card. There are several ways that you can equip your website to accept credit card payments.

One method is by using a web-based credit card payment service that handles the transaction for you. This is sometimes referred to as a third party merchant. One of the best known is PayPal, which allows payments and money transfers to be made online and through your website. It essentially accepts payment for you, and charges a fee for doing so (just how much and other conditions depend on what level of service you choose).

In addition to PayPal, there are numerous other sites that can perform the same function; the exact services and fees may vary. Here are a few options:

CCBill: *www.ccbill.com*
Google Checkout: *http://checkout.google.com*
ProPay: *www.propay.com*

While most artists choose to use third party merchants, at least in the beginning, if you have established that you will be engaging in a large volume of sales, it may be more

economical to open your own "merchant account." This is usually established directly through a bank or credit card company, and is also costly. Ultimately, your decision to use a third party merchant or open your own account will come down to sales volume. In general, most artist businesses function well with a third party merchant for web-sales, and unless you have your own store or gallery where you are regularly selling work, you will likely accept payment in person via cash or check. Similarly with artists who are selling their services, accepting credit cards is usually not something that is done (or that your clients expect). However, we urge you to compare the numbers for yourself.

As a practical matter, adding a "pay now" or "shopping cart" feature to your website is a common practice, and can be set up automatically when you use a third party merchant, and also comes standard in many website templates.

PRICING YOUR WORK

Setting a price or rate for your work or services can be an extremely challenging task for any artist. While we touched on pricing in Chapter 5 (discussing cost awareness), there are many factors that go into pricing your work beyond the cost of raw materials, or even the time that you put into producing or preparing your art. This is one area of the arts in which your medium can make a big difference, as there tend to be norms within specific disciplines and industries. Still, artists should remember that the value of their work will be a function of (1) the market for their medium/discipline, and (2) their specific position in that market. The information gathered during your market research will help you to understand both (see Chapter 14).

There are also good reasons for determining your pricing structure beyond just making a sale. Having well thought-out prices for your work demonstrates professionalism. It shows potential buyers that you understand the market for your art and gives them confidence that they are making a sound investment.

Let's take a brief look at pricing practices by discipline.

PRICING IN THE VISUAL ARTS

While there are many considerations that go into pricing a work of visual art, you should be aware of one major pitfall—once you have established a price, lowering it does not reflect well on your success as an artist. Those people who have already purchased your work at the original price may feel like they made a poor decision, and if they purchased your work as an investment lowering the price may affect their financial interests. Furthermore, lowering your prices may compromise relationships with galleries if gallery representation is part of your business strategy. As a general rule, galleries do not lower the list price of a work

(though they often give discounts). For these reasons, you should think carefully about pricing your work realistically from the outset.

ESTABLISHING PRICES FOR NEW WORK

If you are an emerging artist without a well-defined sales history, your pricing strategy begins by analyzing work that is similar to yours. While you obviously will not find a work that is an exact match, try to look at a work that is similar in size and uses similar materials. You may want to start by browsing art fairs such or at local galleries. If the prices for works are not listed, they are available upon request.

When you are comparing other works, make sure to account for relevant factors beyond size and materials. In particular, look at the résumé of the artist who created the work. Is the artist well-known and how long has she been selling work? What awards has she won, or in which residencies has she participated? Has she exhibited in other galleries or museums? Has she received media attention? It takes most artists time to develop an audience and market for their work, and established artists will be able to charge more than emerging artists even where the works are the same size and materials. You need to compare prices with someone at a similar point in her career.

If you have an established sales history, you likely have a pricing structure. However, if you take a new direction with your work—perhaps using different materials—you may have to set new prices as your audience adjusts to the change. The pace at which you raise your prices may be faster than with an emerging artist, because you have already built a following through your other work—one prominent New York gallery owner spoke to us about an established artist who embarked on a new line of work and was able to raise his prices over 50 percent in a year. That is extremely unusual, and raising one's work when the work is already selling, by 10 percent over a one-or two-year period, is more typical.

OTHER PRICING CONSIDERATIONS: GALLERIES AND SERIES

Many visual artists opt to sell their work through galleries. This has a number of advantages in that the gallery will promote your work to their own clients, and the association can add some prestige to your career, much as signing with a record label does for a musician, or publishing a manuscript through a publishing house does for a writer. The trade-off is that the gallery needs to take a percentage of the sale—it is a business as well—and the industry standard is 50 percent, unless the work is a commissioned work, in which case artists often get 60 percent. Not-for-profit galleries tend to take smaller percentages, usually between 10 percent and 30 percent.

Furthermore, galleries frequently agree to discounts for regular customers (10 percent is common), and museums may get as much as a 40 percent discount. Discounting

has become such a common practice that many galleries build an anticipated 10 percent discount into the original price. As an artist, you should not be discouraged by your work selling at a discount—while you may make less on the sale, it means that someone has responded to your work and you are developing a market. And if that buyer is a significant collector, that will only enhance your status and exposure.

If you are selling work independently, it is a good strategy to price your work without adding in the additional 50 percent that a gallery would take. That means that if you find a similar work in a gallery by an artist with a comparable résumé, you would set your price to what the artist would receive from the sale rather than the list price. While you may feel that you are undervaluing your work, if you eventually do get gallery representation, then it will have less impact on your profits-per-sale—remember, it is better to raise the price rather than lower it. Also, most galleries have developed a core group of clients and buyers who are accustomed to purchasing works in a certain price range, which most individual artists have not. This is especially true for emerging artists who often begin selling to family and friends.

Another consideration is whether the work is a single work or one in an edition. The price of a print or photography in an edition of ten will generally be lower than that of a unique piece by the same artist. Also, if the edition size is larger, say twenty-five pieces, each print should be priced at a lower rate than if you printed only five pieces. The price of a work at the beginning of an edition will start lower and go up toward the end of the edition. This is partly a function of supply and demand, and partly a way to reward the first buyer for taking a chance on the work before its value has been "established." Furthermore, as potential buyers see the price rise as the edition sells out, the rising price may be an incentive to buy. As a reminder, remember to set an edition number for photographs and prints or other editioned works—many emerging artists don't think to do this but it is an important factor to collectors and dealers.

SOME FINAL THOUGHTS ON PRICING FOR VISUAL ARTISTS

Unfortunately, there is no simple formula that visual artists can use for pricing their works. Like many other aspects of being an artist in business, you will have to rely on your own creativity and diligence to find how similar works are priced. By understanding how the larger market is influenced by the interests of collectors and galleries, you can avoid mistakes like overpricing or underpricing your work that may harm your future sales. Finally, determining your prices can be a good opportunity to step back and reflect on your artistic career and ask realistic questions about the value of your work today.

PRICING FOR PERFORMING ARTISTS

Performing artists typically need to set prices for several different categories: physical products like CDs or films, large-scale productions like concerts and plays, and individual services such as serving as an ensemble member.

Performers tend to have an easier time than visual artists when it comes to setting prices. For starters, there is little risk of devaluing your work long-term if you reduce your prices. Your audience is buying access to you for a few hours, or they are buying some manifestation of your intellectual property—a CD, DVD, or other recording of your film, music, or dance. Recordings are usually not intended for long-term use and do not appreciate in value unless it is as an antique. The monetary value of a live performance ends with the performance. Furthermore, the market for recordings, films, or similar products is pretty well-established, in part because these products lend themselves easily to widespread distribution. Let's briefly examine each:

Products

When we discuss products created by performing artists, we refer to the physical means by which their art is distributed, not the underlying work or intellectual property. For a musician this could be a CD, for a filmmaker a DVD, and for a dance or theater company some combination of the two. Increasingly the product is in the form of a digital download.

Because the technology and materials involved are so inexpensive and so easy to reproduce, the market for these products is pretty well-established. Most single CDs and DVDs sell for between $10 and $25, with direct digital downloads priced a few dollars less. A band selling its CD on CD Baby (a major website that allows independent artists to sell their work) will usually do so for around $15. Some artists create special packages with additional footage or multiple recordings, but the prices for those tend to go up proportionally with the number of CDs or DVDs in the package.

Where you should price your product within that range depends on your market, and also on your sales philosophy. Some independent artists prefer to think of themselves as specialty items and thus price their work at the higher end of the spectrum. Their reasoning is that anyone who wants to purchase their work is not an impulse buyer, but rather a genuine fan who is willing to pay more for that particular work. Others, especially those who are seeking to build a following, will price their works more competitively to appeal to casual fans.

Productions

Productions can refer to a very wide range of activities for performing artists, but we use it for the "signature" performances in each performing discipline. For film, it would be the film itself, in theater a play or musical or other dramatic work, in dance a piece of choreography, and in music a concert (and there are many equivalent works in other disciplines, such as an opera, a reading, or a puppet show).

Pricing productions falls into two categories: the price an artist charges individual audience members, or ticket prices, and the price an artist charges the performance venue.

Ticket prices vary by medium, but most general admission performances tend to range from $5 to $50 for independent or self-producing artists. Larger productions at well-known venues and featuring stars frequently charge more than $50, but these decisions are usually made by the venue itself rather than the artist.

When you sell your production to a particular venue, the price depends heavily on your individual market power, and on what kind of "draw," or audience support, the venue believes that you will generate. A live music venue might pay an established artist $2,500 for a Saturday night show, but pay an emerging artist 50 percent of ticket sales for a Tuesday night—and that only after the first twenty tickets are sold. Certain disciplines have more established arrangements. For example, repertory theaters that show independent films will customarily offer the filmmaker $250 or 35 percent of the door. But the general rule is that the individual venue sets the parameters of the deal regardless of your discipline, and until you can demonstrate that you can bring in paying fans you may have limited ability to negotiate.

Services

Many performing artists earn a living by performing complicated or specialized actions rather than creating new works. An opera singer, dancer, actor, or violinist would fit into that category (although they might be producing their own original works separately). These artists typically earn money from their art by being paid to perform in productions.

Like productions, the pricing structure for performers varies greatly depending on their position in the market. If you are well-known in your field, or you have an unusual skill—perhaps you play an uncommon instrument or can mimic certain speech patterns— you can command a higher price. Ultimately, some fields offer stars the chance to make thousands of dollars for a single performance. Unionization has played a role in establishing more uniformity in pricing. Actors in particular have a strong union, so those actors who work on major shows and films can expect to be paid according to union rates (most of which are available online). In general, the larger and more commercial the production, the greater the chance that the performers from all disciplines will be compensated according to a union contract.

Many emerging performing artists will perform for little or no compensation just to get experience, making it difficult to determine a standard price for small productions and freelance work. Performers should speak to their peers to see what the community standard is for these smaller markets in their discipline. Our advice is to refer back to your market research and set a price for your time and services that reflects what your market will support. If you want to donate or barter your skills you can do so, but it is important to establish a value for your work. And unlike the visual arts, you have much more flexibility to adjust your prices if you initially misjudge the market.

PRICING FOR LITERARY ARTISTS

Literary artists either sell their products for mass consumption, or they sell their underlying work to a producer or publisher to turn into a book or production (an example of the latter would be when a playwright or screenwriter sells her scripts to a theater or film producer).

If you decide to self-publish, and that is an increasingly common route to take, you will have to set a price for your book. Just as performing artists have limited flexibility in pricing CDs and DVDs due to the market for these products, literary artists face similar restrictions. While prices can vary according to the subcategory of the literary work, most have fairly well-established market values.

Some of the relevant subcategories include whether the book is fiction or nonfiction, for children or adults, hardcover or paperback, and if it is a textbook. Hardcover textbooks tend to command the highest prices, sometimes exceeding $100, whereas paperback romance novels can be priced as low as a few dollars. If you are selling your self-published book, it is unlikely that you will be doing so for more than $30 unless you are packaging it with another product.

If you sell your work to a publisher or producer, you have a different set of concerns. There are many excellent resources that discuss the process of getting a book deal, and we will not cover this process other than to note some basic elements. Many authors get a literary agent to represent them and handle the "selling" to the publishing company. The most important pricing issues that arise in publishing deals are the author's advance and the royalties. Royalties simply refer to the percentage of each sale that you will receive.

The same categories mentioned above (fiction versus nonfiction, children versus adults, and particular genres like history or mystery) may influence the type of deal offered to you. Many emerging authors do not receive any kind of advance, but if they do they are likely looking at advances of around $10,000—which may later be recouped from royalties—and royalties of between 5–10 percent for paperbacks and 10–15 percent for hardcover. Royalties for e-books (books that are only readable on a computer or a specific device like a Kindle) are often much higher than royalties on traditional books, but the sales prices are often lower so the author may not actually make more money per sale.

The size of an advance and royalty percentages are related, not surprisingly, to the author's market power. Publishers ultimately need to sell books, and if an author has an established track record and readership, or if the author is a celebrity or someone with unique insight on an important topic, the publisher will be willing to invest more in that author's story.

For screenwriters and playwrights, especially at the level of independent films and shows, prices can vary widely. Often the producers are fellow artists with a very small

budget, and the literary artist will enter into a partnership where she contributes the script and receives a percentage of the production's earnings.

SOME FINAL THOUGHTS ON PRICING IN THE LITERARY AND PERFORMING ARTS

The common theme for setting prices in the performing and literary art worlds is market research and market power. If you are an artist in any of these fields and you are seeking to price your work for consumers, you will be working in a limited price range. Money is earned through selling in volume rather than selling several high-priced works, and you need to know what your target audience is prepared to pay. If you are selling your work services to a third party producer, such as a concert venue, publisher, or movie studio, you may have the opportunity to earn significantly more on the initial sale. Still, this depends on your individual strength in the market and whether the producer believes your work or performance will attract a large audience.

18

Networking

If you were to read only one part of this book, we would encourage you to select this chapter. (We do, nevertheless, want you to read the whole book.) As important as strategic planning, financial organization, legal awareness, and marketing and fundraising savvy are, there is no skill that will help your career as an artist—and in anything else that you do in life—more than networking. All of the other skills are complemented and supplemented by an effective use of networking.

If you are searching for a general definition of networking and how it fits in with your larger professional development as an artist, you could say that networking is about engaging in the world. The Merriam-Webster dictionary defines networking as "the exchange of information or services among individuals, groups, or institutions; *specifically*: the cultivation of productive relationships for employment or business." For artists, networking is about developing a base of people who will support your efforts and want you to succeed. People who will play a larger role than just being potential patrons (which is by no means intended to diminish the importance of that role). Networking is about finding and building relationships with people you care about who are linked to new opportunities, new markets, and untapped resources of expertise and support.

Chances are that you have attended some kind of class or lecture where someone successful spoke about how they built and maintained a network. This is valuable information. So are the host of tips, tricks, and organizational tools at your disposal. Start a Rolodex (or, better yet, skip that step and go straight to a digital option). Take advantage of new forms of technology and social media to initiate and *maintain* contact with more people. Attend special networking events for people in your industry or medium. Save every business card you get, and follow up with a letter or e-mail after you meet someone, while the contact and exchange of business cards is still fresh in the minds of both of you. Follow up

to maintain contact and build a relationship. If you have no relevant connections, start with your friends and family and spread out from there—this advice and more is all over the Internet and in books.

But all of the Rolodexes in the world will not address the core challenges of networking, nor will any tools or suggested activities make this activity any less daunting if it is something that does not come naturally to you. This is because access, time, your personality, and most importantly your preconceptions, are the biggest challenges facing any artist looking to network successfully.

It is very difficult to get access to successful people when you don't know them. They have "gate-keepers"—personal assistants and secretaries standing in your way, and even if you somehow get past them there is a good chance that your would-be contact doesn't want to be bothered by a perfect stranger. Think about your own life and work as an artist—when you are in the practice room, writing a chapter, rehearsing, or in the studio, how do you react to someone you don't know knocking on your door looking to talk about themself? Some people might be receptive, but many others would not even bother to answer, or worse, be hostile.

Time is also an issue. Most successful people tend to be busy. Even if you go through the "proper" channels and get a meeting or phone call with the person you feel can help you, chances are that he or she will only have a few minutes to speak. Knowing what to say and how to say it in a short direct way takes practice. As for your personality, you may be one of those fortunate people who simply *is* likeable, who likes people and has an easy outgoing manner. These people probably don't think about it—it just comes naturally. Maybe it's the "gift of gab," an easy smile, some patented jokes, or something indefinable—you might even be one of these people. But many artists are not. We are often a solitary lot, absorbed in our work, defiant of convention, and fiercely devoted to our independence. In short, many of the qualities that make for good artists can also make for bad networkers.

But, that does not have to be the case. Just because you are not a textbook extrovert, does not mean that you cannot develop skills to help you become an effective networker. This is where your own preconceptions come into play. We believe that every artist has the capability to be a first-rate networker with just a small change in thinking. This does not mean that you get to cut any corners—you still have to put in the same amount of work. But think about some of the challenges we associate with networking. Many stem from the idea that you need to *use* your connections in service of your career. Wrong, you need to use your connections in service of your life. If you have already categorized someone and what you hope to get from him or her, any of your interactions that do not further that goal or bring you closer to fulfilling your expectation may seem like a failure. And it may well be techni-

cally a failure, if you overlooked a genuine opportunity that this contact could have led you to because you were too busy focusing elsewhere.

The best networking is about developing genuine relationships with other people, much of which is serendipitous or coincidental, not planned. What you can plan to do is make a conscious effort to abandon bad habits or misconceptions about what networking should be. Some of the most successful networkers do so organically, and they have shared that here. NYFA's Executive Director, Michael Royce (himself an excellent networker), has collected a few truisms about networking from his own observations and experience. The emphasis is not on what you do, but how you do it. Think about each of these ideas and how they might apply to you.

"EVERY PERSON YOU MEET IS A POTENTIAL BUYER, SELLER, COLLECTOR, FUNDER, PRODUCER, OR KNOWS SOMEONE WHO IS ONE OR MORE OF THESE, AND CAN HELP YOU IN SOME WAY."

The emphasis here is on *every* person you meet. We advise you not to single out people solely because of their wealth, title, social status, or whatever else you have identified that might be a benefit to your career. You would not make this distinction when establishing friendships.

Aside from the rather strained interactions that will arise from pursuing only those people you feel will benefit your project or practice, you will be missing out on a huge number of valuable contacts. It is impossible to know what circumstances will lead someone from one position to another, or whether someone's college roommate, cousin, or brother-in-law is intimately connected with someone who can help you directly. Every person that you might perceive as a "valuable contact" is someone else's neighbor, son, patient, or friend. Furthermore, your needs are always changing, and your contact in the banking industry may suddenly become important to you after your contact in the publishing industry helps you put out a best-selling book. Every person can help you in some way, and the best (and most creative) networkers know this.

"LIFE IS SHORT: BE NICE TO EVERYONE."

How many people can honestly say that they are nice to everyone? Such a person probably does not exist. Simply put, it's hard to do. If you have a bad day, or you didn't sleep well, or perhaps someone snapped at you earlier and hurt your feelings, it is all too easy to take it out on another person. Most of us learn, often the hard way, to control this impulse so we are not

taking out our frustration or unhappiness at our boss or someone we deem "important," but alas, all too often the target becomes someone "safe" like a family member who is more likely to forgive us. We caution against this.

Remember, as noted above, every person can be an important contact, and the fact that are able to control ourselves in certain contexts because it is in our best interest to do so proves that we really can do it anywhere. It just takes extra effort, and may require taking time out to take a deep breath, collect yourself, and get back on track. We all tend to be more comfortable with and better disposed toward people who are nice to us; it's human nature. Taking that to the next step, if you make an attempt to be nice, people will be more inclined to help you. It is in your best interests.

"SAY WHAT YOU MEAN AND MEAN WHAT YOU SAY."

There is no greater currency in the networking trade than honesty and reliability. Just as you are building contacts for your own project or practice, those with whom you interact are doing so for their interests as well. From the moment that people meet you, you are building a reputation. If you have a reputation for delivering on your promises, your contacts will come back to you time and time again. As artists, we have all met more people than we can care to remember who make impossible promises on very ambitious ideas . . . and then never follow through. At best, it leaves you disappointed; at worst, it leaves you having lost time and money.

If you can't do something, just say so. Your contact will appreciate your honesty. And if you agree to do something, make sure that you actually do it. You will earn your contact's confidence and he or she will not only return to you with greater opportunities but will feel comfortable recommending and introducing you to their connections (which is the very definition of networking). Failure to deliver on a promise can be costly to your reputation.

"ENJOY EVERY INTERACTION WITH NO EXPECTATIONS. OTHERWISE EXPECTATIONS LEAD TO RESENTMENTS."

People who are good at networking enjoy networking. This goes beyond the human tendency to like those things that we are good at. Rather, it goes to the heart of what NYFA wants you to take away from this section—artists have an innate capacity for making connections with others, even if your real desire is to be alone in your studio working. Part of what draws you to art and makes you good at it is your ability to perceive and appreciate beauty in many forms. You may do this through different media, or be more oriented towards sounds, sights, or concepts, but this ability to appreciate details in the world or the human experience makes you unique. Use this skill to appreciate and enjoy your interactions with others as you

seek to network. You will find that you perceive many details about the other person if you are not framing the interaction with certain expectations before you start. Resentment happens when expectations are not met, so try to avoid them. Instead, just enjoy whatever that person has to offer, build and maintain a relationship and see what happens.

"A GENUINE INTEREST IN OTHER PEOPLE DELIVERS A GENUINE INTEREST IN YOU."

This is really a corollary to point about enjoying the interactions. If you are actually interested in the person with whom you are meeting, it will come across. Most people will find it flattering regardless of their position or experience, but more importantly, it will make the experience rewarding for you. Successful networking takes time and effort, and there is no point in doing it if it feels meaningless to you. By taking a genuine interest in others, you give the interaction meaning. And it should not be difficult to do—everyone has a story if you are willing to listen.

For almost every artist, taking (or even in the beginning, appearing to take) a genuine interest in those with whom he or she networks is a good strategy. It bears repeating that networking is a two-way street. Your contact is not obligated to help you, it's a choice. If you do not take any time to learn about who he is, or show any interest in reciprocating, why would he have any interest in helping you further your career? More often than not, the reason we do not pay attention to the needs and interests of those with whom we network is because we are used to thinking of the contact as someone we have to impress, rather than someone we should get to know. Treat your networking contacts as you would your friends and you will eliminate this problematic dichotomy.

"FIND THE PEOPLE WHO CAN HELP YOU, AND FIGURE OUT WHAT YOU CAN DO FOR THEM, NOT WHAT THEY CAN DO FOR YOU."

Once you have made a new connection with someone, make the most out of it by showing what you have to offer them. This may appear counter to your goals and purpose for approaching them in the first place, but it an important long-term strategy that often pays off. You may not see what you have to offer right away, but there are always little ways in which we can help someone else to achieve her goals. Of course, the only way you will know how to do this is by taking an interest in this person and learning what they consider to be important. If it is another artist, even someone who has achieved considerable success, showing up at her opening or performance can make a lasting impression. She may never visit your website, or she may lose your card, but if you help her with something she truly

needs she will remember you. Helping your contact is the best way to build and maintain a relationship. It is always better to have the gratitude debt working in your favor, that is, not being excessively beholden to others.

"PEOPLE WANT TO HELP. IT FEELS GOOD."

An effective network is more than just having connections with lots of people. It is having connections with people who will actually do something to help your project or practice.

People help because they want to. They may not know anything about the quality of your work, but they will want you to succeed if your relationship with them is genuine. If your network is made up of people who fall into that category then you have a very powerful network. If you treat them well, care about them as people, find ways to help them, and generally remain open to who they are and what they have to offer, the chances are very high that they will return the favor.

"ALWAYS KNOW WHAT 'MAKES UP' A PERSON AND BE PREPARED TO ASK FOR HELP WITH THAT IN MIND, AND THEN PREPARE TO BE TURNED DOWN."

This is the last step in managing an effective networking relationship. Sometimes your contacts will connect you with an opportunity without your asking them, but more often than not you have to ask for help, to remind them that you need connections that they are in a position to make. Chose your requests carefully, thinking about your long term relationship. If you have built an effective network of people who like and want to help you, it will most likely make them feel uncomfortable to have to turn you down. Neither of you will want to be in that position. Are you asking something that they can even do? Want to do? Will you be putting them into a difficult situation or perhaps inviting a conflict of interest? Just because a lawyer can answer your question does not mean that she can do so without taking on liability for giving you legal advice. And just because someone has the financial wherewithal to give money does not mean that he feels comfortable doing so. He may prefer to help in other ways. The only way to know that is to have taken the time to get to know him and how he thinks and reacts.

Nevertheless, even if you have thought about your request, determined it was reasonable, and asked for something that you assume your contact is in a position to do, you still need to be prepared for him to say no. It happens. People are busy, or they may have other concerns you didn't know about, or you may have just caught them on a bad day. If you are prepared for them to say no then it will be an easy conversation. Remember, just because they say no this time does not mean that they will say no the next time you ask. You have

most likely invested considerable time and effort in this relationship (as we said at the outset, networking is hard work), and it would be a mistake to throw it away. The best networkers understand that being rejected is simply part of the process, and do not let it set them—or their connections—back in any way.

MARKETING AND NETWORKING—THE TAKE-AWAY

The topics of marketing and networking, you must keep in mind, are extremely fluid. What works for one artist may not work for another. Likewise, what appeals to one consumer or media outlet may not appeal to another. You must find a way to take what you love—that is, your art—and project that on your potential audience. A great rule of thumb when networking, marketing yourself, and just for life in general is to be genuine. In other words, successful marketing and networking efforts mirror the creative process itself. Using the tools we have discussed, your passion will rub off on others and you will over time gain the success you've been seeking.

A REPRESENTATIVE SAMPLE OF
MARKETING RESOURCES FOR ARTISTS

ArtSlant
Provides an extensive calendar of arts events, a listing of contemporary artists, art buzz, reviews, and commentary on a city-by-city basis to the worldwide art scene.
www.artslant.com

Community Arts Advocates
Community arts advocacy and artist support include marketing, educational and management services to arts non-profits.
www.communityartsadvocates.org

Flickr
Online photo management and sharing application.
www.flickr.com

Mutual Art
Online art information service providing art collectors and enthusiasts with personalized art information about artists, galleries, museums, auctions results, and more.
www.mutualart.com

OtherPeoplesPixels

An affordable artist website provider. Artists can choose a template, add artwork in minutes, and change images and information as often as they need.
www.otherpeoplespixels.com

The Pauper

Website that assists artists with promotion, sales, networking, and finding resources.
www.thepauper.com

Wordpress

A free publishing platform with a focus on building creative dialogue and communities.
www.wordpress.org

Vimeo

Community to share the videos made by individuals in the creative community.
www.vimeo.com

Constant Contact

Email and event marketing for small businesses and individuals.
www.constantcontact.com

Youtube

This Google-owned video sharing site is the leading host of user-generated video sharing.
www.youtube.com

Networking Resources

Art Search

Arts-related search engine for all types of artists (including performing, visual, music, literary).
www.artsearch.com

Art Cards

An online resource for art openings, reviews, entertainment and creative events in the Miami, Los Angeles, San Francisco, and New York areas.
http://artcards.cc/

Artist Data

A site that allows musicians and bands to enter upcoming performance information *once* and then sync it to different social networking sites such as Facebook, MySpace, and Twitter.
www.artistdata.com

Artlog

Designed to build communities among artists and art enthusiasts. Artists can build a personal artlog to follow and share contemporary art and exhibitions.
www.artlog.com

Backstage -The Actor's Resource

Website lists online and print casting calls, job listings, opportunities for theater artists and technicians.
www.backstage.com

ETSY

An online marketplace for artists to sell their work.
www.etsy.com

Facebook

An online social networking site to connect friends and family.
www.facebook.com

idealist.org

Jobs and opportunities in not-for-profit work and the arts.
www.idealist.org

Playbill

Along with event listings, the website lists job opportunities and casting calls.
www.playbill.com

Twitter

The most prevalent of the micro-blogging sites allows users to quickly gather and disseminate up-to-the-minute information.
www.twitter.com

Women Arts

The website contains a listing of residencies, grants, and networking events, and also provides the option of a weekly e-mail with news and opportunities.
www.womenarts.org

Events and News Resources

Art Fag City

An online periodical and blog that reviews exhibitions and events in New York City.
www.artfagcity.com

Alternative Weekly Network

A nationwide network of mostly independently-owned local and regional alternative newspapers/entertainment guides.
http://awn.org/

Village Voice Media

In addition to the well-known *Village Voice*, the company also owns notable alternative newspapers in major metropolitan areas across the U.S.
www.villagevoicemedia.com/

Gothamist

A network of blogs focused on city-specific news, entertainment, art and humor, with *–ist* sites for the cities of New York, Chicago, Los Angeles, Washington, San Francisco, Austin, Boston, Seattle and Philadelphia.
http://gothamistllc.com/mediakit/

Association of Alternative Newsweeklies

A nationwide index of alternative weeklies and entertainment guides. Also offers grant and fellowship resources for writers and journalists, job listings, and webinar/training resources for journalists.
www.altweeklies.com

Artist Fundraising

19

Introduction to Fundraising and Definitions

So, you have planned every aspect of your project, from the first brush stroke to the gallery opening. You have analyzed every cost and are prepared for every contingency. Like a car that is carefully packed for a family vacation, you have air in the tires, a toolkit ready, and detailed roadmaps for your route. But you will still need fuel, and in this case, fuel means money. Budgets and financial awareness can reduce your expenses considerably, but at a certain point every artist will need to generate some form of revenue.

There are a myriad of ways in which artists can and do tackle the difficult task of funding their endeavors. Some art lends itself more readily to the commercial world and can be approached the same way as any commercial venture. Other artists are unlikely to ever recoup a fraction of their costs of making art. We make no judgment either way. The purpose of this book is solely to help you to achieve your goals and to choose a funding model that suits you best.

By the end of this section, we want you to understand three concepts: (1) What kind of funding options exist (a very broad range); (2) How to find these funding options; and (3) How to apply for or otherwise access targeted funding. Each chapter in this section will track these concepts sequentially.

The overall emphasis of this section will be on funding projects and practices that have less commercial viability—typically a more complicated task. We are all familiar with the expression "you can't get something for nothing," or "there is no such thing as a free lunch." Art is no different.

Commercially viable artists borrow money based on the perceived value of their work—or on the expectations of future returns on that work. This often occurs through an intermediary when a production studio or publishing house sees a promising manuscript and invests in it. The company spends money to produce and distribute the work, and then

reaps the profits on the work's sales. On a more individual level, a photographer of iconic imagery may do the same thing when he takes out a small loan to finance the mass production of these images into calendars and postcards, which he then sells to stores in the tourism industry. In both cases, someone is investing money to fuel the production of the art and they are doing so because they believe this art to be commercially viable. Likewise, buying paints, brushes, and canvas is an upfront investment.

Many worthwhile projects are not ultimately profitable, which does not necessarily detract from their value. Keep in mind that this is also a relative concept—a concert by a famous singer may sell out a performance hall and generate $75,000, but if the singer has an artist fee of $100,000, this project is not profitable. Making it happen will require tapping alternative funding sources, or funding that is not an "investment" in the traditional sense. On a larger level, many artists' entire practices face similar challenges, regardless of how careful they are with their finances (although care in that area can reduce the shortfall considerably).

A note before we dig into the specifics: Just like commercially viable projects attract funding by demonstrating value through profitability, so must you demonstrate the value of your art by whatever measurement you or, more accurately, the funder/investor deems most appropriate. In the end, you will get a grant, award, or donation because the funder believes your project has value. Your challenge is to show that it does. This concept ties in to many of the others discussed in this book. For instance, proving your value to get funding as, say, a great painter is hard to do without spreading the word about your work through marketing and promotion. Conversely, a great marketer needs something solid to back up the hype, something like great paintings. This book seeks to enlighten the reader to the many interconnected tasks involved in becoming a profitable artist.

FUNDRAISING AREAS, TOOLS, AND TERMS

We understand that the names of the funding areas we will discuss are used interchangeably by many people and institutions. For example, NYFA awards artists in a range of disciplines—visual, literary, performing—with fellowships every year. Our recipients often characterize these as either grants or awards. In the academic context, what some universities term a "fellowship" is called a "scholarship" by others. There is no universally accepted definition for any of these terms. The definitions we provide below are used as a guide in this book; we group funding areas by certain core characteristics such as the source of funding, application requirements, and purpose of funding. And as you will see, certain areas can only be considered funding in the loosest of ways. Our intent is for these definitions to help guide your thinking and planning. When you put this section's tips and

strategies into practice, do not be misled into thinking that an opportunity with a particular name does not apply to you—look at each carefully before dismissing any!

In the art world, the most common types of funding are *grants*, *awards/fellowships*, and *donations*. While the specifics may differ within each category, the basic requirements are rather similar. Learning how to research and write grant applications, or how to solicit funding on a general level will serve you time and time again. Like the other skills we teach in this book—for example, cost identification through the Artist's Cost Tree (see Chapter 5)—the importance lies in the process rather than the specific examples.

In the field of grant writing, it is essential that you use solid research and organization techniques throughout your career. These will help you far more than simply learning the details of one lucrative grant or award that seems perfectly tailored to you. And the same focus on process over detail applies equally to other fundraising areas—it is better to have a strategy for soliciting funds from multiple sources rather than searching in vain for that one ideal patron.

Creativity in fundraising plays an important role as well. It is rare that any artist can fund a project through one source alone. There is a common misconception in the arts world that government and foundations have limitless amounts of money waiting for artists, and that with the right wording or even the right connections you can unlock this. It simply does not work that way. A timely grant or serendipitous patron might bridge the gap for an artist on a project, or give them a few free months of creative time, but it will not sustain a career or support a project in its entirety. Most successful artist-fundraisers not only combine sources but find innovative solutions like *strategic partnerships*, *sponsorships*, and *barters*, which enable stakeholders to contribute in ways other than cash.

Residencies and *scholarships* are other important funding outlets that artists often overlook. A residency can give you valuable time and space to create a project (for example, to finish a manuscript, compose a new work, or start a new series of paintings), while also offering both creative stimulation and access to a community of like-minded people (fellow residents) and new networking contacts (critics and other potential patrons who visit open studios, readings, or performances). Likewise, scholarships can enable you to acquire new skills, study a complex subject in-depth that you will later incorporate into your practice, or to gain credentials that are required for certain jobs.

GRANTS

Grants are perhaps the most common type of funding that artists think of when they begin to consider external sources to cover noncommercial projects. For our purposes, the term "grant" is intended to be used for a specific purpose. The purpose can range considerably from the general (e.g., unrestricted cash funding to make art—the most desirable kind), or

specific (e.g., write and direct a play about environmental conservation to be performed in the public schools).

In general, grants are given out by government agencies or by foundations (funding from entities like these is sometimes known as "Institutional Giving"). Both typically have mandates to disperse money in furtherance of a particular mission. While the mission can be extremely broad—for example, the mission of the National Endowment for the Arts (NEA) is to "support artistic excellence, creativity, and innovation for the benefit of individuals and communities"—it is common for private foundations to have a purpose that is more narrowly tailored—perhaps supporting work that furthers a social message. In both cases, there is usually some sort of limitation by category, such as discipline or geography, or whim of a family foundation funder.

Grants are characterized by a formal application process. The funder will typically have a finite application period where anyone who fits the category specified will be able to submit an application. Many grants have a standard application form (usually available online), although many others will simply give instructions to applicants on how they should submit their applications. Grant applications will almost always require some form of supplemental materials beyond a standard form, and we will discuss the application process in greater detail in Chapter 21.

Two other key features of grants are (1) time limitations and (2) oversight and reporting, both of which are related to accountability. Most grants will be awarded on the condition that the funded project be completed by a particular date. The time between when the recipient is notified and when the project is to be completed (and/or the final report is due) is often referred to as the *grant period*. Some funders will condition the release of funds on the successful completion of the project. This ties into the issue of oversight and reporting. Because the recipient is given the grant money for a specific purpose, the funder will want to know how that recipient is progressing and will want to see proof that the project was completed as promised. Depending on the size and scope of the grant, this oversight can range from an occasional phone call and short report at the end of the grant period to regular meetings throughout the grant period and detailed interim and final reports. In other words, the grant recipient is accountable for his or her use of the grantor's funds; a grantor, in turn, especially if a foundation or government entity, typically issues reports on the use of funds granted to a board of directors or government accounting agency—yet another layer of accountability.

The key distinguishing feature of a grant is that it is given for something—the recipient is expected to deliver something specific (some grants are backed up by formal contracts). The funder has a specific goal in mind and is in essence hiring the recipient as a subcontractor for the purpose of achieving that goal. While the funder may have broader goals in mind

when making the selection (for example, providing work for artists in a disadvantaged neighborhood), the end product is a very important component of the grant.

One caveat regarding grants is that artists should check to see whether the funds become available immediately, or are only available as a reimbursement (the latter being known, not surprisingly, as *reimbursement grants*). This is an important distinction that the artist needs to consider—if she receives a reimbursement grant for $50,000, does she have ready access to that amount of money? Even if she does, would it be wise to take that amount out of her savings or investments for this purpose? Doing so might leave her (or her organization) with very little cash reserve. Because of this, she will probably need to take out a loan which will not only add to her administrative expenses, but will cost money in interest. If so, she may need to build this expense into her budget (see Chapter 21 for a discussion on grant proposal budgets).

As a side note, many grants are not available to individual artists, but rather to groups or organizations, meaning that an individual artist would not qualify for these grants. We will address ways to get around this restriction in Chapter 21 ("Fiscal Sponsorship").

AWARDS (AND FELLOWSHIPS)

When we use the term awards, we are referring to money that is given to individual artists by an outside entity in recognition of the artists' achievements, skills, or potential. While awards can be quite specific (for example, rewarding excellence in a particular discipline, or work with certain materials in that discipline), the awards themselves are not given with specific expectations. An artist awarded a Guggenheim Fellowship in music composition receives money to aid in "artistic creation," but is not actually required to compose a single bar of music. Some awards do come with requirements—NYFA Fellows must fulfill a separate public service requirement in order to receive the final 10 percent of the otherwise unrestricted cash award, and other awards prohibit spending the money on anything other than a specific purpose—but the funding is not tied to a predetermined activity or project.

Like grants, most awards have an application process, and the competition for larger awards can be significant. The emphasis of the application, however, is on the artist's work. The work is often reviewed by panels of accomplished practitioners of the same discipline (known as "peer review"); the applicant's work sample is usually far more important than his or her written statements on the application. We will offer tips on effective work samples in Chapter 21.

Despite the fact that many awards have open applications, some only select recipients through a nomination process. A prominent example is the MacArthur Fellows Program (sometimes known as the "Genius Award"), which chooses its awardees through an anonymous nomination and panel system.

Due to the fact that awards tend to go to individuals rather than organizations, and also because there are few strings attached to the funding, award amounts tend to be smaller than grants. Therefore, funders can be small family foundations, corporations, or even nonprofit organizations. Many are local, are only offered sporadically, and are not well-publicized, thus necessitating good research skills by would-be recipients.

SCHOLARSHIPS

Scholarships provide funding for academic programs and sometimes for study not connected with an academic program. These are usually cash grants or reimbursements, or when offered by the academic institution or trainer directly, waivers of the tuition. The amounts range from partial discounts for discrete units of the program (a scholarship for the first year of study) to the entire degree.

While most scholarships are restricted to degree-granting programs, there are some forms of funding that specifically fund private study with an individual. An example of this kind of nontraditional scholarship would be NYFA's Strategic Opportunity Stipend (the "SOS" award), which funds an "Exceptional chance for advanced *study with a significant*

Keigwin + Company received a Building Up Infrastructure Levels for Dance (BUILD) from NYFA in 2007 — Keigwin + Company, pictured — Aaron Carr and Ashley Browne, a New York-based dance company.

PHOTO BY Matthew Murphy

mentor (outside of a classroom setting and not related to any degree program)" (emphasis in the original).

DONATIONS

Donations are, by and large, cash gifts by individuals, companies, or organizations. Donation amounts vary more widely than any other type of funding, quite literally ranging from a few dollars to millions.

Donors themselves—and their expectations—vary almost as widely as their gift amounts. A donor might be a parent or friend who cares about your career and wants to help you get started or to help you through a rough patch. A donor could also be someone totally unconnected to you but who believes in your project or a direction of your practice. As a general rule, donors with a significant personal investment in you or your work are more likely to give money for unspecified purposes. It is far more common for a donation to be tied to a defined project or stated objective (supporting an artist's 60th birthday concert, or the opening of a photography exhibit featuring Civil War battlefields). Effective donor campaigns both identify those likely to give and craft the "pitch" in such a way as to make it appealing. We address soliciting donors in Chapter 21.

One important characteristic of donations is the potential tax implication from the donor's perspective. Under U.S. tax law, many donations to charities or not-for-profit corporations (often known as 501(c)(3) organizations or, more casually, "nonprofits") are tax deductible. This is true for both individual and organizational taxpayers. So, in addition to entirely altruistic motivations, savvy donors may structure their contributions to serve as tax write-offs. As this may skew donations towards IRS-approved recipients, there are ways in which artists who do not have these designations can still take advantage of this feature of U.S. tax law. We will discuss this further when we deal with Fiscal Sponsorship and other elements of donor-based fundraising.

While we are using the term donation to refer mainly to cash contributions, it is worth noting that the definition can extend to virtually any kind of good or service. Donations of this kind are usually known as "in-kind" donations. A common example of this is a professional who donates his or her time to conduct professional services on behalf of an artist's project or practice (a carpenter who builds a set for a theater, or an accountant who assists an artist in filing her taxes). In some cases these donations are tax-deductible for the donors if made to a charitable organization—the general rule is that goods are deductible and services are not. There are obviously complicated valuation issues and the regulations governing this practice are ever-changing. An analysis of which donations are in fact tax-deductible is beyond the scope of this book, but the short answer is that, like cash contributions, every donation is evaluated on a case-by-case basis. The donor will need to get a

professional opinion before claiming any deductions, and when soliciting donations you should be careful not to mislead people into thinking that their donations are deductible. However, it is useful to know that the possibility exists as, in some cases, donors may have an added incentive to donate to you or your project.

PARTNERSHIPS

By "partnership," we are referring to any sort of professional relationship that the artist enters into with a person or entity who becomes a legitimate stakeholder in the artist's project or practice. The partner acquires this "stake" (or interest) in exchange for a contribution of some kind, be it cash (capital), services, or some kind of goods that plays an important role in furthering the artist's goals.

It's important to note that we are not referring to partnerships in the legal sense and as discussed in Chapter 11. Most artists enter into informal partnerships that are short term and usually undefined. These are closer to collaborations or "marriages of convenience" than a true business relationship. For example, two sculptors may split the rent on a studio and share space. Or a gallery seeking additional foot traffic may agree to host a classical music series in its space. However, there are many instances where artists will partner to achieve a common goal, especially for larger and more complex projects. This is especially common in a field like filmmaking, where it is nearly impossible for any one person to fulfill every responsibility. In this case, the lead producer may direct the artistic development while partnering with a promoter and a distributor.

In some cases, what we consider to be a partnership others might refer to as *bartering*. If a musician agrees to play at a church's Sunday services in exchange for being able to practice on the church's pipe organ (and thus develops a marketable skill), it is hard to say that the church has acquired a stake in the musician's career, or that the musician has a stake in the church's ministry. Nevertheless, we still treat these as partnerships from a funding standpoint to encourage you to think creatively when seeking alternative funding sources. When the musician in the previous example initially looked at the cost of his practice, renting or purchasing a pipe organ may have been prohibitively expensive. By working with the church he reduces that cost considerably, which in turn frees up other funding that he might obtain to cover additional expenses. Everyone has heard the expression, "A penny saved is a penny earned," and nowhere is that more true than fundraising. When artists look at their available funding options, too often they ignore strategic partnerships that can both reduce costs and add value.

SPONSORSHIPS

We define sponsorships as assistance or backing given to an artist or artistic endeavor by an outside party in exchange for acknowledgement. Sponsorships are sort of a unique hybrid

between donations and partnerships. The term sponsorship tends to be associated with corporations, where a company gives some amount of money to a project and has the company's name and logo printed on any promotional materials.

This model is more or less a form of noncommercial advertising. Turn on any PBS special and you will see the language "This program is made possible to you in part by the generous support of _____." Sponsors tend to look for projects that they believe will project a positive light upon themselves to a strategic audience, often funding sponsorships from their advertising budgets rather than corporate contributions. Thus, sponsors give stronger consideration to those projects that they believe will succeed—that is, ones that will give them a return on what is essentially an investment.

In addition to corporations, a range of noncommercial entities (and individuals) can also serve as sponsors. Nonprofit organizations, religious and community groups, and even politicians sponsor projects and events. Due to the more limited budgets of these entities, the sponsorships tend to be for smaller or more local projects. The decision to sponsor an artist may not be a business decision, but it is still motivated by the desire to advance a goal of some kind, often an ideological or organizational one. This is not to imply that sponsorships are somehow disingenuous, any more than receiving a tax deduction makes contributing to a charity disingenuous. A state senator who sponsors a crafts fair in her district may want to encourage economic development, increase her name recognition with voters, and truly love crafts. These are not mutually exclusive. But recognizing that sponsors—like donors—have a myriad of reasons for sponsoring an event will help you to define this category of potential sponsors broadly and to view them as a funding tool.

RESIDENCIES

We define a residency as any funded opportunity for an artist to focus on his or her work. The extent of the funding may vary widely. A residency can be, as the term implies, a chance for the artist to live in a space where his basic needs are met while giving him time to devote exclusively to his work. At the other end of the spectrum, a residency might be access to a workspace for a few hours per week in a desirable location.

Residencies are provided by any number of potential hosts, but the most frequent hosts are charitable or academic institutions with a serious commitment to the arts. Academic residencies tend to follow a "scholar in residence" model where the artist teaches some high-level course or master class and spends the rest of his time researching—or in the case of most artists, working on his craft. The amount of funding varies; the actual cash is usually minimal as the goal is to provide time and space for inspiration and conception, and not money for the actual execution of the project or work. However, the actual space—living and/or studio—can be, as the expression goes, "priceless." An exception might be in the academic context. Here, the residency is actually a lot closer to a short-term faculty position

Creative partnerships and sponsorships, both artistically and with members of the larger community, are an invaluable tool for realizing large artistic projects — Katy Rubin (Artist as Entrepreneur Boot Camp participant), *Hellter Shelter*, 2011.
PHOTO BY Barry Rosenthal (also an Artist as Entrepreneur Boot Camp paricipant)

and allows for an accomplished artist to serve as an unofficial professor, even if she otherwise lacks the credentials, earning experience and a valuable résumé entry. It is important to note that after the offer for residency has been given, an added unofficial bonus is the residency offering to make arrangements for discounted rates for travel, room and board, and/or other expenses, as well as working with future residents to keep these costs low or free.

The expectations attached to a residency are usually quite flexible. In this sense, a residency has much more in common with an award than a grant. While some residencies may ask to see a finished product at the end of the period (these are sometimes referred to as "project-based residencies"), most do not (sometimes known as "time-based residencies"). The goal is to provide artists with the time, space, and/or materials to create. The underlying philosophy is that artists do not simply create work spontaneously, but rather require certain minimum conditions in which to make work. Because of this, residencies are often considered to be an artistically "pure" form of funding as they emphasize the creative process. They are also available in almost any discipline.

In addition to time and space to develop one's practice or complete a project, residencies can be good opportunities to network with the other artists, administrators, and supporters. These people will be able to get to know you over a period of weeks or months, and will also be able to see your art in-depth. While we discuss networking in depth in _ Chapter 18, time and access are two major challenges to any artist seeking to network and a residency can give you access to both. Some residencies, like Art Omi, offer feedback from curators, academics, critics, or industry leaders, which can be valuable exposure and input. And, like any grant, award, or academic degree, residencies are résumé builders as they indicate that a reputable organization has supported or vetted you.

We should note that there are numerous residencies where artists get the benefits of a traditional residency but pay a fee for the privilege. Some are subsidized and competitive and, therefore, more like awards. From a fundraising perspective, we do not include unsubsidized fee-based residencies in our definition, and some, but not all, fee-based residencies also tend to be missing other important characteristics of funded residencies, namely the résumé building (prestige) factor, and a less rigorous application process. However, fee-based residencies can be a wonderful resource for artists with the required funds to further their artistic goals, and you should be aware of them while researching residencies.

BARTERS

Bartering is essentially trading or exchanging one goods or service for another. The IRS defines bartering as follows:

"Bartering occurs when you exchange goods or services without exchanging money. An example of bartering is a plumber doing repair work for a dentist in exchange for dental services. The fair market value of goods and services received in exchange for goods or services you provide must be included in income in the year received."

And there is more:

"The Internet has provided a medium for new growth in the bartering exchange industry. This growth prompts the following reminder: Barter exchanges are required to file Form 1099-B for all transactions unless certain exceptions are met."

So, if bartering is actually an exchange and is tracked by the IRS similar to any other purchased goods or service, why discuss it here? Strategically, bartering can be an important fundraising tool for artists by enabling the artist to engage in a transaction he or she could not otherwise make. Suppose a sculptor needs to hire a lawyer to help him obtain an "artist's visa" to complete a series of works in the United States. Between the lawyer's time and the associated filing fees, the total bill might come to $2,500. If the only means of exchange is currency, the sculptor may be out of luck. But he has a studio full of sculptures and the

lawyer is an art collector. The lawyer looks at the sculptor's work, chooses a piece, and obtains the visa in exchange for the sculpture.

Did the sculptor in this example receive funding? Technically no—the lawyer still performed a $2,500 service and received a sculpture that was (reportedly) valued at $2,500. But, on a practical level, this is fundraising as it enabled the artist to get something he could not have otherwise been able to afford. There was no guarantee he could have sold the piece for $2,500, or quickly enough to make the visa deadline.

If you make bartering a regular practice, you would be wise to investigate the IRS regulations carefully and learn how to calculate the value of goods and services you provide. Not only will this keep you from unpleasant interactions with the IRS, it will ensure that you are engaging in transactions that are fair to you. One danger of bartering is that artists may systematically undervalue their work or services, in which case they are losing money through bartering rather than using it to their advantage. Many factors influence value in a barter, so truly understanding your costs and your needs are essential to making it worthwhile.

For now, keep it in mind as yet another fundraising tool. Successful artist-fundraisers use creative and flexible methods to meet their goals.

RESTRICTED VS. UNRESTRICTED FUNDING

One final category we need to discuss regarding funding is not a specific funding stream but a classification. Funds can be broken down as "restricted" or "unrestricted." "Restricted" means that these funds can only be spent for a specific purpose (as determined by the funder or grantmaker). This is most commonly seen in the grants context, where a funder has elected to give money only to support a particular project. Usually the funder does not itemize the individual categories of allowable expenditures, but rather gives the recipient discretion to use the funding to complete the project as they see fit. This is one reason that submitting realistic budgets is so important when applying for funding (we will discuss this in more depth in Chapter 21). If you have itemized and given realistic estimates to the categories for which you seek funding, it will make your reporting responsibilities easier.

NYFA's re-granting programs offer several examples of restricted and unrestricted funding. Our Building Up Infrastructure Levels in Dance program (BUILD), offers *restricted* funds to dance companies that fall into certain parameters. The restriction in this case is that the funds may not be used for purely artistic purposes (such as creating a new work), but rather for expanding the dance company's infrastructure. So, hiring a grantwriter, purchasing new bookkeeping software, or even renovating rehearsal studio space would all be allowable expenses, but commissioning a choreographer or a composer would not. Functionally, this restriction is enforced by having occasional check-ins with the grantees

and requiring a final report that explains the use of the funds (as well as any significant deviations from the original proposal).

The NYFA Fellowships, on the other hand, are an example of *unrestricted* funding. On a cyclical basis, artists from every discipline are awarded $7,000 to use as they see fit. An artist can use it to buy materials for an installation work, but he can also use it to pay his rent or throw a party for his parents. The funder (NYFA) does not place any restrictions on how he uses the money aside from the stipulation that 10 percent of the funding goes toward a public service component of the work.

As we mentioned in the definitions above and will address in greater detail in the section on applying for funding, Chapter 21, the applications and criteria for the restricted funding (BUILD, a *grant*) differ from the applications and criteria for the unrestricted funding (the NYFA Fellowships, an *award*). The restricted funding is a detailed application that emphasizes the applicant's intended use of the funds. While the underlying art is an important consideration, the funder is most concerned with how the funding will further the applicant's stated objectives and whether those objectives fit within the parameters of the funding program. The application includes a detailed budget form in which the applicant must itemize revenues and expenses for the past, current, and upcoming fiscal year. The application process for NYFA's unrestricted award is really all about the artist's work. There are parts of the application where the artist must provide background on himself and his work, but the single most important part of the application is his work sample.

As you construct your own fundraising strategy, it is important to keep in mind whether the funds you seek are restricted or unrestricted. We will dissect the funding of a sample project in detail at the end of this section. But, for now, remember that a major consideration will be whether you have restrictions on how you spend the funds that you raise. Knowing the details of the costs associated with your project or practice will give you the flexibility to seamlessly integrate restricted funding into the larger budget, and will also keep you from applying for funding that you might receive but could not use.

How to Identify and Research Funding Opportunities

As you start to become aware of the very broad range of funding available to artists, you will next look for the specific opportunities right for you. Being aware of so many potential avenues can be overwhelming from a planning perspective, especially if this is a new area for you. You will likely want to find a starting point from which to base your research.

FOR WHAT DO I NEED FUNDING?

One way to determine your starting point is by asking a seemingly simple question: "For what do I need funding?" In other words, build your budget first. By knowing all of the costs associated with your project or practice, you will then be able to match specific needs with specific funding opportunities.

If you read through some of the earlier sections of this book, you have already encountered the Artist's Cost Tree. If you haven't read through the finance or strategic planning sections or gone through any of the exercises, we recommend that you take those steps. In short, what we emphasized was the importance of understanding and categorizing all of the costs associated with your art or business, and also creating a plan to help implement your objectives. If you have done this already, look carefully at the final version of your Artist's Cost Tree, specifically at the cost categories you arrived at for your project or practice. Let's take a quick look at five broad categories for which almost every artist needs to find funding.

YOUR TIME

A universal need would be your time. We addressed opportunity cost in the finance section, but even if you are not taking time away from another job or source of income (opportunity cost), you need to get paid. We will revisit this when we get to actually structuring a specific

proposal, but you should get in the habit of thinking about your time as a real expense from a funding perspective.

SERVICES AND LABOR

While some artists might be inclined to ignore or undervalue their own time, if you need services performed by others you will quickly have to consider the value of *their* time. Try to break down exactly what kind of services you need. Is it general administrative assistance, or an extra pair of hands on the set/studio/office? You will most likely be able to pay by the hour, or you might even consider putting someone on salary if there is enough that needs to be done. If you require more specialized services, such as equipment repair, legal help, or accounting advice, these providers sometimes charge a flat fee depending on what you need done.

One tip to remember when it comes to specialized services is that, while these are likely to be more expensive than general labor costs, you may have a better chance of getting funding to cover professional services. For one, some professional associations (like law) require pro bono hours from their members. Another reason is that specialized services tend to be easier to track—there is often some standardization of prices, and they fit well as a "line item" on a budget. This makes them easy to understand and estimate from a funder's perspective. It also makes them good candidates for bartering as you can more readily assign a value to them for tax purposes.

SUPPLIES

What sorts of supplies will you need for your project or practice? If you are a studio artist, this could range from the cost of paints and brushes to the cost of raw materials for a sculpture. Set designers might need lumber and nails and choreographers need costumes for their dancers. As you revisit your cost tree section where you itemized all of your project or practice's costs, take note which of these arise from supplies and any details you notice about them. Are you purchasing from a particular company, individual, or geographical region? Is this a one-time or recurring expense? All of this information can ultimately be worked into a funding campaign.

SPACE

With a few exceptions, most artists will need space for their projects, whether it is to create and store the art, rehearse the performance (or simply maintain the artist's skills if he or she is a performer), or present the work. Even those artists who work from home are still using space—and paying for it. Location is a factor, as those artists who need to be near a particular population center may find that paying for space is their single largest expense.

TRAINING AND EDUCATION

Many artists find that they require training or additional credentials in order to achieve their goals. While the cost of training or education is unlikely to be covered by most project-based grants, there are other significant funding opportunities in this category (primarily through scholarships).

THE BIG PICTURE: ANYTHING AND EVERYTHING CAN BE CONSIDERED "FUNDING"

Five categories of things requiring funds is by no means an exhaustive list. You will have to analyze your own needs to get an accurate picture of what you must fund. The point here is that you can ultimately view every aspect of your project or practice as something fundable.

At first glance that may seem like you have made your job more difficult, not easier. However, analyzing your entire project as something for which you need to find funding should ultimately be extremely liberating—you have just expanded your options immeasurably. Many artists limit their search for funding to large, unrestricted awards, and thus miss out on a whole range of other opportunities. Everyone wants a MacArthur Genius Grant, but you can better spend your time focusing on funding over which you have more control. As an artist you need to expand your conception of what is funding. Remember to think of funding expansively as obtaining something that you need for your project or practice for which you do not have to pay.

IN-KIND DONATIONS = FUNDING

In-kind donations, while they may lack the fanfare and prestige of a competitive award, are functionally the same as receiving a check for the cost of the item donated. Take a look back at the five categories we identified earlier. If an artist is seeking studio space in a neighborhood where studios routinely rent for $500 per month, and she then finds someone to donate a studio rent-free for a year, she has in effect just "raised" $6,000. Perhaps she is in a very tight real estate market and cannot convince her landlord to donate a studio for an entire year. However, he does agree to drop the rent from $500 to $400. Once again, she has secured funding, this time worth $1,200. Many traditional grants and awards are worth far less than this.

SPONSORSHIPS = FUNDING

Continuing with the studio example but in another funding context, suppose the landlord owns several buildings in the area and is trying to establish an arts presence in the neighborhood (perhaps he believes the arts will raise property values, something known to happen).

He offers the artist a 50 percent reduction in the $6,000 rent, and—in exchange—asks that his company's name and logo be displayed on the street-level windows of the studio and that the artist keep a stack of his company's brochures near the front door so that visitors will easily access them. This can be considered a sponsorship, and the artist will have found funding worth approximately $3,000. We say "approximately" because there are some strings attached to this funding—the artist may not want to display the landlord's materials, and most certainly would not have done so without the reduction in rent—and that may reduce the value somewhat. However, most artists will accept these kinds of conditions in exchange for what the landlord is offering. This is, of course, an individual decision.

BARTERING = FUNDING

Perhaps the landlord is an art collector and likes the artist's work. The artist agrees to give the landlord a signed print in exchange for a free year of studio space. Did she just receive funding? This is a much more difficult question and, as we discussed earlier in the section on bartering, involves a lot of calculations to arrive at a real answer. The short answer is, it depends on the value of the work (as well as other factors like the artist's income and what kind of deductions she could have taken on the studio, which is beyond the scope of this book and would likely require the services of an accountant). On a practical level, the answer is usually yes. If the artist had a well-defined and ready market for her work, or could sell it for a significantly higher price than $6,000, she would simply do so and pay the rent directly (again, unless there were tax advantages to an exchange). Most barters or exchanges are not of equal value, and one party almost always accepts an item with a lower "paper" value than what he gives up. However, the landlord and artist both benefit in a way which may not have been possible using a traditional monetary transaction and the artist has—essentially—received a form of funding.

THINKING CREATIVELY ABOUT FUNDING

These examples illustrate ways in which an artist can employ nontraditional funding techniques to meet important needs while not receiving money outright. Nevertheless, each funding example represents a situation where the artist receives something that reflects a real monetary value. Once you recognize that you can apply this approach to virtually every single cost associated with your project or practice, you will grasp just how wide your potential fundraising world is and how many resources you have at your disposal.

Your creativity as an artist will serve you well here. Your ability to think fluidly will help you identify nontraditional ways to cover your costs. If, after extensive research and inquiries, you determine that there are no grants that cover your transportation expenses,

try a different angle. Can you partner with someone to split the gas (a tax-deductible expense if not funded), or get an airline to sponsor you? Perhaps you can find a way to cover another expense and thus free up extra money for transportation.

Finally, be a detective. Look at artists who have been in similar situations or have put on similar projects. How did they do it? Were their budgets larger or smaller than yours? If you attend a show, be sure to pick up a playbill, which list sponsors and other funders. If an artist you admire has a corporate sponsor, perhaps it suggests that the company is courting a new demographic and that another company in the same industry will consider your project. Don't just toss invitations to arts organizations' benefits because you cannot afford a ticket. Check out the sponsors and benefit committee for ideas. Just as in art, in the research stages of funding alternatives, there are no silly ideas.

DOING THE RESEARCH

Becoming aware of the wide range of potential funding sources and understanding how your funding needs fit into this matrix is only one step in the process. You also need to dive into the research itself. Let's examine some ways to approach this. We will discuss research strategies according to categories that share common characteristics.

As noted earlier, grants are sometimes known as "institutional funding," mainly because the primary grant makers are large institutions. However, large institutions often fund awards and fellowships. And, given the lack of standard definitions in the funding world, people sometimes refer to the different categories interchangeably (grants and awards for one). This both hurts and helps your research. On the one hand, you can search for several kinds of funding in one location. On the other hand, your searches may yield less targeted results, which simply shifts the burden to you to comb through these results more carefully.

The Internet is your most important tool for researching institutional funding. At this point almost all major funders have websites, which post guidelines and past recipients; they also make their applications available online. In fact, some announce funding opportunities exclusively online (as we will discuss in the next section on Applications, an increasing number also require online submission of at least part of the application). While there may be the rare exception, you will likely be able to discover their existence with a thorough web search anyway.

NYFA works with some of the leading grantwriters and development experts in the field, and they repeatedly stress two points about Internet research for funding. First, begin by tailoring your search to organizations and corporations with an interest in your specific medium. As everyone knows, the Internet is a dauntingly big place. It's very easy to get sidetracked or completely lost, even on a limited search. By starting with your own medium,

you are more likely to have some early successes with websites and organizations that offer relevant information or opportunities. Even those sites that don't have anything directly of interest might have useful links or be part of a larger network that has what you want to find—which is grants, awards, or fellowships for which you are eligible.

The second recommendation is that any artist who wants to undertake serious funding research be familiar with good search practices in databases and online search engines. For instance, the dominant search method is known as a "Boolean" search. An example of Boolean logic would be the use of the words *and, or,* and *not*—among others, as well as quotation marks—between words in your search. Pennsylvania State University offers a helpful explanation of this concept at *www.sgps.psu.edu/foweb/lib/boolean_search/index.html.* Also indispensible is Google.com, the Internet's dominant search engine. Boolean logic does work with Google, but is more useful on more focused databases.

Internet research really comes down to creative thinking and willingness to patiently explore by trial and error without getting sidetracked from your original goal. Try to search for terms specific to funding to your medium, narrowed down as much as possible, and avoid very general terms, which can yield unrelated results (for example, "painting" will bring you to a history of the art form, painting for commercial structures, and art supply stores, whereas "painting fellowships 2011" will give you more targeted hits). Once you have identified one fellowship, grant or award, pull language from the application where it discusses exactly what kind of work it funds. Running a search for that language might bring you to similar funding applications.

GETTING A HEAD START ON INSTITUTIONAL FUNDING RESEARCH

With the ease of Internet links, almost any website can be an informational clearinghouse for grants, fellowships, and awards. Your college or university's career services page might have collected some funding opportunities and links and your local or state arts council might, too. There are dozens, if not hundreds of reputable societies or not-for-profit groups that focus on promoting a particular arts discipline. Their sites will almost certainly have links you can use (see Fundraising Resources for Artists at the end of this section for some additional suggestions).

There are also several well-known "repositories" of funding information that cover numerous disciplines and funding categories. These will be useful to any artist as a starting point, and we have summarized two of the most complete below, the Foundation Center and NYFA Source.

Foundation Center

The Foundation Center is America's largest source of information on private philanthropy. By offering a comprehensive website and five regional library/learning centers, the Founda-

tion Center allows philanthropic organizations to get the word out about their mission and, in turn, provides a central clearinghouse of funding information for grant seekers. Also available is a wealth of information intended to guide individuals and organizations seeking non-profit status.

Available both online and in the Foundation Center's library/learning centers are books and periodicals on foundations, fundraising, nonprofit management and philanthropy and reference librarians and guides to help you find the right information for you. Additionally, the Foundation Center offers a range of courses (online and in-class), seminars and webinars geared toward fund seekers of all levels and at various stages of the process, some free and others for a fee.

An emerging artist living in or near Washington, D.C., New York City, San Francisco, Cleveland, or Atlanta who wishes to learn how to write a grant proposal, for instance, may take advantage of the free, in-class *Proposal Writing Basics* at his or her local Foundation Center Library/Learning Center. For those not so close to a brick-and-mortar site, both a free online guide/tutorial and webinar are available and cover the same material. Also offered to the novice grant or fund seeker are online and in-class instruction on other areas, such as budgeting basics.

NYFA Source

NYFA source is an extensive online directory—national in scope—that lists awards, grants, residencies, services and publications for artists across disciplines. Artists seeking resources to further their career, such as space in which to work, funds for a project, arts-in-education opportunities, or material suppliers, are able to access NYFA source free of charge to find what they need.

NYFA Source is unique among funding databases in that it is specifically tailored to artists. It is especially useful for individual artists or those who do not have not-for-profit designations or fiscal sponsorship.

Updated regularly, the thousands of listings can be searched by discipline, location, award type, deadline, organization and keyword. Organized to maximize usability, each listing provides a description of the opportunity, the deadline (if applicable), application requirements, organization contact info, and a URL where available. This highly navigable format allows any artist to quickly find opportunities that neatly fit his or her qualifications and interests.

Source lists opportunities and services that are discipline-specific as well as those that are cross-disciplinary, specific to certain regions or available to artists across the United States or worldwide.

For example, a search for "Artist Communities/Artist-in-Residence Programs," located in the "Awards" tab, results in a total of 555 Opportunities.

Fig 19.1 - NYFA Source
Database, www.nyfa.org

Fig 19.2 - NYFA
Source Lisitings

Fig 19.3 - NYFA Source,
Artist Communities/
Artist-in-Residence
Programs

Fig 19.4 - NYFA Source,
Opportunities by
Discipline

Fig 19.5 - NYFA Source,
Programs Open to
Applicants Worldwide

Fig 19.6 - NYFA Source,
Opportunities

This can be further refined in any number of ways to find opportunities more specific to a discipline, location, or special demographic. Clicking on "Refine Search" and then the "Discipline" tab, and selecting "Dance">"Dance, all" narrows the list down to 62 Opportunities that are specific to dancers.

Clicking once again on "Refine Search" and then on the "Programs Open to Applicants Worldwide" tab, results in 28 International Opportunities for dancers.

Of course, the Internet is not the only way to search for institutional funding opportunities. As we said before, be a detective. Your local library or bookstore may have books about funding or grantwriting. Some of these will have indexes with examples of funders. Look for books that deal with your medium in any way, and check the title pages and acknowledgments section. It is quite possible that the author received a grant or some sort of funding, and the funder will be acknowledged here. This may apply to you even if you are not a writer. Institutions that fund books on "The history of 19th Century Theater" may also fund contemporary theater companies. Search playbills, gallery websites, and any other literature published by funded artists to learn by whom they are funded. And be strategic with your research—recently funded projects or artists are more important to you than those that were funded twenty-five years ago. If an individual artist received an NEA grant in 1985, that doesn't help you since the NEA no longer funds individual artists!

Residencies and Scholarships

When researching residencies and scholarships, you will be using many of the same tools that you used in researching institutional funding. Certain repositories will no longer be useful—for example, the Foundation Center doesn't cover these kinds of individual opportunities—but others (such as NYFA Source) list residencies and scholarships as well.

An important point to remember is that these are mainly individual awards (i.e., funding that covers one person). If you are seeking a scholarship to an academic institution, you should start with that institution. Most schools have both merit- and need-based scholarships that are completely separate from other forms of financial aid and student loans, and information on those awards will be readily available either on the website or by calling someone in the financial aid office and asking what is available. Sometimes departments within schools have specific scholarships, so it is a good idea to search the web pages for each department (or contact the chair of that department).

Moreover, many interest groups offer scholarships as well. As with institutional funding research, many organizations and interest groups have resource listings. However, some of these groups offer small scholarships, especially if their organizational mission is to advance an art form or a particular subgroup in an art form. As you have already done in the strategic planning section, and possibly in your marketing research, consider what kinds of

categories can be applied to you. It is worth repeating that how you see yourself and your art may not be the same way that the outside world does. Artistic medium, race, ethnicity, gender, geography, age—all of these are categories that may attract scholarships (or other funding) from different groups. If you balk at the notion of identifying yourself with a certain category that is completely understandable and, obviously, your decision—just know that you may be eligible for funding in these categories.

For residencies, your best research strategy will be the same kind of detective work you would use for institutional funding. NYFA Source is an excellent starting point (see ____ for an example of how to make the most out of a search in this database). Another comprehensive resource is the Alliance of Artists Communities. For your other searches, keep in mind how most artists take advantage of residencies—making work. So if there is an artist whom you admire in your field, or simply one who has enjoyed success, look carefully at his or her biography and résumé. Residencies are considered prestigious and will be listed there. Like scholarships, many residencies are offered according to demographic categories, so researching artists with whom you share common traits beyond medium may give you some leads. And as always, your personal network will be a valuable resource too—many residencies are small and best found through word of mouth.

Once you have identified several residencies in your field, do Internet searches with the names of those residencies as that might lead you to sites that list others, or to a discussion forum where artists discuss their experiences. If you want your next work to be a large installation piece, look into the size of the space offered. If you can visit the space in person, even better. Given that the residency concept is so personal and so tied into how you create, you will want to do additional research on the program after you have identified it. Applications take time, and there is no point in applying to something that will not be a good fit for you or your art even if you could be accepted.

Sponsors and Donors

Searching for sponsors and donors is a far more complicated task. This is especially true for donors who are private individuals—organizations tend to keep this information confidential both because they do not want the competition and out of respect for the donor's privacy. While you can often obtain the name of a significant donor by engaging in similar detective work to what you have done for the other funding categories—for example, many arts organizations and presenters publish names and general amounts ("Gifts in the amount of $5,000 or more were received from ____), either in programs, websites or annual reports—you probably won't have contact information.

If an artist receives a large cash donation from his mother, she would be considered a donor, but you would have no reason to believe that she will donate to your project. She

might be doing this for tax purposes, or because she wants her son to succeed, or because she is just a patron of the arts. That is the difficulty with researching private donations—knowing who these donors are does not help you very much. Making meaningful connections is one reason networking is so important and so intertwined with your fundraising strategies.

Sponsorships tend to be easier to research because they are intended to be publicized. If an artist is sponsored by a corporation or organization, that information will be displayed prominently on any promotional materials produced by the artist, including the artist's website. If the sponsor is a large entity, you will have easy access to a wealth of information about it online. Once you find a corporation that sponsors on artist or project, begin searching for instances of the corporation's sponsorship program. Do they sponsor multiple artists and projects? Is it part of a defined sponsorship program? Is there a specific contact person at the company that handles sponsorship inquiries? Also look for patterns—you may see that the sponsorships take place in certain regions, or fund certain types of projects (perhaps ones that could be used to promote the company's product or mission). The more you know about who they have sponsored before, the more targeted your solicitation will be.

One other suggestion is that you should reexamine all of the categories to which you may belong—just as you did when researching scholarships—but also to look carefully at any materials with which you work. Unless you are gathering and constructing them yourself, you purchased your supplies from somewhere and they were made by someone. Either the retailer or the manufacturer could have an interest in sponsoring your work depending on the nature of their business. This is especially true if you are seeking a discount or in-kind donation rather than cash.

Barters, Partnerships, and other Nontraditional Options

Research into these areas is extremely varied because the nature of the funding is so diverse—as we discussed earlier in this section, most of these categories would not qualify as "funding" in the traditional sense. Nevertheless, they are proven avenues that may help you to bridge a financial gap in your project or practice, and you should have a strategy to research these as well.

While networking plays a vital role in everything you do and is a key part of your donor research, it is absolutely essential for identifying potential partners, in-kind donors, or people with whom to barter. Because so many of these opportunities exist on a local level, there is often no way to learn of them other than through word-of-mouth. Furthermore, as many of these opportunities involve working with another person, you probably want someone you trust to have vetted the other party, or at least to have heard of them. There are no application processes in these areas, and while you may be adept at evaluating a potential

partner or collaborator, you will be relying on intuition as there is rarely information/ records to confirm your first impressions. We usually think nothing of dealing with total strangers in a business setting, because the basis for the exchange is money. If the basis shifts to a relationship or to a promised service, the need for trust increases.

If your network is not that well-developed, or even if it is, there are other online options, particularly for bartering. Just enter "barter" or "bartering" into any search engine and you will find any number of websites that offer bartering services or purport to be a marketplace of sorts. We would caution against using any of these unless you know other people who have used them successfully. Remember, most of these activities are unregulated.

Craigslist.org

One of the largest online "marketplaces" is Craigslist (*www.craigslist.org*). Craigslist has proven to be a significant resource for many artists. There is certainly no shortage of scams or predatory individuals on the site—it is a huge site with no restrictions on who can use it—but the fact that it is free, easy to navigate, and organized both logically and locally, has made it a popular stop for artists.

The site has sections designated for trades, but people post barter options under almost every category. There are numerous sections devoted exclusively to the arts, and also sections devoted to community-building. If you click on the "for musicians" link, you will see posts looking to sell old guitars, advertising music for weddings, auditions for established bands, specific calls for last minute gigs, but also posts by individuals looking to form bands, to hold a jam session, or just to find other people who appreciate Jimi Hendrix and want to meet up and listen to rare recordings. As the site is organized geographically, the big cities with more established arts communities tend to have more listings than areas with smaller populations. There are benefits and drawbacks to both, as the big city pages tend to have many more "spam" posts along with more opportunities, whereas pages covering a smaller population tend to get a higher percentage of serious posters, thus increasing the likelihood that you will make a legitimate connection. Because the site is free, you can access (and post) in any region that interests you, so if you are looking to see what commercial space costs in another region, you can get a feel for the market. The search function is limited to specific sections of the site, but otherwise operates like most search engines.

TAILOR YOUR SEARCH TO YOUR NEEDS

Ultimately, you will choose a funding plan that best suits the funding needs of your project or practice, and will structure your research accordingly; more importantly, it is essential to keep in mind that for the next project, the plan may change. What we would urge you to

remember is that your creativity and flexibility are your most important assets. The suggestions and resources that we have put forward in this chapter are just that—suggestions. But if you remain aware of how many different kinds of funding options exist, and how they these interact with your larger planning, budgeting, and networking efforts, you will find a way to fund your project or practice.

PUT YOUR RESEARCH INTO ACTION

NYFA has provided a sample "Funding Table" for you to begin organizing your funding plan (see Figure 19.7). You can create a similar sheet in Google documents, on a word processor with the "Table" function, or simply by hand.

Application Management Worksheet

Organization	Solicitation	Amount	Deadlines	Status	Response	Contact
NYFA	Online Application	$7,000.00	12/01/10	Pending	Received	David Terry (212) 366-6900
City of Chicago Dept. of Cultural Affairs, Community Arts Assistance Program	Application	$1,000	1/31/11			culture@cityofchicago.org

Fig 19.7 - Application Management Worksheet

Applications and "Asks"— How-to from the Experts

After you have conducted your research thoroughly into which specific funding opportunities are most appropriate for your project or practice, your next step is to work toward securing that funding.

There is no one right way to do this. There is no "standard" grant proposal, no winning formula for artist work samples, and no perfect conversation that will inspire a donor. But, there are certain common features in most funding applications, and certain basic techniques that fundraising specialists use when soliciting individual donations. We will begin by examining the common elements for grant and award applications, then dissect the anatomy of an "ask" (soliciting an individual donation), and finally address how awareness and good networking skills can help with some of the less traditional funding categories (as well as the more traditional ones, too).

APPLYING FOR INSTITUTIONAL FUNDING: THE APPLICATION PACKET

As we did in the research chapter, we will discuss the applications for grants, awards and fellowships together under the category of institutional funding. We begin with the steps you would take in an application for a grant (as defined in Chapter 19) since these applications tend to be more formal and complex than those for awards and fellowships. Nevertheless, many of the basic "tools" you would use in a grant application could be used for a fellowship or award, if adapted slightly. We will address some of the few significant differences between these types of applications as well. Just a quick terminology note—applications for institutional funding are often known as "proposals," so we will use proposal and application interchangeably.

YOUR GRANT PROPOSAL

The work on your proposal actually begins prior to assembling it. For a significant grant proposal, it is customary to reach out to the potential funder before you apply. You would usually do this by a letter or e-mail to the program officer in charge of the grant program, or the executive director (or president) of the institution if there is no designated contact person. If you have had contact with the institution before, a phone call might be appropriate. Your communication will consist of what funding professionals sometimes refer to as an "elevator speech" (yet another instance where your mission statement will help you). In it, you will tell them directly:

- Who you are
- What you do
- How what *you* do fits well with what *they* do. This last part is especially important.

There are several reasons for making this initial contact. Some grants require pre-approval from the funder before they will even consider your application. More commonly, however, making contact with the funder gives you the chance to gauge whether you are a legitimate candidate for the grant. Institutional funding staffers are very busy and need to go through many applications—they have no interest in reviewing ones that are not serious. By reaching out beforehand you are being respectful of their time and yours. And that is the final question that you should be asking prior to applying, "Is this worth my time?" Although we encourage artists to be creative when it comes to fundraising and to find unique ways to cast their projects, we also don't want you wasting time writing hopeless proposals when you could be making art. Before you make any form of contact, it is essential that you are totally familiar with the potential funder. Read the funder's mission and any grant guidelines. You do not want to waste your precious time in a pointless quest, nor do you want to embarrass yourself by asking them questions that would have been answered by their written materials.

ELEMENTS OF A TYPICAL PROPOSAL

Many proposals require certain basic elements. While the instructions will ask for these items specifically, it helps to know what they are before you begin as it will help shape your thinking. It will also save you time if you are planning to apply for many different sources of institutional funding; you will already have many of the materials ready to go and can just adapt them as needed to the opportunity. The common elements that we will address are the project narrative or description, executive summary, résumé, biographies, artist statements, work sample(s) (this is usually required for fellowships and awards, and less commonly for grants), a budget (the reverse is true), and references and letters of recommendation.

Narrative or Project Description

The narrative or project description is part of all grant proposals and is part of most awards and fellowships as well. It is probably the most important part of the application, because you get to "make your case" for why you should receive this funding. This is where you get the most space to talk about your project, and you will want to make sure to discuss why there is a *need* for it. That is, what makes your project necessary or revolutionary or worthwhile? Your focus should be on how your project applies to the funder. Why should they care? Why should they commit entrusted funds or taxpayer dollars to you? When you did your initial research, you should have also examined the institution's mission. If its mission is to help educate children about art, and the stated purpose of the grant is to fund projects that teach art in the public schools, you need to make sure that the narrative tells them why this effectively educates children about art and how you are going to do this in the public schools.

That may sound obvious. But it highlights the single most important thing to remember with grantwriting: follow the instructions. Many proposals fail because the applicants did not properly read what the funder was looking for. Often the question in the application that asks for the narrative will be open-ended, and that gives you some flexibility to frame your project creatively. But if the application calls for something specific, provide it. Failure to do this means your application will not make it past the initial checking to see if the rules were followed.

Another tip for successful narrative writing—never *assume* knowledge on the part of the person reading the application. This is not intended to deride funders in any way, just to remind writers that you need to define clearly anything that you believe is essential to understanding your proposal. The institution may be calling for proposals in a new area, and the staff has not had time to learn all of the industry jargon or significant "players." Your goal should be to make reading your application as easy as possible for the potential funder.

Finally, you may want to describe briefly your background, and/or the history of the project, depending on the nature of proposal. This is not the place for your biography or résumé—that will come later. But highlighting anything that will give the funders confidence that you have the experience and commitment to accomplish what you are proposing will ultimately help your chances of success. Do not risk sounding presumptuous or arrogant by just saying "see attached résumé." Remember your elevator speech? A sentence about yourself, not just your work can also be useful. The same can be said for any significant developments or milestones in your project's history that have led it to the point where it is now. Your funders are ultimately accountable to someone—board members, supervisors, voters, shareholders—and they want to ensure they "invest" in the right proposal. Your narrative should erase any doubts, misunderstanding, or questions they could possibly have.

Executive Summary

The Executive Summary is always brief, perhaps as short as one paragraph. It quickly summarizes the key points of your project, and gives a decision-maker the chance to understand what your proposal is about without having to read the entire application. An executive summary is often not required, especially in award or fellowship applications. Even if not required, you might want to think of it as an introductory and/or closing paragraph if you are submitting a narrative text.

Résumé

Almost everyone is familiar with a résumé, which essentially lists your professional information and history. Depending on your audience, medium, and objectives, your résumé will arrange and highlight information accordingly. An artist who regularly applies for funding might have multiple résumés that she uses for different purposes. For example, one might highlight her skills and experience as an educator, and another might focus on her history as a successful performance artist. It is not a question of substance but rather of emphasis—if brevity is the soul of wit, it also does wonders for résumés. Your résumé should highlight those strengths and qualifications that will impress the funder and show that you either have the capability to carry out the project or continue producing quality work. Everything else is unnecessary. Even artists with successful fifty-year careers will need to truncate their exhibition histories or discographies, because a résumé that stretches to seven pages looks unprofessional rather than impressive (the general rule of thumb is that you should keep it no more than two pages, with one page as the ideal). The exception is an academic curriculum vitae (CV) for a college or university job where comprehensive length is encouraged, not discouraged.

The following is a rough guide to a recommendation for the order of information in an artist's résumé:

- Name/Contact info
- Education
- Current, Future, Past Exhibitions (for a visual artist)
- Significant performances, roles, or recordings (for a performing artist)
- Publications (for literary artists); for visual artists this section often includes reviews about the work published by others rather than in a section labeled "press."

- Honors or Awards
- Residencies
- Press
- Other noteworthy accomplishments

Depending on your medium, you will obviously use the appropriate category. And in truth, the order is not all that important after the first few categories. People could argue that press should come before residencies, or residencies before awards, and they would all be correct. The most important thing to remember is that your résumé reflects those achievements and qualifications that will be of interest to the funder. In fact, you might consider tailoring or fine tuning your résumé for each application. As long you communicate that you have the experience, competence, and talent the funder is seeking (and you make it brief enough that the funder will actually get to it), then you will have done your job.

Biography

An artist's biography is a condensed narrative version of his or her résumé written in paragraph form. One key to remember when writing your biography is that it is written in the third person, not the first person (easily used in press releases and introductions. When you write it, imagine what you would like to see written about yourself in an announcement of an upcoming show.). Most "bios" include the artist's place of birth, education, and career highlights. It is condensed relative to the résumé because it will not list as much detail—it is in narrative form and needs to read well.

Artist Statement

Perhaps no element of a funding application confounds artists more than the artist statement. Written in the first person, it is supposed to detail the artist's inspiration and creative process.

As we discussed in the section on strategic planning, the artist statement is one of several statements that you may be called upon to write as you professionalize your project or practice. Artists tend to dislike the artist statement because it asks you to define something that you do intuitively. Writing substantively about an abstract topic is difficult enough, but many artists feel frustrated that whatever words they select do not adequately express their actual artistic vision. Some even feel uncomfortable because they do not seem to have a clear vision, and being asked to write about their vision feels confining and artificial. Others say, "I'm an artist, not a writer." There is also the thankfully less-often-heard

comment: "artists don't write," which is surely a deal breaker when it comes to requests by funders to describe the work for which they are being asked to provide funding!

Your artist statement is important, but not your highest priority. Many grant proposals do not even require an artist statement, and those award or fellowship applications that do require one are far more focused on your work sample. Art and funding professionals who have sat on multiple panels will tell you that they often don't see an applicant's artist statement, except in extremely rare cases as a tiebreaker (and the résumé would precede that in importance). Nevertheless, it is important to have a solid one prepared for the cases where it is indeed an important element.

Budget

For grant proposals, the budget is almost as important as the project narrative. In some cases it is even more important. As we discussed in the finance section, the "numbers" associated with budgets can intimidate many artists, and for no good reason. This should be something that you have already done for yourself, if for no other reason than to determine whether and for how much you need funding. You should think of your budget as a way to tell the story of your project, but *in number form*. And if you have already gone through the exercise of preparing a cost tree and a budget for your project, this will be a very simple task. Be as specific as possible; if the funder has any doubts as to what it will actually be funding, this is your opportunity to inspire confidence.

Typically, applications will include a budget form designed by the funder. Most of these are fairly similar and just ask for projected expenses and income. The specific line items may reflect the funder's interests or concerns.

Under the "expenses" category, refer back to the five general expense categories we addressed in Chapter 20 on researching funding. For a project-based application, you will likely list supplies, travel, and any labor or services relevant to the project (you will probably not be listing education or training on a grant proposal as that would raise a red flag to the funder that you are not ready to undertake the project). And remember never to be afraid to *pay yourself*. It is an expense associated with the project. It is very important to be reasonable, or it can be off-putting to the funder.

The income category can be a little more difficult if most of it is projected. Proposal budgets usually differentiate between earned and contributed income. Earned income refers to revenues that your project or practice generates directly—this could be artwork that you sell, or tickets to a performance, copies of a book, or even services rendered (this is conceptually easier when dealing with your practice and your own time, but could well apply to a project that creates an entity to carry out services in service of an artistic mission). Contributed income refers to any other traditional fundraising you will receive, such as other grants or awards, donations, and in-kind donations. Make sure to list both *known* and *projected*

contributions (for example, if you have secured a $5,000 grant and have a patron or other stakeholder who contributes $1,000 almost every year, you would list both and put "antici-pated" or "projected" in parentheses next to the line item). The "projected" or "anticipated" category also applies to the grant for which you are currently applying.

Artists sometimes have questions or concerns about listing other contributions in a proposal. Part of this stems from a sense that revealing other funding sources will make the funder less interested in them because they will seem less needy. Most of the time, this is a misconception unless that particular grant or award is designed for low-income recipients, which will be made clear on the application (the applicant would typically have to submit an income verification form and other financial details). Having multiple funders tells other potential funders that you are serious and stable and thus more likely to succeed. Having the support of other funders also shows that you have been vetted by other knowledgeable people in the funding world, and will boost a potential funder's confidence in you and your potential. Few funders like being the sole source of support. Furthermore, your budget will still demon-strate need even if you have multiple funding sources—if you have truly covered every imag-inable expense (including your time), you shouldn't be applying for that grant anyway!

Your budget evolves with your project and should reflect a project that has been care-fully thought out and fully developed, detailing expenses and income from start to finish. Therefore, even though you have been thinking about financial aspects of the project from the beginning of the application process, it makes sense for you to prepare the final draft of the budget at the end of the application process. Also, don't worry about the bottom line—your budget should reflect your actual need as opposed to your desire to meet a certain grant amount. Just because a funder is accepting proposals for projects between $100,000 and $1,000,000 doesn't mean that you should try to triple the costs of your project. Conversely, if a grant will only fund 10 percent of your project, show the funder that you have plans to cover the other 90 percent and that the project will move forward if you receive the request-ed amount.

Work Sample

For fellowships and awards, the work sample is the most important part of your application. Work samples are usually reviewed by a panel of experts who have been asked to evaluate your skill or potential as an artist. For grant proposals, it depends on the nature of the fund-ing and work samples may carry equal weight in the funder's consideration with your writ-ten justification for seeking project funding. In either case, an unprofessional work sample can still make a poor impression even on funders who are primarily evaluating the descrip-tion of the project because it can cast doubt on your abilities—after all, if you cannot present your own art in a professional way, how can you be trusted to use the funder's money responsibly?

If you are a visual artist, you will want to present your work in the most "well-groomed" way possible. You might want to use professional photographers or videographers to ensure that the piece has the proper lighting and perspective. If it is a large work with specific details you want the funder to see, include a shot of the larger work and then clearly identify that the detailed shot is part of a whole. If it is an installation piece, it will help to present images that show both the scale of the work and how it functions and interacts with the larger environment.

If you are a performer, many of the same concerns apply, especially depending on what format you use (or the funder requires) to submit your work samples. If you are a theater artist, dancer, or choreographer, you will want the photos and video you submit to be of a professional quality. If you are a musician or composer, you will want to make sure that your recording is clean and free of background noise. In addition, time becomes a major factor. Most funders have specific time limits on submissions, and their instructions as to what to select are frequently vague (you will see many phrases along the lines of "submit samples that best reflect your work"). This can be a very difficult choice, as you may feel that no one segment of a piece adequately represents the whole. If you happen to have any works that are relevant and of very short duration, you may want to submit those. Otherwise, try to find a discrete scene, segment, or movement. As for aesthetic choices, one long-time administrator of a major fellowship program put it succinctly: "Give us the money shot." One technique is to survey a few friends or colleagues to see what they consider the most important or memorable part of your work. If you have already prepared sample materials for promotional purposes, these might be appropriate.

On the technical side of things, most funders will ask for specific cue points on videos or recordings, and these should correspond to whatever script, score, or other notated version of the work you present. Though it may seem obvious, double check to make sure that your CDs and DVDs actually play and are compatible with whatever system the funder will use to review them (if you are unsure, contact the funder to get that information). Pair your sample with a brief description of the work, usually one sentence up to a short paragraph (this is sometimes called a "work statement").

In any case, make sure all your images or other work samples hold together as a related body of work. You do not want the panelists to view or listen to work samples and be distracted by the dissimilarity of items you submitted, asking "are these all by the same artist?"

References and Letters of Recommendation

Some applications will require letters of recommendation or at least a list of references. In either case, think about who you know that can truly speak to (1) your qualifications as an

artist or a project leader, and/or (2) the details of your project. Many artists waste valuable time trying to find a recommender or reference with a lot of influence or star power, when the best option is to choose someone who knows you or your project well and will speak positively about both. In other words, *what* is said is often more important than *who* says it. It is advisable to reach out to a recommender beforehand to ask him if he is comfortable doing so. Not only is it courteous, but it will save you considerable embarrassment if that person was not able to give you a good recommendation. Having a member of Congress write a letter or serve as a reference is impressive, but that will be quickly undone if the funder calls and that recommender can't remember you or anything about your project.

Like every other part of the proposal, think about what the funder wants. For recommendations, funders basically want to see that you have a support structure and others who believe in your project or work. A recommender or reference who can speak about your proposal in detail communicates that. If someone agrees to be a reference for you, be sure to send them a copy of your proposal (along with any other information they want) in case the funder follows up—having access to a quick refresher will only make for a better conversation. If you are requesting a letter, an outline of what you know the funder needs to hear, with the basic facts, is very useful for the letter-writer to have for reference while preparing the letter. Some potential references will even ask you to prepare a draft letter for them to customize, edit, and sign. If so, be sure to say positive things about yourself. Remember, you are asking a favor of someone; make it as easy as possible for them to oblige you!

RESIDENCIES AND SCHOLARSHIPS

While most residency applications require a résumé, biography, artist statement, and even a project narrative in some cases, residencies are primarily looking at an artist's work. The prospective resident's work is "juried," meaning that it goes before a panel similar to panels used for fellowships and awards. The panel will likely examine the work for more than just artistic excellence—it will be interested in how the artist will work in the space, or interact with other potential residents (be part of the artistic resident community). These decisions will obviously vary with the size and prestige of the residency, and the more "thematic" the residency the more important that the artist and his work fit in with that theme (certain residencies have a political or social bent to them, others an aesthetic one).

A résumé showing other residencies is important, especially as you progress to larger or more prestigious residencies. Like other funders, residency administrators want to make sure that they select an artist who will make good use of the time and space and will continue to contribute to the program's reputation. Fair or not, demonstrating that you have

successfully completed other residencies will help your candidacy. Do not worry if it is your first; everyone has a *first*.

If you are targeting a particular residency there can be ways to bring attention to yourself and your work even without prior residency experience. Many residency programs offer smaller programs that are accessible to a wider group of artists, and the application processes tend to be more sympathetic to (or even favor) emerging artists. At a minimum, make sure to attend any and all "open studios" or free performances, as it will not only give you the chance to meet some of the administrators and decision-makers, but it will help you to determine whether that residency is really a good fit for you. Moreover, you will be able to refer to having visited in your application, indicating a seriousness of intent.

With scholarships, there is such a wide range in the types that are offered that there is no set pattern for an application. For academic scholarships, many will track typical college applications, with an added worksheet to verify your income (or your family's income depending on your age and dependency status) if they are need-based. If they are academic scholarships, you may qualify for these simply on the basis of test scores or grade point average at a past institution. Many will require essays that will ask you to demonstrate why you would benefit from attending the institution in question. Art schools or departments will ask for work samples, similar to residency or award applications. Performance-based programs will almost always require a live audition, although in certain rare cases a video will suffice. With scholarships, however, the emphasis will be on potential for growth rather than past achievement or current abilities.

If you have developed your materials for grant, award, fellowship, and residency applications, you will be well-prepared for any scholarship application. The only "twist" to these applications is the prevalence of written questions which may look a little different from other funding applications. Most of the time they are asking for much the same thing you have already prepared for other applications (e.g., an artist statement, a narrative, a work statement, a bio), but perhaps just wording it differently. Look back at the "statements" discussion in the section on strategic planning. Once you become proficient at writing statements on various aspects of your goals, mission, and art, you will be able to answer any question that comes your way. Proficiency comes with practice.

BEFORE YOU MAIL THE APPLICATION (OR HIT SEND)

Your proposal should represent your best work, a compelling pitch as to why your project should receive funding, or why you are deserving of the award or fellowship in question. A strong proposal has been examined and reexamined for weakness at every step of the process. Just as you rework your strategic plans, cost trees, and budgets, your proposal

should be similarly fine-tuned. Get outside input—ask a friend to read the proposal and give you feedback. And don't just ask people who are familiar with your medium. Having someone read it who is completely unfamiliar with the subject matter is a great way to test the clarity of the proposal, especially if you are seeking funding for something technical. Sometimes you will be reviewed by peers (other artists) and other times by foundation board members who typically come from a wide range of backgrounds with art as an avocation, not necessarily a vocation.

Beyond clarity, consistency, and typos, try to analyze whether there is anything in the proposal which may seem unappealing to the funder. This requires a deep understanding of the funding institution and its mission. Try to anticipate a discussion between panelists, one who backs your project and one who does not. What does the contrary voice have against your proposal? If you can identify this before you send the proposal, you have a chance to convince this person before you start (and you won't have to rely on someone else to make those arguments for you).

Read the instructions multiple times. The application may call for things that seem unnecessary or redundant (for example, specifying a font size and spacing, sending six copies, etc.), but failing to follow instructions will put your application in a bad light and may even result in its rejection for not following the guidelines. When you have a friend read your final draft, ask him or her to read the instructions as well and note any discrepancies. While an increasing number of applications are done entirely online, many others are a hybrid (online statements, hard copies of work samples), and some still require that the entire application be submitted as a hard copy (if so, you may be adding printing costs into your cost tree and budget!).

AFTER YOU RECEIVE A RESPONSE

Regardless of whether your proposal is accepted or rejected, respond to the funder. If your proposal was accepted, before you celebrate accordingly, make sure to let the funder know that you are still interested. Most likely they will tell you how to do this upon acceptance, but if not, pick up the phone. It's likely that there is additional paperwork or contracts that need to be signed, and even if your delay does not jeopardize the funding, at the very least you will delay your receipt of the funds. Be sure to express your gratitude at having been selected.

If you are rejected, it is still important to respond. Let the funder set the mode of communication—if they notify you via regular mail, write a letter back and thank them graciously (or do the same by e-mail if that is how they contact you). If you are rejected, wait a day or two to compose yourself and then call the program officer. Don't be defensive or

angry. Politely ask him or her specific questions about your rejection. Why was my project rejected? What were the differences between my proposal and those which were chosen? Sometimes the program officer does not know the answer or is not in a position to give you specifics, but any information you receive will only make your next proposal or application stronger. Even rejection should be a learning experience; think of the feedback as "constructive criticism," something that can be used to make the next application better.

SOLICITING INDIVIDUALS: THE "ASK"

Soliciting donations from individuals is a much more varied process than from institutions, which tends to follow a certain pattern. Funding professionals refer to "the ask" as the basic structure for soliciting donations from individuals. We will examine that here.

As we discussed in the funding research and networking chapters, finding potential donors is really a test of your networking capabilities. Just because you have identified a patron of the arts does not mean that you can approach that person for money—there needs to be some connection. This discussion will assume that you already made some preliminary contact with the potential donor, and that he or she has expressed some kind of interest in your project or practice.

One of the keys to a successful "ask" is preparation. Just because a potential donor is willing to meet with you does not mean that your work is finished. In leading up to an "ask," you will again rely heavily on your network, this time for information. Use any and all connections you have to help tailor your "ask" to the donor in advance of the meeting. Do your research. Develop what the professional fundraisers call "talking points."

When you undertake this research, you will be asking specific questions about the potential funder(s):

- What are their interests in the arts?
- What are their personal interests?
- What is their background?
- What is their capacity for giving?
- What are *their* needs? How do you give back to them?
- Are you asking the decision-maker? (If this person needs to check with his or her spouse separately, you may not be dealing with the decision-maker.)

Knowing the answers to these questions will ensure a far smoother conversation. You don't want to ask someone for a donation who is completely outside of their means, and you don't want to ask for support on a project the donor would never support (an opera patron

may give a lot of money to musicians, but you should not assume that they will also fund a heavy metal concert). You *do* want to present the donor with a project that speaks to their personal tastes and interest in the arts or philanthropy.

You may be able to answer many of these questions by researching the donor's giving history, (you may have already done this in whatever initial research led you to identify this person as a prospect). The Internet remains a valuable tool in this regard, but when preparing for a one-on-one meeting, there is no substitute for personal knowledge. If the potential donor is within your circle of family or friends this will be an easier task. If not, follow up with the connections that put you in touch with this person initially and work from there.

THE "ASK" CONVERSATION

As a preliminary matter, the ask should take place somewhere quiet and intimate, not a busy restaurant or coffee shop full of interruptions and distractions. You want the potential donor

Rachel Selekman (Artist as Entrepreneur Boot Camp participant), *The Conversation*, 2009.

PHOTO COURTESY OF
the artist

to feel relaxed, hear what you have to say, and think. The conversation will follow a five-step process:

Step One: Warm up

Begin with small talk. It is important to make a personal connection leading in to your ask, and your prospect research on the donor's personal interests and background will help shape the conversation. An experienced fundraiser once advised that "sometimes the donor wants to fund your project, and sometimes they just want to fund you." Give them that option. It is more likely the former, so start by assuming that; the latter can sound presumptuous.

Step Two: Create Context

Give the reasons for your request and outline what your needs are. You can think of this as a conversational version of your project narrative, but you have the funder in front of you. Take advantage of this human element and build anticipation without being overdramatic. You should already know the donor's charitable motivations before the meeting, and your goal is to make a connection for the donor between the cause she cares about and you.

Step Three: Make the Ask

Make the ask—request whatever funds or assistance you are seeking. And then be quiet. You want to let her digest your request and not feel pressured. Let her ask you whatever questions she may have about your project, how you will use the money, or anything else. As part of your preparation for the meeting, you should come ready to address not only the specific details of your project (including the budget), but also any kinds of specific limitations on the gift. She may want to know exactly how her money will be used, or have things that she does not want it to fund. Some prospective donors will want to know what they can get in return. Be prepared to give an answer other than "you can see the finished product." You should plan out in advance just what you kinds of limitations you can accept and what other requests you are able to meet.

Step Four: Reiterate Your Appreciation

Just as you would do with a grant proposal, you will want to thank the potential donor profusely for their time, regardless of the response. This person just took considerable time out to listen to your request for money or assistance. You should genuinely be grateful. Like we discussed in the chapter on networking, just because someone says no now does not mean that they will say no again in the future. Thank them again.

Step Five: Follow up

A large ask likely won't get an immediate answer—the donor may need time to sleep on it, so do not have any expectations of a quick response. Instead, talk to your prospective donor about a specific time that would be convenient for further discussion. If he or she is unwilling to commit to a time right then, ask them if you can simply follow up in the future. You should then send the prospective donor a recap of your project and needs, thank them again, and look to schedule a time then. The donor will look to speak with you when he or she is prepared to give an answer.

USING THE ASK IN OTHER CONTEXTS: SECURING ALTERNATIVE TYPES OF FUNDING

While fundraising professionals have developed an approach for traditional "asks," there is no reason that you cannot use this as a blueprint for your requesting less traditional types of funding. Whether you are pursuing a partnership, a barter, or an in-kind donation, you are always "asking" for something. This is why networking is so interconnected with everything an artist does, and why simple tactics like politeness and interest in others can take you so far.

If you are asking your parents to borrow their car for your band's tour, chances are that you won't need to go through a five-step process—you may just pick up the phone. The same may not be true for your uncle. Even if it is, he may well appreciate the gesture and the entire process will go more smoothly. The same is true for a prospective partnership. You might be able to ask a friend casually to go in with you on a project because she trusts you. But an acquaintance probably requires more care. And if you are in the habit of doing this with people who care about you, you will do it more naturally when you are asking a relative stranger for something. Just because it is in someone's interest to work with you does not mean that he or she always will. You can incorporate "asks" into even the most casual and limited types of fundraising, and you will see better results.

FISCAL SPONSORSHIP

One of the most powerful fundraising tools available to artists is known as "fiscal sponsorship." Artists (or an organization of artists) may affiliate themselves with a 501(c)(3) tax-exempt organization (a not-for-profit organization) that acts as their fiscal sponsor. For more information on tax-exempt organizations (not-for-profits), see the discussion in Chapter 11. Fiscal sponsorship is the process by which an artist becomes "sponsored" by a not-for-profit, thus giving the artist access to funds donated by foundations or other organizations that are restricted to giving money to charities (501(c)(3)s), as is the case with many

An individual artist's NYFA fiscally sponsored project — Michelle Jaffé (Artist as Entrepreneur Boot Camp participant), *Wappen Field*, 2003.

of the opportunities compiled by the Foundation Center. Another important benefit of fiscal sponsorship is that it allows private donors to make a donation to the sponsored artist and receive a tax write-off. Both of these scenarios are possible because the check is actually made out to the sponsor organization and not the individual artist. The donor or funder is technically giving money to a 501(c)(3) for charitable and tax purposes; the fiscal sponsor acts as the banker for the sponsor organization or individual project.

This does place an extra administrative and accounting burden on the sponsor organization, as it not only must process checks to the artist, but it must ensure that the sponsored project serves a charitable purpose. This does not mean that the artist or his project cannot make a profit, but simply that some public interest is served by the project (on a practical level, this is often satisfied by a free performance or master class, though there is no universal formula). Because of these added responsibilities, an organization offering fiscal sponsorship will usually ask for a small percentage of the money raised by the artist *through the fiscal sponsor* in order to cover the sponsor's expenses.

Much like applying for other types of funding, an application for fiscal sponsorship may require detailing your project (and your budget in particular), artist statements and work samples, and references. An application for fiscal sponsorship differs from similar types of applications in that the work is not usually judged according to artistic merit. Instead, the primary criteria for fiscal sponsorship are your ability to create an effective budget, write a strong proposal, meet deadlines, and generally follow through with a strong

project. In short, the sponsor needs to be confident that you have the capability to make use of the designation effectively—raise the funds needed to complete the project or keep the organization viable.

Fiscal sponsorship programs vary from organization to organization in terms of the percentages for servicing the account that they take and the additional services that they offer. Artspire, NYFA's national fiscal sponsorship program, offers more services than most in terms of accounting and consultations, but our application is correspondingly more rigorous too and our fee higher than the "no frills" sponsors. While some artists may find the application process challenging, others see a benefit from having been vetted as it not only helps them to focus their project early on, but it shows other funders and donors that another major funder has "invested" in their project.

For artists contemplating starting a nonprofit organization in order to qualify for particular funding streams, fiscal sponsorship can be a real time (and money) saver. Fiscal sponsorship does not carry any of the legal requirements of having a board of directors, meetings, minutes, publications, or any of the other formalities of a not-for-profit organization. It is usually possible to have your fiscal sponsorship application reviewed on an expedited basis, far more quickly than the IRS reviews 501(c)(3) applications. Consequently, many organizations awaiting an IRS decision will make use of fiscal sponsorship as a bridging mechanism.

A NYFA fiscally sponsored organization, Music and Mentoring House, founded by Lauren Flanigan — Lauren Flanigan, pictured with students and parents of Music and Mentoring House, 2010 (Artist as Entrepreneur Boot Camp participant).

PHOTO BY Philip Caggiano

USING TECHNOLOGY FOR FUNDRAISING

As we have addressed most of the traditional and nontraditional fundraising strategies, we want to make note of a technique that has been gaining popularity in the arts world. It is known as "crowdfunding" and uses a central website to host a funding campaign for an artist (three of the most well-known sites are Kickstarter.com, Rockethub.com, and Indiegogo.com).

Artists create a profile page for their projects, similar to the kinds of profiles created on other social media sites, where they set an amount of money they need to raise and a time limit for the funding campaign. They will also include a personalized pitch, work samples, and a way to track the campaign's progress. Perhaps most importantly, these sites require that the artist give something in exchange for the funds, like an autographed CD for a small contribution, or a studio tour, dinner, and a set of prints for a larger donation.

Contributors can make a pledge directly on the profile page for the project, and the collection of funds is handled by the website, which takes a small commission (usually between 5 and 10 percent). The advantages for the artist are simplicity, as setting up a project page is very simple and user-friendly, increased visibility, as people interested in funding artistic projects may be browsing that site, and quick access to funds. The last point is very important. While grants may take a year or more to actually disperse funds, an artist can immediately start a Kickstarter campaign that will end in 10 days. Many artists use crowdfunding sites to close the gap on a project that has obtained some, but not all, of the necessary funding.

Crowdfunding sites also allow for integration with other social media tools, so you can blog about your project, post a link to it on your Facebook page, and even "tweet" about it.

Each site is a little different, so be sure to read the details about any restrictions or requirements. Most attach some kind of penalty if you don't raise your target amount; with Kickstarter you simply do not get any of the funds raised if you fall short, and with Indiegogo you can receive the funds even if you don't make your target, but the site takes a greater percentage of the amount raised. Restrictions notwithstanding, crowdfunding represents an effective and innovative way to use the Internet and social media to your fundraising advantage.

WHAT YOU NEED TO REMEMBER MOST

As you look to fund your project or practice, remember that your greatest asset is your innate creativity as an artist. Whether you are researching previously unexplored funding outlets or crafting a proposal to an institutional donor, your talent for identifying unusual and exciting connections will serve you well. Successful fundraising combines many of the topics addressed in this book—if you have a clear vision, plan, and budget then you will

significantly increase your chances at qualifying for grants and other donations, and your ability to use any donated funds effectively. Similarly, a compelling marketing and promotional campaign will attract the interest of potential donors and collaborators. Finally, an improved networking strategy will yield connections that may lead to unanticipated funding opportunities, while helping you to gain more stakeholders in your art.

A SAMPLING OF FUNDRAISING RESOURCES

Alliance of Artist Communities

Provides a comprehensive listing of national and international residencies. Searchable by location, cost, length, and more.
www.artistcommunities.org

American Composers' Forum

Lists grants, awards, and paid opportunities for emerging and experienced composers.
www.composersforum.org

Artspire

Artspire is an online community for artists and arts organizations brought by NYFA. Among many other useful resources, it provides fiscal sponsorship from one of the most respected programs in the country.
www.artspire.org

ASCAP

An organization dedicated to fostering musical talent and growth through education, professional development, and community outreach programs. On the website there is also a list of grants and awards available to composers of music.
www.ascapfoundation.org

Dance/USA

A resource listing of funding opportunities for choreographers and dance companies.
www.danceusa.org

Foundation Center

Though not specific to the arts, this site is among the most extensive lists of grant and award opportunities available to artists. It also offers webinars on grant-related topics, training videos, and other web-based resources for anyone seeking funding.
www.foundationcenter.org

Google Grants

Google Grants is a unique in-kind donation program awarding free AdWords advertising to select charitable organizations.
www.google.com/grants

Michigan State University Libraries

Provided by Michigan State University, this site offers an exhaustive list of funding opportunities for writers.
http://staff.lib.msu.edu/harris23/grants/3writing.htm

NYFA Source

Massive online searchable database specifically designed for artists and listing artist resources. Technical assistance by phone and e-mail is also available.
www.nyfa.org/source/content/search/search.aspx?SA=1

ResArtis

An association of over 300 centers, organizations, and individuals in over 50 countries, each dedicated to offering artists, curators, and all manner of creative people residency opportunities.
www.resartis.org

Poets & Writers

This online component of the well-known literary magazine *Poets & Writers* features up-to-date listings of grants, contests and awards along with requirements and deadlines for each.
www.pw.org

The University of Iowa—Division of Sponsored Programs

This offering of the University of Iowa lists funding opportunities, proposal-writing guidelines, a glossary of relevant terms, sample grant proposals, links to helpful sites and other resources relevant to the grant process.
http://research.uiowa.edu/dsp/main/index.php?get=grantwritertools

Acknowledgments

NYFA would like to thank all of the many contributors and supporters who helped us in the research, drafting, and editing of *The Profitable Artist*. Without their hard work, expertise, and overall enthusiasm, we could not have written this book.

NYFA WISHES TO ACKNOWLEDGE THE FOLLOWING INDIVIDUALS FOR THEIR CONTRIBUTIONS:

A special thanks to Stacy Lefkowitz, Esq., for her assistance on contracts and on the legal section as a whole.

A special thanks to D. David Parr, Jr., Esq., for his expertise and input on the Business Law section.

A special thanks to Jerry Shrair for his guidance on the Negotiation chapter.

A special thanks to the following individuals for their substantial assistance in the editing process:

Susan Ball, Ph.D.	Steven Cobb, M.D., C.F.P.
Tess Billhartz	David Court
Marnie Black	Elena Dubas
Sonel Breslav	Joshua Gardener
Peter Cobb	Karl Kellner

Joey Lico Neil Reilly

Theresa Marchetta Michael L. Royce

Monica Pa, Esq.

NYFA WISHES TO ACKNOWLEDGE THE FOLLOWING INDIVIDUALS FOR THEIR INVALUABLE SUPPORT AND GUIDANCE THROUGHOUT THE PROCESS:

Gabriel Alegria, Ph.D. Maria Rapoport

Heather Darcy Bhandari Naomi Reis

Judith K. Brodsky Barry Rosenthal

Carolyn Camp, Esq. Carol Ross

Anne Dichter Mark Rossier

Lauren Flanigan Howard Rothman, Esq.

Emma Golden Katy Rubin

Cheryl Grandfield Megan Runyan

Nina Manasan Greenberg Isabel Sadurni

Katherine Griefen David Schroeder

Felicity Hogan Matthew Seig

Michelle Jaffe Rachel Selekman

Diane Klein, Esq. Carol Steinberg, Esq.

Bart Keijsers Koning J. Whitney Stevens

Louky Keijsers Koning Travis Sullivan

Margret Louis, Esq. David C. Terry

Paulanne Queen Latasha Thomas

Maria Villafranca

Sebi Vitale

Sarah Walko

Frank Webster

John F. Williams, II

Rebecca Wohl

Elizabeth Yee

Finally, the Editorial Team at NYFA would like to thank our editorial assistant, Joshua Gardener, for all of his hard work and dedication to the project.

Books from Allworth Press

Allworth Press is an imprint of Skyhorse Publishing, Inc. Selected titles are listed below.

Making It in the Art World
by Brainard Carey (6 x 9, 256 pages, paperback, $24.95)

Starting Your Career as an Artist
by Angie Wojak and Stacy Miller (6 x 9, 288 pages, paperback, $19.95)

The Business of Being an Artist, Fourth Edition
by Daniel Grant (6 x 9, 408 pages, paperback, $27.50)

Legal Guide for the Visual Artist, Fifth Edition
by Tad Crawford (8 ½ x 11, 280 pages, paperback, $29.95)

Art Without Compromise
by Wendy Richmond (6 x 9, 232 pages, paperback, $24.95)

Artist's Guide to Public Art: How to Find and Win Commissions
by Lynn Basa (6 x 9, 256 pages, paperback, $24.95)

Selling Art Without Galleries: Toward Making a Living From Your Art
by Daniel Grant (6 x 9, 288 pages, paperback, $24.95)

Fine Art Publicity: The Complete Guide for Galleries and Artists, Second Edition
by Susan Abbott (6 x 9, 192 pages, paperback, $19.95)

How to Start and Run a Commercial Art Gallery
by Edward Winkleman (6 x 9, 256 pages, paperback, $24.95)

The Artist-Gallery Partnership, Third Edition
by Tad Crawford and Susan Mellon (6 x 9, 224 pages, paperback, $19.95)

Business and Legal Forms for Fine Artists, Third Edition
by Tad Crawford (8 ½ x 11, 176 pages, paperback, $24.95)

The Artist's Complete Health and Safety Guide, Third Edition
by Monona Rossal (6 x 9, 416 pages, paperback, $24.95)

Learning by Heart
by Corita Kent and Jan Steward (6 7/8 x 9, 232 pages, paperback, $24.95)

The Quotable Artist
by Peggy Hadden (7 ½ x 7 ½, 224 pages, paperback, $16.95)

Guide to Getting Arts Grants
by Ellen Liberatori (6 x 9, 272 pages, paperback, $19.95)

To see our complete catalog or to order online, please visit *www.allworth.com*.